Visions of Illinois

A series of publications portraying the rich heritage
of the state through historical and contemporary
works of photography and art

Prairiescapes
Photographs by Larry Kanfer

Nelson Algren's Chicago
Photographs by Art Shay

Stopping By: Portraits from Small Towns
Photographs by Raymond Bial

Chicago and Downstate: Illinois as Seen by the
Farm Security Administration Photographers, 1936–1943
Edited by Robert L. Reid and Larry A. Viskochil

CHICAGO
AND DOWNSTATE

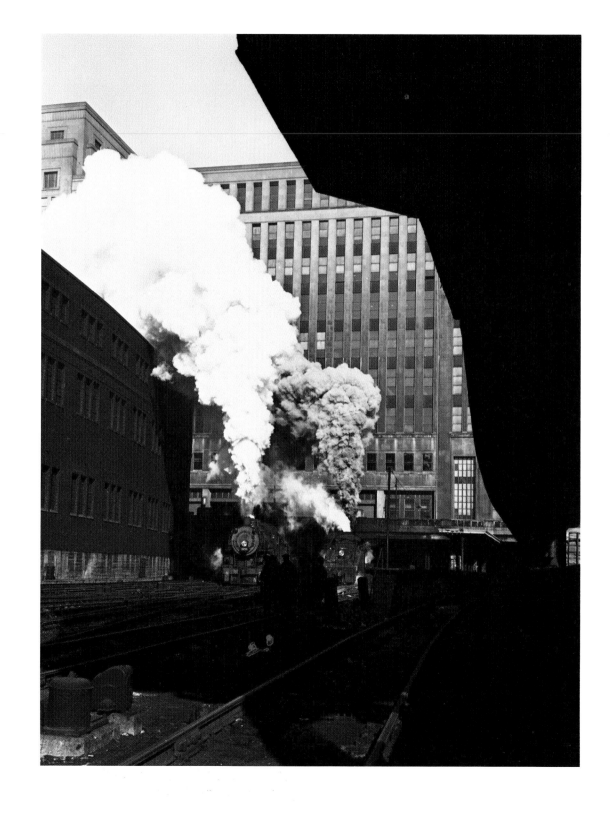

CHICAGO
AND DOWNSTATE

Illinois as Seen by the
Farm Security Administration Photographers
1936-1943

Edited by
ROBERT L. REID
and
LARRY A. VISKOCHIL

Chicago Historical Society | University of Illinois Press *Urbana and Chicago*

frontispiece: Trains pulling out of the south side of Union
 Station. Chicago. February 1943. *Jack Delano*

contents page: State line between Indiana and Illinois.
 February 1940. *Arthur Rothstein*

© 1989 by the Board of Trustees of the University of Illinois
Manufactured in the United States of America
1 2 3 4 5 C P 5 4 3 2 1

Library of Congress Cataloging-in-Publication Data

Chicago and downstate.

 Bibliography: p.
 Includes index.
 1. Chicago (Ill.)—Description—1875–1950—Views.
2. Illinois—Description and travel—1865–1950—Views.
3. Chicago (Ill.)—Social life and customs—Pictorial
works. 4. Illinois—Social life and customs—Pictorial
works. 5. Photojournalism—Illinois. I. Reid,
Robert L., 1938– . II. Viskochil, Larry A.
III. United States. Farm Security Administration.
F548.37.C523 1989 977.3'1104 88-27873
ISBN 0-252-01635-1 (cloth)
ISBN 0-252-06078-4 (paper)

CONTENTS

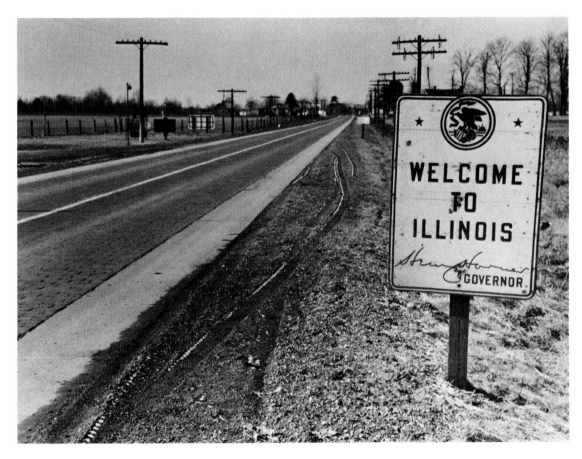

ACKNOWLEDGMENTS

■ This album of photographs shows us images of Illinois and Chicago captured on film approximately fifty years ago by some of America's finest photographers. The book is a companion to a major exhibit that features a selection of Chicago photographs. This exhibit will be shown at the Chicago Historical Society in the spring of 1989, the 150th anniversary of the invention of photography. With funding support from the Illinois Arts Council, the exhibit will later travel to other sites throughout the state.

The editors together reviewed the 2,400 Illinois images in the FSA-OWI Collection, from which the final selections were made. Larry Viskochil wrote the introductory essay on photography in Chicago and assumed major responsibility for the organization and presentation of the exhibit. Robert Reid wrote the introduction and the text opening each section of photographs.

Many people contributed to this publication. We are indebted to Jack Delano and Theo Jung for sharing information. Two others closely associated with the FSA-OWI, Jean (Mrs. Russell) Lee and Louise (Mrs. Edwin) Rosskam, graciously recalled their experiences with the project. John Vachon's daughter, Ann, and his brother, Robert, gave their permission to quote from personal correspondence. James C. Anderson and David Horvath facilitated the use of the Stryker Collection at the University of Louisville. Russell Lewis, Director of Publications at the Chicago Historical Society, and Sandra Hermann, a faculty member at the University of Southern Indiana, provided useful editorial comments. Richard L. Wentworth, Director of the University of Illinois Press, brought his extensive publishing experience to bear on all phases of this project and facilitated its production in virtually every way possible. We are grateful to André Kuzniarek and Barbara E. Cohen for their splendid work in designing and copyediting the book.

The staff of the Prints and Photographs Division of the Library of Congress provided valuable assistance; special thanks go to Beverly W. Brannan, Curator of Photographs, and to Evelyn Nave of the Photoduplication Department for their good work. The manuscript was typed by Michele Yonts and Martha Barrows. George Eadie, Professor of Mining Engineering Technology at the University of Southern Indiana and a resident of Eldorado, reviewed the section on southern Illinois. John M. Hoffmann of the Illinois Historical Survey, Dr. Percy Clark of Indianapolis, and Elton Williams of Chicago provided research assistance. Others who encouraged and supported this book include Mr. and Mrs. C. Joseph Compton, Mrs. Ruth Elkins, and Dr. David L. Rice. Robert Reid also acknowledges his children, Erik and Kristin, and his wife, Joanne, who was born in Morris, Illinois.

PICTURING CHICAGO'S HISTORY

Larry A. Viskochil

■ Asked by their subjects "why do you want my picture?" Farm Security Administration photographers sometimes replied, "for history."[1] Satisfied with this answer, people usually cooperated willingly. Most photography, however, is not inspired by history. Although some amateur photographers understand the importance of a historical visual record, it is the proliferation of the camera and snapshot throughout society, not a historical viewpoint, that makes their work so valuable. Each year Americans take many billions of photographs, many of which survive in personal and institutional archives, that record our lives. In many cases they will be the *only* records of the people, places, and events of our society and culture. But unlike the casual "snapshooter" whose primary interest may be adding to the family album, the photographer-historian has the larger vision of making a creative statement about what is important to remember about his or her times.

Over the past 150 years, since the invention of photography in 1839, amateur and professional photographers have consciously or unintentionally created a visual heritage of life in Chicago. Before the advent of photography in the 1840s and 1850s, most visual depictions of the city were made by painters, printmakers, or cartographers. The earliest photographs of Chicago are daguerreotype and ambrotype portraits of the city's founding settlers. Produced on metal or glass as unique images, these photographs were technically difficult to make, especially if the subjects were in motion or were far from the darkroom; few exist that were not made in the studio of a professional portrait photographer. The introduction of paper photographic prints made from negatives, similar to photographic techniques used today, made photographs affordable and stimulated the growth of professional photographers. In Chicago, the professional studios of John Carbutt, Edwin Brand, S. M. Fassett, Alexander Hesler, C. D. Mosher, and others sprang up in the 1850s and 1860s to meet the insatiable demand for carte-de-visite and cabinet card portraits. Images of members of the city's middle and upper classes were made in the tens of thousands as mementos for Chicagoans to mount in special albums.[2]

These founders of Chicago's commercial photography industry also produced outdoor views of their frontier city for the carte-de-visite and cabinet card trade, but the real mass market for city views came with the introduction in the mid-1860s of the stereographic view cards. Unlike cards made for albums, these dual-image photographs were viewed through special devices that created a three-dimensional illusion. Immensely popular, stereo-card views of local scenes were often published in sets and distributed nationally. The stereo

viewer and a basket of stereo cards sitting in the parlor were as common in the nineteenth and early twentieth centuries as television sets are in living rooms of today.

George Eastman's inexpensive and easily operated Kodak camera introduced in 1888 revolutionized amateur photography; anyone could become a photographer. Americans began to document every aspect of their lives and creating "visual biographies" of family members became an important leisure activity. Pictures of picnics, parties, vacation trips, and holiday celebrations made by average citizens may become as important to future histories as family letters and diaries have been to scholarship of earlier ages. Since the last decade of the nineteenth century, amateur photographers continue to capture aspects of daily life in Chicago that few professional photographers would consider recording on film.

Chicago was the major printing and publishing center in the West during the nineteenth century. After the 1890s new technological innovations in the printing industry made photographic reproductions in books, magazines, newspapers, and other printed materials practical, and a new type of commercial photographer evolved to meet this new market.[3] Unlike the early studio photographers who concentrated on portraits, these photographers focused on architecture and advertising work. Commercial firms such as J. W. Taylor (1880s–1916), the Barnes-Crosby Company (1890s–1960s), George Lawrence (1890s–1930s), Raymond Trowbridge (1923–32) and the Hedrich-Blessing Company (1930–present) profited from a boom in real estate and commerce that encouraged new ways of using photography to promote and sell services and products.[4] Commercial photographers operating small family-run or neighborhood-based businesses began to appear around the same time. Their stock in trade was supplying the photographic needs of everyday life—weddings, baby christenings, bar mitzvahs, and passport photographs as well as coverage of local ceremonies, store openings, and neighborhood events for the community newspapers and local businesses.[5]

One of the richest sources of city views at the turn of the century was the picture postcard, which was produced by major commercial photography firms as well as by the smaller independent neighborhood-based studios. First published in America in Chicago in 1893, picture postcards had instant success, sweeping the country much like stereo cards had earlier in the century. Cheaper to produce and even more popular because they could be mailed with a message, postcards carried images of Chicago (and other American cities) around the world. Their greatest popularity lasted from the late 1890s until the 1920s, a period during which America changed from a rural to an urban society. These urban views, produced in enormous numbers by commercial photographers like Chicago's Curt Teich Company, the Barnes-Crosby Company, and Charles Childs, pridefully recorded this shift, promoting the new urban society better than any chamber of commerce advertisement.[6]

These different types of amateur and professional photographs—studio portraits, city views, and family snapshots—provide historians with a valuable visual record of Chicago from its early beginning to the present. Despite the great breadth of urban life this body

of work covers, it is a limited record at best. Fortunately, its most glaring shortcomings have been overcome by a different, more conscious and more deliberate kind of documentary photography that began to evolve around the turn of the century as part of the burgeoning field of photojournalism.

Amateur and commercial photographers have paid scant attention to social problems. There are few markets for images of the poor, the exploited, the criminal, or the unpleasant and unfamiliar worlds they inhabit. In the late 1880s a group of photographers specifically interested in ensuring that the urban blemishes usually kept out of mind did not remain out of sight first captured the underside of urban life in harsh realistic images. This mission was undertaken by a few investigative journalists working for civic-minded newspapers or by employees of progressive social service organizations who saw photography as a new tool to awaken the public to the need for social reform in the nation's rapidly changing urban centers. In Chicago during the first decades of the twentieth century, photographers for organizations such as the Infant Welfare Society and the Visiting Nurse Association followed the example of social-reform photographers Jacob Riis's and Lewis Hine's New York work by recording the difficulties of new immigrant groups in the city's slums and ghettos.[7]

This early documentary work spawned a flood of photojournalistic images that gradually changed America from a literary into a visual society. This kind of documentary photography reached its zenith in the 1930s and 1940s in publications such as *Life* and *Look*,

which covered both timely international issues and the everyday life of average citizens in immensely popular human-interest picture essays. These large-circulation picture magazines brought hundreds of documentary photographs into millions of homes each week. Their hallmark was the ability to respond to news with a kind of speed that previously only local newspapers showed. *Life*, which was printed for national distribution in Chicago, covered major social issues as if they were breaking news each week.[8]

While the new photojournalism attempted to cover daily events as they happened, a parallel movement in "official photography"—images that try to show things as they are supposed to be—was developing. The official and quasi-official agencies that run every city from civic departments to chambers of commerce began photographing their activities to promote their missions and to prove their effective governing to their constituents. Often the most interesting images of this genre have been created by special official and semi-official agencies and commissions empowered from time to time in a city's history with specific agendas. The most ambitious project of this kind undertaken on a national scale was the Farm Security Administration (FSA) photography project. The FSA photographs made in the 1930s and 1940s clearly form the most important photo-documentary project in history. One aspect of this project's uniqueness is its merging of the best of photojournalistic techniques and point of view with the special opportunities for reform that working in an official capacity afforded the photographers.

Eager to show that all segments of society, even

previously neglected ones, were to be part of the national effort, most FSA photographs of Chicago focused on the city's growing black populations. Richard Wright, who used many FSA photographs of Chicago in his 1941 book *Twelve Million Black Voices*, was probably correct when he said that "no other community in America has been so intensely studied, has had brought to bear upon it so blinding a scrutiny as Chicago's South side."[9] Other authors, however, had not illustrated their books with pictures that accurately showed how blacks in Chicago, or other cities, lived. For the most part, such pictures did not exist in numbers large enough to be useful for research or publication. For years blacks, if they were photographed at all, were shown either as quaint rural folk in art studies or as stereotypes. No tradition of photographing blacks developed throughout the long period of slavery because they were considered unworthy of notice. Since slavery, blacks have until recently been excluded from written history, and their records neglected by museums, libraries, and archives. Throughout their history, blacks have lacked the resources and opportunities to produce and preserve for themselves the photographic story of their difficulties and achievements.

The paucity of photographs of the everyday lives of blacks makes these Chicago images by FSA photographers all the more important; they reveal both poor and middle-class Americans during a period of economic hardship, not an exotic nation within a nation. Early FSA photographs had shown to white city dwellers the effects of the depression and contemporary agricultural practices on rural Americans. The images of Chicago and of other large industrial cities also documented the lives of previously neglected or ignored citizens who could make significant cultural and economic contributions to the country if only given a chance.

The goals of the FSA project to inform, persuade, and motivate the public and the government were achieved not only because an accurate photographic record was produced but also because these records were powerful artistic statements. Ironically, some today believe the FSA was primarily a federal make-work program for photographers and other artists and that their images produced for political reasons were intended mainly to stand as aesthetic expressions. Although many of the FSA photographers were artistically talented, they felt for the most part that art was a desirable by-product of their work but not the reason that they were hired. Nevertheless, the FSA photographers' work helped the general public accept the modern notion that photography could be considered an art form.

During the postwar period the idea that photography itself was a medium worthy of serious study grew steadily. Galleries selling photography as art formed and art museums, like historical archives before them, began to accept photographs for their permanent collections. By the 1960s a veritable boom in photographic collecting, publishing, and exhibiting had begun to sweep the nation. During this prosperous decade, the socially concerned photographer found more support from the private sector—commerce, industry, and the print and electronic corporate media—than from public

agencies. Reporting the social ferment of the 1960s and 1970s brought a resurgence in what some called "concerned photography." Unlike the "official photography" sponsorship of earlier photodocumentaries, these portrayals of the civil rights or antiwar movements were often powerful and uncomfortable indictments of government itself and of society at large.

The wave of interest in all things photographic continued into the 1970s as universities, colleges, and even high schools established formal photography programs. Photography education opportunities in the Chicago area were especially plentiful, and thousands received training that had been unavailable anywhere only a generation earlier. The schools popularized a new kind of documentary photography. Independent of both government and commerce, these photographic training centers concerned themselves more with aesthetic training rather than with political or economic study. Students were encouraged to use their new skills to look inward and to express their personal view of the social landscape around them. This new generation of photographers is still active today. This resurgence of interest in photography during the last twenty years has created a revitalized commercial photography climate in Chicago and a flood of museum and gallery exhibitions, books, catalogues, and photodocumentary projects.[10] Special exhibitions on Chicago subjects have been staged with increased frequency at all of Chicago's major cultural institutions. The most recent large-scale documentary photography project, entitled Changing Chicago, was inspired in part by the FSA photographers' work in Chicago. Co-sponsored by the Focus/Infinity Fund and five major Chicago cultural institutions, this project records aspects of Chicago during 1987-88 through the work of thirty-three photographers.[11]

Any effort to comprehensively photograph Chicago, or any city, will produce an incomplete record. Such attempts are limited by what individual photographers can photograph and by their personal vision that structures how a subject is actually recorded. Because the photographer cannot hope to photograph everyone and everything of interest, the historian's task is to discriminate between those subjects that have achieved importance by being photographed and those that have been overlooked. The challenge of the historian is to select from the ever-growing mountain of photographic records produced by our visual society those images that are most meaningful. In this regard Chicago's photographic heritage is especially rich. A new generation of photographers and historians, born into an age where pictures have all but replaced printed pages for many Americans, has unparalleled opportunities to see the city of Chicago and its inhabitants as they have never been seen before.

NOTES

1. Many FSA photographers found that communicating FSA director Roy Stryker's goal of creating a visual historical record of America to their subjects was helpful in breaking down natural resistance to being photographed by a stranger.

Russell Lee recalled in 1964 that: "Whenever they asked me, 'What are you doing out here taking pictures?' I said, 'Well, I'm taking pictures of the history of today.' And they understood this. And this was an entree to the people that were difficult to communicate with. . . . I sort of felt, too, that by means of these pictures, we were helping some . . . parts of the country understand what the other parts were like." Quoted in Robert L. Reid, *Back Home Again: Indiana in the Farm Security Photographs, 1935–1943* (Bloomington: Indiana University Press, 1987), ix.

2. The Chicago Historical Society, for example, has almost 30,000 of these early card portraits among its holdings. For an account of early commercial studio photography in Chicago see Larry A. Viskochil, "Chicago's Bicentennial Photographer: Charles D. Mosher," *Chicago History* (Summer 1976), 95–104.

3. The introduction of factory-made gelatin dry plates freed photographers from using the cumbersome wet plate negatives that had restricted photography to only the most dedicated or privileged few. The other great innovation was the introduction of half-tone and other photomechanical printing methods and high-speed printing presses, which allowed photographs to be published easily and cheaply. Later, the availability of flexible roll film; inexpensive, simple cameras, like the Kodak; and the rise of the commercial photofinishing industry greatly increased photographic activity and awareness.

4. The work of commercial photography firms is well represented in the collection of the Chicago Historical Society and other historical archives. An excellent study of their impact on photography and the way we look at cities as a result of the images they made is Peter Bacon Hales's *Silver Cities: The Photography of American Urbanization, 1839–1915* (Philadelphia: Temple University Press, 1984).

5. Because of their seemingly ordinary nature, these collections of small business records have often been overlooked by historians and archivists. As they find their way into public collections, they will prove to be an extremely rich source for the study of daily urban life. A good example is the 1,200 photographs made in Chicago's Lake View community from 1942–53 by neighborhood photographer Henry Delorval Green, which are held by the Chicago Historical Society's Prints and Photographs Collection.

6. Photographic postcards and photomechanically printed postcards depicting urban scenes and subjects have long been systematically collected by both individuals and institutions. Chicago's Curt Teich Company, the largest producer of cards in the world, printed thousands of city views from 1898 to 1974. Housed today in the Lake County Museum in Wauconda, Illinois, this important collection is a valuable resource for pictures of cities and towns around the world. The Chicago Historical Society also has large collections of photographic picture postcards including a 5,000-card collection of Charles R. Childs, a postcard photographer who specialized in images of Chicago and other Illinois cities and towns from 1907–50. Another important firm in the history of postcard views of Chicago was the Barnes-Crosby Company. A detailed account of this history is Larry A. Viskochil, *Chicago at the Turn of the Century in Photographs* (New York: Dover Publications, 1984).

7. A brief discussion of reform photography in Chicago can be found in Glen E. Holt, "Chicago Through a Camera Lens: An Essay on Photography as History," *Chicago History* (Spring 1971), 158–69.

8. Many of the contemplative photo essays that would compete for space with the week's main events often were not published in these magazines. For example, *Life* freelance photographer Andreas Feininger came to Chicago around the same time as the FSA photographers had been sent here to develop a photo essay on the city that he hoped *Life* would publish. During a twenty-day period he made 312 photographs, but *Life* showed no interest. The images remained

in his hands until 1980 when he finally found a publisher; see Andreas Feininger, *Feininger's Chicago, 1941* (New York: Dover Publications, 1980).

9. Richard Wright, July 1945, quoted in St. Clair Drake and Horace R. Cayton, *Black Metropolis*, rev. ed. (New York: Harper and Row, 1962), xix.

10. The Chicago Council on Fine Arts Artist-in-Residence Program, for example, sponsored more than twenty separate documentary photography projects from 1977 to 1981. Members of the Chicago Area Camera Clubs Association, through their Chicagoland-in-Pictures project, have contributed more than 36,000 documentary photographs of Chicago and its suburbs to the Chicago Historical Society since 1948.

11. See *Changing Chicago: A Photodocumentary* (Urbana: University of Illinois Press, 1989).

CHICAGO
AND DOWNSTATE

INTRODUCTION

Robert L. Reid

■ Looking back on his experiences as a photographer for the federal government, Russell Lee remembered the hard times the American people had endured during the 1930s. He recalled these years as "a period of real stress in the country. We were in bad shape and all of us knew it. There were people starving, half-starving, God!" For seven years, from 1936 to 1943, Lee worked for an agency known as the Historical Section of the Farm Security Administration. A native of Ottawa, he made several visits to Illinois in these years, returning to his home state to capture on film the lives of ordinary Americans caught up in the Great Depression and World War II.[1]

The photographs taken by Russell Lee and his colleagues constitute one of our nation's richest treasures. Housed in the Prints and Photographs Division of the Library of Congress, they are the legacy of the "most momentous" photography project ever conceived. The seeds of the project were sown in 1935 when President Franklin D. Roosevelt signed an executive order creating a new agency, the Resettlement Administration (RA), to assist the rural poor. The Agricultural Adjustment Act, enacted two years earlier, was the major New Deal farm legislation; the Act had paid little heed to the small farmers, tenants, migrant workers, and share-croppers in the countryside. The Resettlement Administration, and the Farm Security Administration (FSA) that replaced it in 1937, sought to correct this oversight, reaching out to the "poor people on poor land" who helped make up the lower one-third of the American people described by President Roosevelt as "ill-housed, ill-clad, ill-nourished."

To document the work of the RA, Assistant Secretary of Agriculture Rexford G. Tugwell brought a former student and colleague from the faculty of Columbia University, Roy Emerson Stryker, to Washington, D.C. From the beginning Stryker hired talented professional photographers, including Dorothea Lange, Carl Mydans, Arthur Rothstein, Walker Evans, John Vachon, Jack Delano, and Lee. His goal became the creation of a documentary record that would tell Americans "about ourselves."

In building that record, Stryker's photographers took more than 270,000 photographs, covering the nation on assignments related to the work of the agencies to which the project was assigned. From an initial focus on government resettlement projects, the coverage expanded to recording virtually all aspects of the New Deal experience. With justifiable pride Stryker considered the development of the extensive file to have been a bureaucratic miracle; the photographers had been the right group of people at the right spot at the right time. Their cameras filmed "as much of America as we could see in terms of people and the land. We photographed

destitute migrants and average American townspeople, sharecroppers and prosperous farmers, eroded land and fertile land, human misery and human elation." The result, he concluded, produced "as well rounded a picture of American life during that period as anyone could get."[2]

The unique combination of Stryker's expanding vision and the artistic skills of his now legendary staff made possible this rich documentary record. As events on the international scene shifted American energy toward preparation for war, the FSA project expanded to film activities on the home front. The Japanese attack on Pearl Harbor on 7 December 1941 intensified this coverage. The agency's wartime role, preparing positive images for propaganda purposes, achieved official status in October 1942 when the FSA project was placed under the Office of War Information (OWI). Stryker's instructions to concentrate on "shipyards, steel mills, aircraft plants, oil refineries, and always the happy American worker" suggest his mounting displeasure with the constraints placed on his photographers.[3] One year later, he resigned. Before leaving, however, he made certain that this magnificent documentary record, now called the FSA-OWI Collection, would be preserved. Stryker arranged the transfer of the entire set of 107,000 captioned prints and a total of more than 180,000 unduplicated negatives to the Library of Congress.

During the life of the project, the photographs were made available free of charge to government agencies, newspapers, magazines, and the motion picture industry. Many have become familiar through their inclusion in textbooks, exhibits, and pictorial collections depict-

ing America's past. Approximately two hundred images appeared so frequently that the staff referred to them as "cookie cutters," a term supplied by Dorothea Lange for such classic portraits of the depression years as Lange's "Migrant Mother," Arthur Rothstein's "Dust Storm," and Russell Lee's "Hands." As the reputations of the FSA photographers grew, exhibits, photoessays, and books were produced that featured the individual photographers and their portfolios. These images tended to dramatize the human consequences—the faces of despair—of "The Bitter Years," using the now familiar photographs of eroded land, dust bowl conditions, and impoverished people. In recent years, scholars have extended our appreciation of the FSA-OWI Collection through new approaches to the documentary photographs. These publications include studies of medicine, railroading, and village life in New Mexico together with compilations of pictures organized by states including Virginia, Kentucky, and Indiana.[4]

The captioned prints in the FSA-OWI Collection fill 235 file drawers. Originally arranged by field assignments, the collection was reorganized by Paul Vanderbilt in 1942. The photographs were filed under six geographical regions and organized by subject headings such as the land, agriculture, people, transportation, and industry. The Midwest section includes more than 2,400 images taken in Illinois, the source for the 162 selections presented in this book. Although more than twenty staff members took pictures for the Historical Section during the life of the project, eleven gained recognition as the major FSA-OWI photographers. Of these eleven, seven took pictures in Illinois: Russell Lee,

Arthur Rothstein, John Vachon, Jack Delano, Theodor Jung, Carl Mydans, and Dorothea Lange. Also represented are photo editor Edwin Rosskam and two OWI photographers, Ann Rosenor and Esther Bubley.

Jung, Mydans, and Lange made only limited contributions. Born in Europe, Theodor Jung (1906–) grew up in Chicago. After graduating from the University of Chicago, he studied photography at the College of Graphic Arts in Vienna, the city of his birth. An "ardent New Dealer," he was one of the first photographers hired by Stryker.[5] While on assignment in the Midwest, he visited the major resettlement project in Illinois, Lake County Homesteads. Only a single image from the visit, that of a house under construction near Libertyville, appears in the Illinois file. Like Jung, Carl Mydans (1907–) worked on the FSA staff for less than a year. He covered the conservation project at Pere Marquette State Park and grain elevators near Gibson City. Mydans joined the staff of a new mass-circulation picture magazine in 1936. Working for *Life* during the entire span of its regular publication, 1936–72, he gained a reputation as one of America's finest photojournalists. Dorothea Lange (1895–1965), best known for her compassionate depictions of migrant workers, took only two photographs in Illinois: interior scenes from government buildings in downtown Chicago. They date from June 1939 when she accompanied her husband, the economist Paul Taylor, as he attended a national meeting in the Windy City. The best image, her shot of spectators attending an aldermanic committee meeting, is included in this album.

Arthur Rothstein (1915–86) acquired his strong interest in photography while he was an undergraduate student at Columbia University. A native New Yorker, he came to Washington, D.C., in the summer of 1935 to set up the photo laboratory for Stryker. Within weeks, he was in the field taking photographs. In 1940 he left the FSA staff to take a position with *Look*, the other major photography magazine that developed in the 1930s. For many years he served as Director of Photography for that publication. His photographs taken in Illinois include beach scenes from Chicago, a series from Peoria that features prostitutes, and extensive coverage of the depressed conditions of the coal industry in southern Illinois.

Only a few images of southern Illinois taken by John Vachon (1904–75) appear in the file; his major contributions present activities in the central part of the state and in Chicago. A native of St. Paul, Minnesota, he emerged from a position as file clerk to become a staff photographer. After the war, he rejoined Stryker on the photography project sponsored by Standard Oil (New Jersey) before becoming a photographer for *Look*, where he worked until that magazine ceased publication in 1972. While indebted to Dorothea Lange, Walker Evans, and Ben Shahn for his inspiration and example, Vachon developed his own distinct style, seen in pictures such as the elderly woman on the front porch in Elgin or the crowded Chicago parking lot with the large outdoor advertising sign for Pabst beer in the background. Vachon photographed his Chicago images as he traveled out from the nation's capital on trips that usually combined a visit home to Minnesota with specific assignments in the Midwest and Great Plains.

Russell Lee (1903–87) trained as a chemical engineer at Lehigh University. When he inherited several farms near Ottawa in 1929, he resigned from his position as the manager of a roofing factory in Kansas City to study art. Photography became his preferred medium of expression. Hired by Stryker in 1936 when Mydans resigned, Lee's first assignment kept him in the field for nine months, mostly in the Midwest. He took photographs of farm activity near his home community of Ottawa and covered the destruction caused by the Great Flood on the Ohio River in February 1937.

Lee returned to Illinois in April 1941. He drove from Washington, D.C., with his constant companion, his wife Jean, and a former staff member, Edwin Rosskam. The latter had left the FSA to become photo editor for a new book commissioned by Viking Press. Other books, including Archibald Macleish's *Land of the Free*, Herbert Clarence Nixon's *Forty Acres and a Steel Plow*, Paul Taylor and Dorothea Lange's *American Exodus*, and Sherwood Anderson's *Hometown* had successfully blended FSA photographs with poetry and prose. Rosskam's new project took as its subject the great migration of blacks from the rural South to the urban North in the twentieth century. The text was written by Richard Wright, whose novel *Native Son*, published one year earlier, established him as one of America's leading writers. Reviewing the FSA files, Wright and Rosskam recognized the need for further illustrations. Unofficially, Stryker allowed Lee to spend two weeks in Chicago taking photographs in the Black Belt, the setting for Wright's best seller, *Native Son*.[6] When published later that year, *Twelve Million Black Voices* combined Wright's passionate words with eighty-six pictures, of which eighty were selected from the FSA files, including twenty-two taken by Lee and Rosskam that April in Chicago.

Russell Lee left the FSA-OWI in 1942 to join the Army Air Transport Command as a photographer. After the war he rejoined Stryker, who was employed on the large photo-documentary project for the Standard Oil Company. When that project ended in 1950, Lee became a freelance photographer and university faculty member. Described as "the ideal FSA photographer," Lee took more photographs and spent more time in the field than any of his colleagues in the Historical Section.[7] Only Roy Stryker and John Vachon exceeded his length of service.

When Arthur Rothstein joined the staff of *Look* in 1940, a commercial photographer from Philadelphia named Jack Delano (1914–) replaced him. Most of Delano's contributions record the nation's early preparations for war and the war years on the home front. His Illinois assignment was to document the role of the nation's railroads in supporting the military. For six months, from November 1942 to April 1943 he worked out of Chicago, the nation's largest and busiest transportation center, covering transcontinentals such as the Atchison, Topeka, and Santa Fe Railroad and local lines such as the Indiana Harbor Belt Railroad, a switching line confined to the many railroad yards in and around Chicago. Delano documented the Union Station in great detail and prepared a photoessay on a railroad switchman, Daniel Senise, and his family in Blue Island. In addition, he photographed families in the Ida B. Wells

project in the Black Belt, churches on the south side, and scrap drives and parades on the north side of the city. Delano's photographs taken in Illinois fully justify his reputation as a photographer who was always seeking the perfect image. After the war, he returned to Puerto Rico, which he had visited on an FSA assignment in 1941. Delano established a permanent residence and became director of the public radio and television station there.

While the professional photographers on Stryker's staff drove across the nation collecting visual documents of America, another group of Americans, unemployed writers, worked for the Works Progress Administration (WPA). Both amateurs and professionals, they also used automobiles as they gathered materials for written guidebooks. Though not intended to describe the FSA, the recollections of one WPA author captured the experience of both the FSA photographers and the WPA writers in these words: "[We] were riding about the country at about the same time, in search of the same information. We pulled in and out of industrial centers, spent many days in small towns, hung around CCC (Civil Conservation Corps) camps, and other federal projects, stared appalled at the shanty settlements and cabin villages of our pariahs—Negroes, Mexicans, poor whites . . . and listened and listened and listened."[8] The FSA photographers not only listened, they clicked shutter after shutter after shutter.

The Federal Writers' Project, created to devise appropriate jobs for a group of Americans otherwise left unemployed, produced more than 226 books, including individual guidebooks to each of the forty-eight contiguous states. John Steinbeck remembered this American Guide Series as "the most comprehensive account of America ever got together, and nothing since has ever approached it."[9] On occasion, the visual imagery of the FSA project and the words and text written for the WPA converged. Three publications related to Illinois brought pictures and words together. One, the *WPA Guide to Illinois*, offered a descriptive text of nearly 700 pages filled with useful information. Published in 1939, it began with a description of the state's history and culture, economy, social life, and racial and ethnic groups. Capsule descriptions of towns and cities followed; the book concluded with detailed tours guiding the visitor across the principal highways of the state. It used six photographs from the FSA files, a common feature of most of the state guides. The second book, a research monograph, detailed the severely depressed conditions in the coal fields of southern Illinois. Entitled *Seven Stranded Coal Towns: A Study of an American Depressed Area*, the book included ten photographs taken by Arthur Rothstein for the Work Projects Administration, the agency that supported the social research. The three southern Illinois counties of Franklin, Saline, and Williamson were discussed together as a "special victim," one of the nation's depressed areas "where unemployment has struck the hardest and persisted most stubbornly."[10]

The third book, *Black Metropolis: A Study of Black Life in a Northern City*, was not published until 1945. However, the research for this major sociological study was financed by the WPA and conducted by a team headed by W. Lloyd Warner (1898–1970) of the University of Chicago and Horace R. Cayton (1903–70), a

Chicago social worker and social scientist. Begun in the late 1930s, the Cayton-Warner research was completed by 1941 when Cayton, with co-author St. Clair Drake, prepared a first draft of the manuscript. When Wright met Lee and Rosskam in Chicago, he introduced them to Cayton. In his role as director of the Good Shepherd Community House near the center of the Black Belt, Cayton was himself a respected leader in the black community. His wide range of contacts and his knowledge of the south side enabled the two white photographers to travel freely taking photographs of this crowded ghetto community. The images selected for *Twelve Million Black Voices* supported Wright's emotional text seen in such passages as, "The souls of our simple folk lives ran out on the cold city pavements."[11] Most of the twenty-two Chicago photographs used in the book expressed the conditions of poverty so evident in Bronzeville, as the Black Belt was also called. But, in retrospect, Rosskam and Lee covered a broad range of daily activity including work, play, and worship. Their photographs fit the descriptive text of *Black Metropolis*, which was not illustrated, far better than Wright's strident protest in *Twelve Million Black Voices*.

The writers of the *WPA Guide to Illinois* called the Prairie State "the Hub of the Continent." Split into thirds geographically and culturally from north to south, the state divided economically among manufacturing, agriculture, and mining. Chicago, with 3.4 million people, ranked as the nation's "Second City," a transportation and commercial center for the United States. In the words of the *WPA Guide*, "Across this state have eddied almost all the major currents from both without and within the country. Crisscrossed by railroads from all corners of the country, a steel-maker as well as a wheat-stacker, Illinois in its entirety functions as a working model of the Nation as a whole."[12] Places visited by the photographers included the four corners of the state from East Dubuque to Libertyville and Cairo to Shawneetown, and cities, towns, and farms in between. They photographed people at work—farmers, coal miners, railroaders, preachers, housewives, commission merchants, clerks, meat packers, and oil drillers—as well as people at play relaxing, bowling, roller skating, dancing, and pursuing a host of other leisure activities. This remarkable breadth of coverage marks the Illinois file as one of the most representative set of materials in the FSA-OWI Collection.

The Illinois file is an artificial construct derived from the various assignments that brought the photographers to the state. Unlike the WPA Guides of the Federal Writers' Project, the FSA made no attempt to systematically cover each state. Yet the Prairie State file supports the proposition of the *WPA Guide* and repeated by recent scholars, that Illinois amounted to a working model of the United States, in fact the nation's most representative state.[13] Rural and urban, downstate and Chicago—the photographs taken in Illinois by the FSA-OWI photographers reflect the state's rich diversity and its special marriage of city and prairie.

Three unique features stand out. The first is the strong urban representation. More than three-fourths, or 1,800, of the pictures come from the metropolitan environs of Chicago. Not only does this represent a large number of urban views, but these are photographs of

exceptional quality that make Chicago one of the best photographed cities in the collection. These images from the Illinois file challenge the understanding that the FSA-OWI project concerned only rural America or, as Stryker described it in his appeal to preserve the collection, "the record of America from 1935—the small towns, the farms, and the people," together with the "war's impact on the domestic scene since 1942." Repeating this assessment, Robert J. Doherty, former director of the International Museum of Photography at George Eastman House, criticized the author of an exhibit and catalogue entitled *Just Before the War* for suggesting that the FSA "was equally concerned with the urban scene" and then illustrating this fact with pictures of small towns. Doherty wrote that "the extent of documenting the urban scene" were occasional shots taken by FSA photographers passing through towns and cities and the pictures Arthur Rothstein took in New York City when he returned to visit his family.[14] Doherty was wrong, however. In addition to the Chicago images, there is a rich selection taken in Minneapolis and St. Paul found in the Midwest section. All of these, together with the strong representation of Washington, D.C., the "back yard" of the photographers, indicate that our basic understanding of the FSA-OWI project should be broadened to recognize the extensive documentation of urban America in the file.

Of the 1,800 Chicago images, almost half were taken by Jack Delano. In addition to his work on the "story of the railroads" during World War II, Delano covered Chicago's first black housing project, the Ida B. Wells Homes, located on South Parkway Avenue between Thirty-seventh and Thirty-ninth Streets and added further documentation to the religion file by photographing churchgoers on Easter Sunday, 1942. His images from the Black Belt complemented the set Lee had taken one year earlier. Most of the remaining urban images were taken by John Vachon, whose scenes from the Union Stockyards and wholesale markets depict the destinations of agricultural products moving from farm to city. Photographs of the Loop, Michigan Avenue, city beaches, and the Black Belt round out the Chicago file.

The extensive coverage of Black Metropolis is a second unique feature of the Illinois file: there are more than six hundred photographs taken of life on the south side, primarily by Russell Lee and Jack Delano. Instead of the familiar FSA images of black sharecroppers in the South, we find excellent depictions of black professionals as doctors, realtors, undertakers, and clergymen, together with clerks, typists, waitresses, musicians, and dancers. These are unexpected for, as Larry Viskochil has noted elsewhere, images of blacks in the cities during this time period are not easily found. These scenes from Chicago's black ghetto reveal the complexities of emerging black Americans in transition from segregation to participation.

A third feature distinguishing the Illinois file is the preponderance of images showing people experiencing economic hardship. While this is in keeping with the popular understanding of the FSA photographs, Stryker expressed another outlook by noting that "probably half of the file contained positive pictures, the kind that give the heart a tug."[15] Given Illinois' representative nature, this balance could be expected especially because most

of the photographers visited the state in the late 1930s and the war years. By 1935, New Deal programs had helped to ease some of the worst conditions of the depression. But little evidence of recovery appears in the Illinois photographs, perhaps because of the subject matter. The victims of the 1937 flood scene at Shawneetown present one form of suffering, that brought on by natural disaster. The tragic faces of the unemployed miners in southern Illinois in 1939 illustrate the misery related to an industry that only began to recover as the war economy heated up in the 1940s. And even with the nation at war and despite the varied activities covered by the photographers, few places could document conditions of poverty better than Chicago's Black Belt. As a result, the scenes from the Prairie State portray some of the worst features of the depression years. Yet the determination expressed in John Steinbeck's famous lines from *The Grapes of Wrath*—"We ain't gonna die out. People is goin' on. Changing a little, maybe, but goin' right on."—comes through these Illinois pictures.[16]

The photographs in this book present a selection of the best images from the Illinois file, representing all the major photographers who took pictures in the state. In keeping with the strong urban emphasis, more than half the images depict the Chicago area. The quality, uniqueness, and importance of the Black Belt scenes demand they be given priority. Not as well represented are the railroad pictures taken by Jack Delano, mostly highly specialized and somewhat repititious. Chicago is featured in the first section, "The City of Big Shoulders." The next three sections cover the Downstate, the

Great Flood of 1937, and Distress in Southern Illinois. Five sections are organized around themes used by Horace Cayton and his co-author, St. Clair Drake, in *Black Metropolis*. In addition to a section depicting physical scenes of the Black Belt, four sections are taken from the "axes of life" around which, argued the sociologists, individual and community life revolved.[17] These organizing themes are "Staying Alive," "Having a Good Time," "Praising God," and "Getting Ahead." A fifth axis, "Advancing the Race," considered political leadership in Bronzeville. Because public officials and leaders are almost completely absent from the entire FSA-OWI Collection, there are not enough selections in the Chicago file to use this theme for a section. The two final sections are "Two Families," one black and one white, and "World War II."

Chicago and Downstate presents a unique set of historical documents, visual representations that we can both view and interpret. Taken by some of America's finest photographers, they show us an Illinois strategically located in the nation's Heartland during the years of the Great Depression and World War II. Representative of the entire forty-eight contiguous states, the pictorial images reveal to us the severe conditions faced by Americans fifty years ago. Contrary to general understandings of the FSA photographs, those taken in Illinois provide an outstanding collection of urban images, including an exceptional set taken in Chicago's Black Metropolis. Bringing us back in time to a simpler era, these powerful, often poignant images from the Prairie State help illuminate the complex, paradoxical American society in the twentieth century.

8

NOTES

1. Rob Powell, "An Interview with Russell Lee," *British Journal of Photography* (10 October 1980), 1013.

2. Roy E. Stryker interview with Richard K. Doud, 13–14 June 1964, Archives of American Art, Smithsonian Institution, Washington, D.C.; Roy Emerson Stryker and Nancy Wood, *In This Proud Land: American 1935-1943 as Seen in the FSA Photographs* (Greenwich, CT: New York Graphic Society, 1973), 14.

3. John Vachon, "Tribute to a Man, an Era, and Art," *Harper's* (September 1973), 99.

4. John D. Stoeckle, M.D., and George Abbott White, *Plain Pictures of Plain Doctoring: Vernacular Expression in New Deal Medicine and Photography* (Cambridge: The MIT Press, 1985); James Valle, *The Iron Horse at War* (Berkeley, CA: Howell-North Books, 1977); *Russell Lee's FSA Photographs of Chamisal and Penasco, New Mexico*, edited by William Wroth (Santa Fe, NM: Ancient City Press, 1985); Brooks Johnson, *Mountaineers to Main Street: The Old Dominion as Seen Through the Farm Security Administration Photographs* (Norfolk, VA: The Chrysler Museum, 1985); *A Kentucky Album: Farm Security Administration Photographs, 1935–1943*, edited by Beverly W. Brannan and David Horvath (Lexington, KY: University Press of Kentucky, 1986); *Back Home Again: Indiana in the Farm Security Administration Photographs, 1935–1943*, edited by Robert L. Reid (Bloomington, IN: Indiana University Press, 1987). The most recent major study of the FSA is *Documenting America, 1935–1943*, edited by Carl Fleischhauer and Beverly W. Brannan (Berkeley, CA: University of California Press, 1988).

5. Theodor Jung letter to author, 15 April 1988.

6. Interviews with Louise Rosskam, 29 May 1988, and Jean Lee, 10 June 1988. Both Mrs. Rosskam and Mrs. Lee remembered that Stryker wanted the photographs, but did not want to be criticized for sending Lee, a government employee, on an assignment that could be seen as a private project for Viking Press.

7. Hank O'Neal, *A Vision Shared: A Classic Portrayal of America and Its People, 1935-1943* (New York: St. Martin's Press, 1976), 135.

8. Anita Brenner, "Rorty Reports America," *The Nation* (12 February 1936), 194.

9. John Steinbeck, *Travels with Charlie: In Search of America* (New York: Viking Press, 1962), 120–21.

10. Malcolm Brown and John N. Webb, *Seven Stranded Coal Towns: A Study of an American Depressed Area*, Research Monograph 23 (Washington, D.C.: Work Projects Administration, 1941), xvi. The Works Progress Administration became the Work Projects Administration in 1939.

11. St. Clair Drake and Horace R. Cayton, *Black Metropolis: A Study of Negro Life in a Northern City* (New York: Harcourt, Brace and Company, 1945), 788; Richard Wright, *Twelve Million Black Voices: A Folk History of the Negro in the United States* (New York: Viking Press, 1941), 136.

12. Federal Writers' Project, *The WPA Guide to Illinois* (New York: Pantheon, 1983), 6. It was originally published as *Illinois: A Descriptive and Historical Guide* (Chicago: A. C. McClurg, 1939).

13. Here are four such representative comments:

 Illinois "reflected with a high degree of accuracy the condition of the nation." David J. Maurer, "Unemployment in Illinois during the Great Depression," *Essays in Illinois History in Honor of Glenn Huron Seymour*, edited by Donald F. Tingley (Carbondale: Southern Illinois University Press, 1968), 120.

 Illinois "is one of the most heterogeneous states in the Union. In its social structure and its patterns of political response it is very likely the nation's most representative state." Daniel J. Elazar, *Cities of the Prairie: The Metropolitan Frontier and American Politics* (New York: Basic Books, 1970), 282.

 Illinois is "the heterogeneous centerpin of the nation." Neal R. Peirce and John Keefe, *The Great Lake States of America: People, Politics, and Power in the Five Great Lakes States* (New York: Norton, 1980), 102.

Illinois is "probably more representative of the nation as a whole than any other state. Its historic growth and achievement are a microcosm of America's economic development." Cullom Davis, "Illinois: Crossroads and Cross Section," in *Heartland: Comparative Histories of Midwestern States*, edited by James H. Madison (Bloomington: Indiana University Press, 1988), 142.

14. Roy Stryker letter to Jonathan Daniels, 13 September 1943, Roy E. Stryker Collection, University of Louisville; Robert J. Doherty, "The Elusive Roy Stryker" in *Roy Stryker: The Humane Propagandist*, edited by James G. Anderson (Louisville: University of Louisville Photographic Archives, 1977), 8.

15. Stryker and Wood, *In This Proud Land*, 14.

16. John Steinbeck, *The Grapes of Wrath* (New York: Viking Press, 1939), 577.

17. Drake and Cayton, *Black Metropolis*, 385.

THE CITY OF BIG SHOULDERS

■ Chicago, the nation's second largest city, was a place of "tremendous vital energy that enabled it to grow from an isolated frontier post to a giant metropolis within a century." By the late 1930s, the Windy City's population was approaching 3.5 million. Contradicting the notion that Illinois was a rural state of farms and small towns, nearly fifty percent of the people of the Prairie State lived in the metropolitan environs of Chicago. Providing insights into the Downstate as well as "boosting" Chicago, the WPA *Guide to Illinois* noted that this phenomenal urban growth had occurred without the help of Shawneetown. The local bankers had refused a loan request of $1,000 from Chicago in the 1830s on the assumption that a village so distant from Shawneetown "could never amount to anything."[1]

The Illinois economy was a blend of agriculture and industry. Illinois led the United States not only in meat processing, corn refinery products, and confectionaries, but in the manufacturing of farm implements as well. The metropolitan area produced more than three-fourths of the state's manufactured goods, prepared and distributed products from the farms, and served as the railroad center of the nation. Carl Sandburg's words "Stormy, husky, brawling, City of Big Shoulders" aptly described Chicago.

John Vachon expressed his enthusiasm for Chicago in both words and pictures. In the summer of 1941, he visited the city on two occasions to photograph the stockyards and the fruit and produce markets. In a letter to his brother, Robert, he wrote that he had been

> swimming, listening to bands in joints, visiting the art institute and exploring the city on foot. Working for the government is o.k. The point is I'm supposed to photograph the stockyard, but I've been told I couldn't get in without special credentials. So I've just been waiting for special credentials. It's a swell town to wait in. Of course I've been shooting my leica off every day as I tramped around, so the taxpayers are getting something for their dough.[2]

He told his boss, Roy Stryker, "Slaughtering pix are absolutely tabu," but that he had taken exterior shots of Union Stockyards and pictures of "cold storage plants . . . fruit and vegetables—unloading trains, loading trucks, commission merchants examining produce, making notes and [an] auction. Also much Leica work of crowds on street, heavy traffic on boulevards, people going up El steps, etc."[3]

Vachon, who had been a literature major in college, wrote to his wife, Penny, "I've been playing Studs Lonigan all day. Maybe tonight I will play Bigger Thomas," referring to the protagonists in the novels of James Farrell and Richard Wright. A lover of jazz music,

Vachon did visit the south side, including the Club Delisa, in his evening rounds, listening to musicians such as Benny Goodman, Warren "Baby" Dodds, and Jimmy Noone. These night clubs were a welcome change of pace from the lonely nights spent in the movie theaters of smaller towns and cities across America. He described the stockyards to Penny, telling her of "the gal in the stockyards office who said 'you can tell which way the wind is blowing by whether you smell pig shit, cow shit, or hog shit.'"[4]

Vachon's photographs support his comment that he did most of his exploration on foot. His walks started from the Allerton Hotel where he paid two dollars per night for his room. Many of his photographs are of scenes in the Loop, the rectangle defined by the steel frame of the elevated rail tracks high above the city blocks bounded by Wabash, Lake, Wells, and Van Buren streets. They depict burlesque houses on South State Street, people waiting for trains, jaywalkers, and crowded parking lots. A particularly compelling photograph shows the Chicago skyline reflected in a window and framed by signs of the times: "No Jobs Today" and "Defend Your Country." "How sad to leave Chicago," he wrote, "I have had a wonderful week, and such dandy fun, and seeing so much going on." On seeing his negatives, he commented, "Chicago, I think, I did pretty well."[5]

Given Chicago's reputation for big city politics, the photograph of relaxed spectators at the rear of a committee meeting of the Board of Aldermen is an unusual contribution. That Dorothea Lange took this picture is even more remarkable, for she was rarely in the Midwest. Lange was nearing the end of her association with Stryker and the FSA when the photograph was taken. Another familiar feature of the city, its twenty-five miles of lakefront, is revealed in the photograph of Oak Street Beach taken by Arthur Rothstein.

Three Jack Delano images complete this urban overview. Two are dramatic shots taken from elevated perspectives: one of the north side looking south toward the Loop and the other of the switching yard at Proviso in winter. The Proviso yard was the world's largest railroad classification complex. Delano's image of trains departing from Union Station complements the interior scenes of that passenger terminal shown in the section on World War II.[6]

NOTES

1. Federal Writers' Project, *The WPA Guide to Illinois*, 205, 436.
2. John Vachon letter to Robert Vachon, June 1941, private collection.
3. John Vachon letter to Roy Stryker, 3 July 1941, Stryker Collection, University of Louisville.
4. John Vachon letter to Penny Vachon, 27 June, 3 July 1941, private collection.
5. John Vachon letter to Penny Vachon, 3 and 8 July 1941, private collection.
6. James Valle, *The Iron Horse at War* (Berkeley, CA: Howell-North Books, 1977), 45. The scene of trains leaving Union Station is the frontispiece of this book.

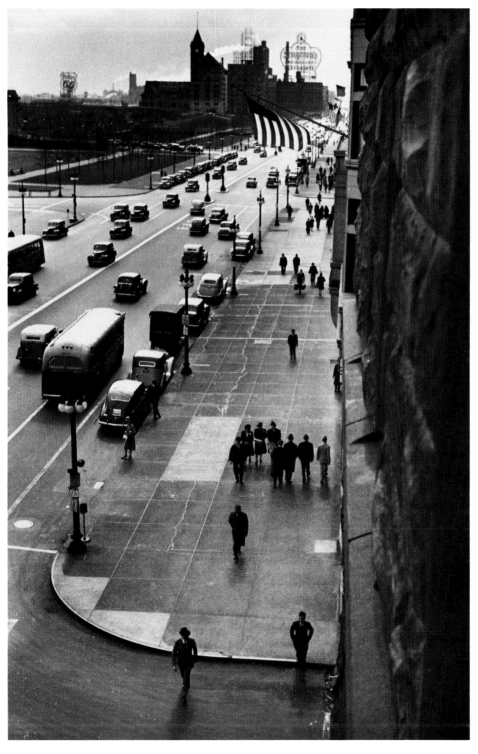

Michigan Avenue.
Chicago. October 1940.
John Vachon

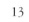 13

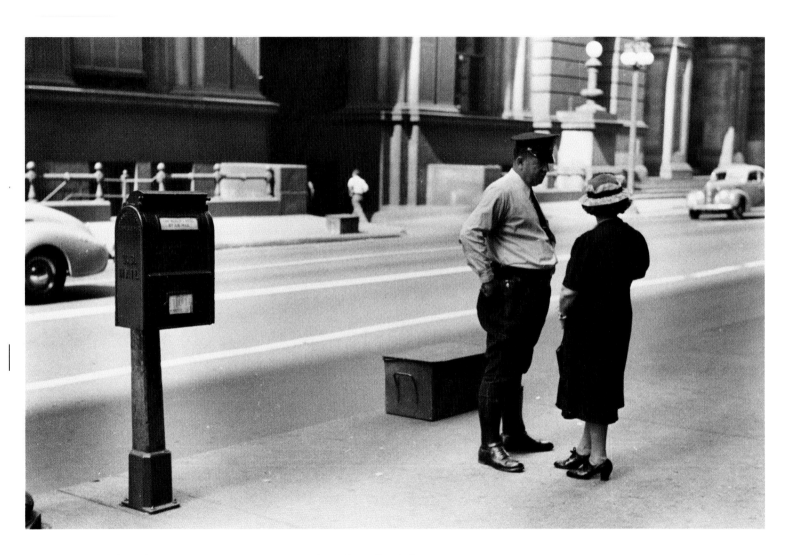

Lady talking to policeman. Chicago. July 1940. *John Vachon*

Burlesque house on South State Street. Chicago. July 1941. *John Vachon*

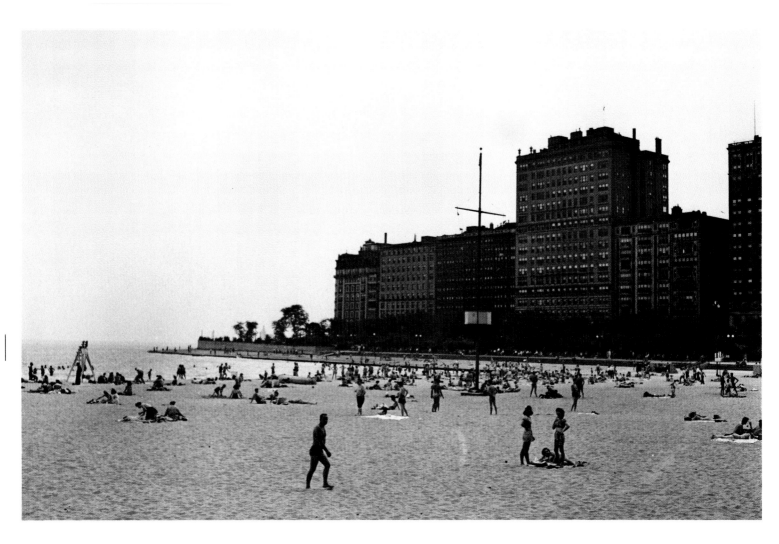

Lake Michigan beach. Chicago. July 1942. *Arthur Rothstein*

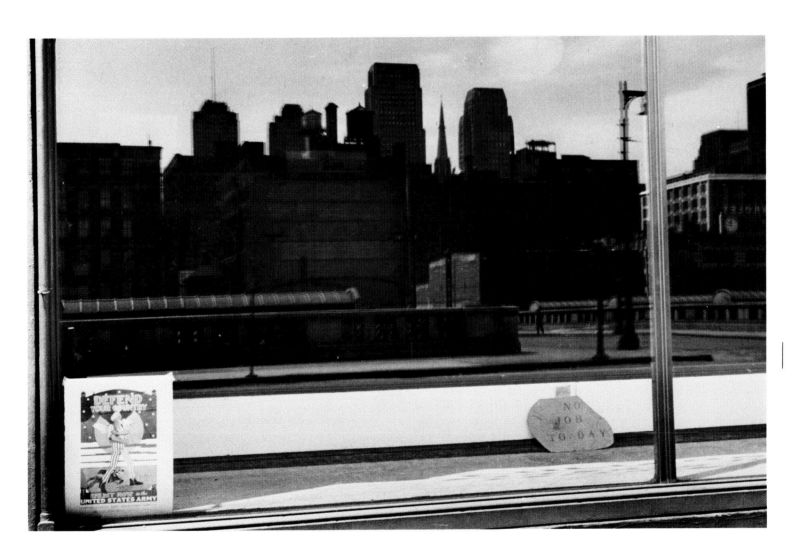

Reflection in window of an employment agency. Chicago. July 1940. *John Vachon*

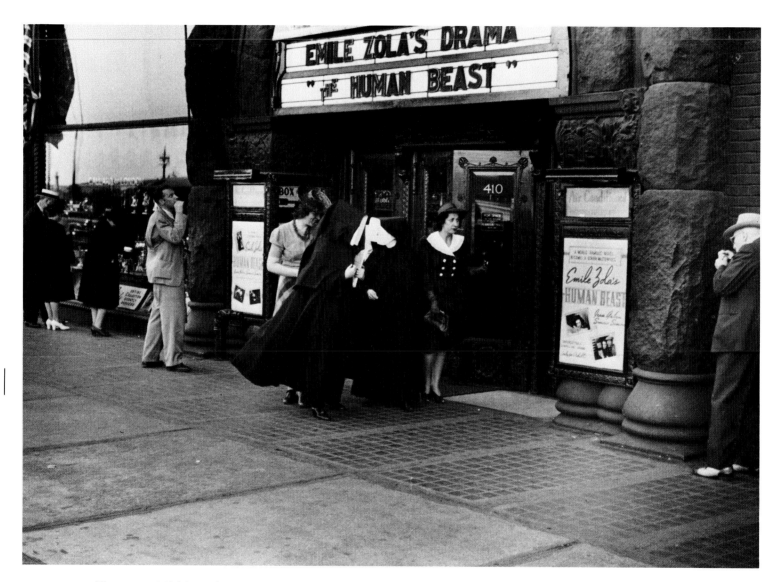

Theater on Michigan Avenue. Chicago. July 1940. *John Vachon*

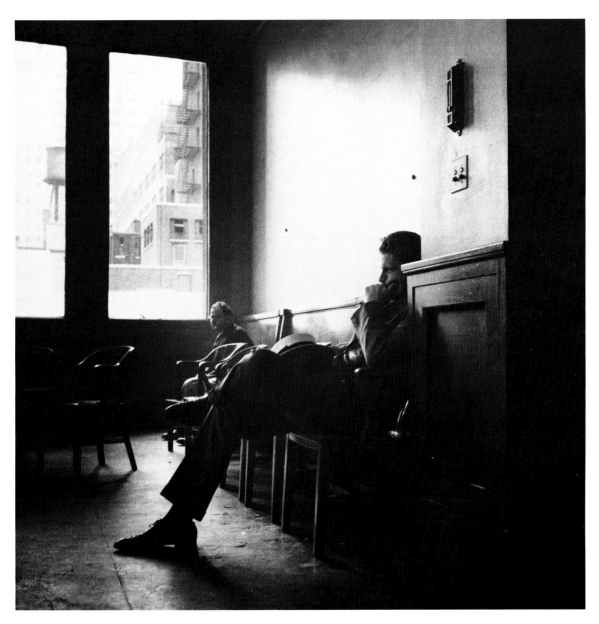

Spectators in committee room during session of Chicago Board of Alderman.
Chicago. June 1939. *Dorothea Lange*

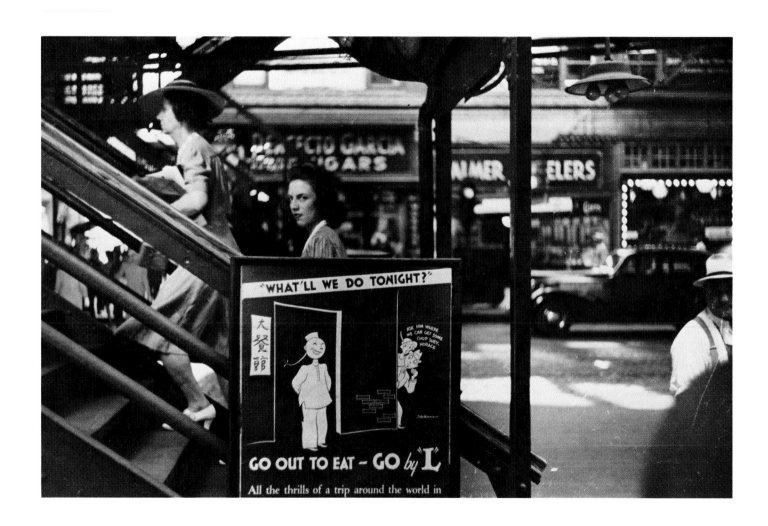

Ascending steps of El. Chicago. July 1941. *John Vachon*

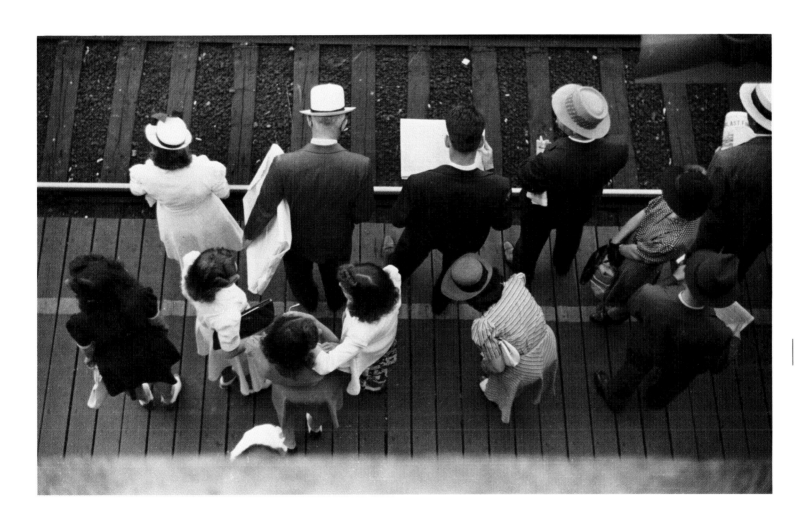

Commuters waiting for the southbound train. Chicago. July 1941. *John Vachon*

Commission merchant examining fruit at the terminal warehouse. Chicago. June 1941. *John Vachon*

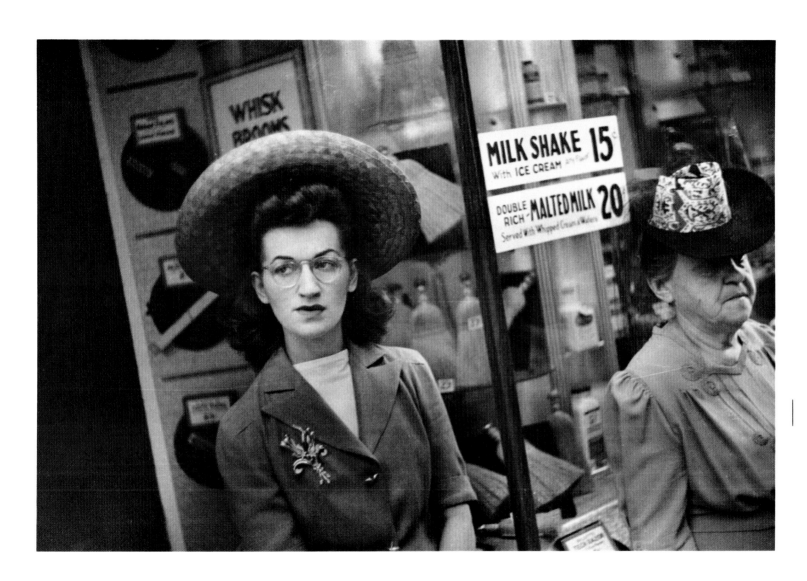

Waiting for a street car. Chicago. July 1941. *John Vachon*

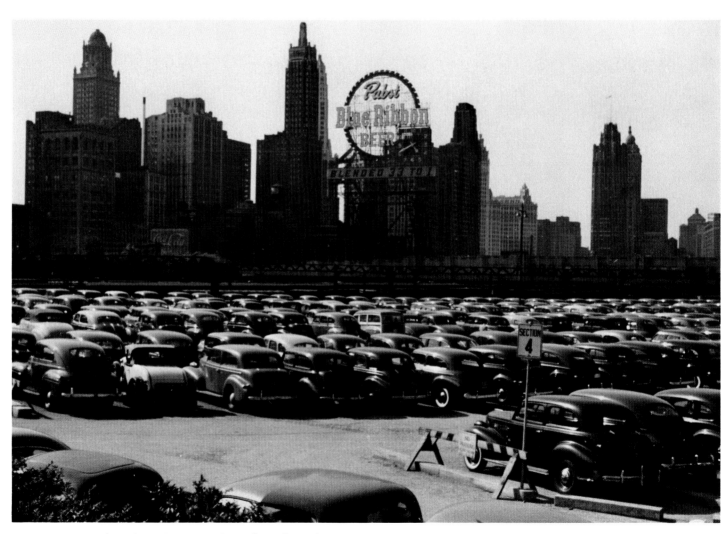

Parking lot. Chicago. July 1941. *John Vachon*

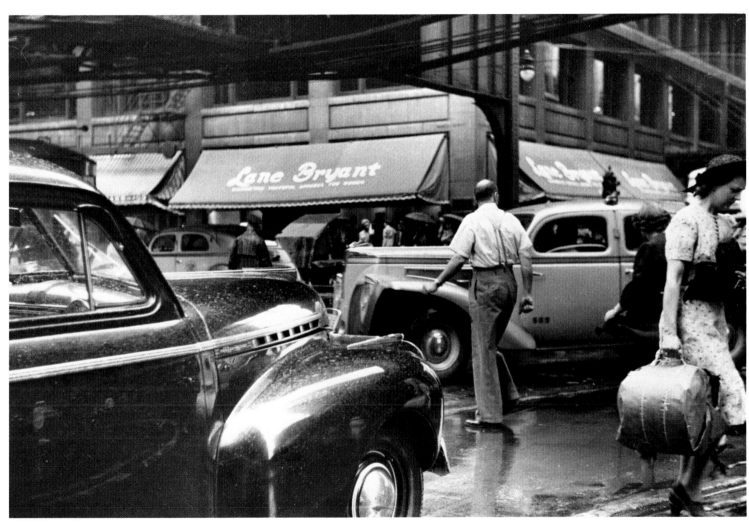

Jaywalkers. Chicago. July 1941. *John Vachon*

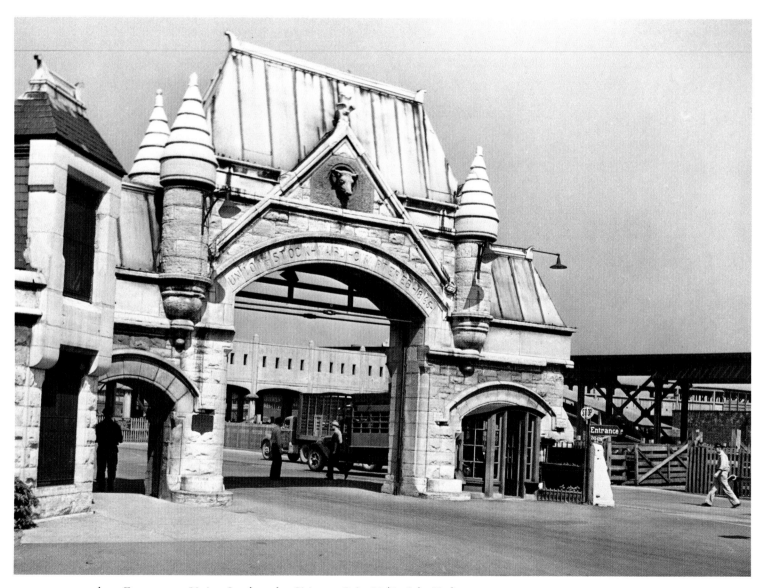

above: Entrance to Union Stockyards. Chicago. July 1941. *John Vachon*

opposite: Buyer looking over cattle at Union Stockyards. Chicago. July 1941. *John Vachon*

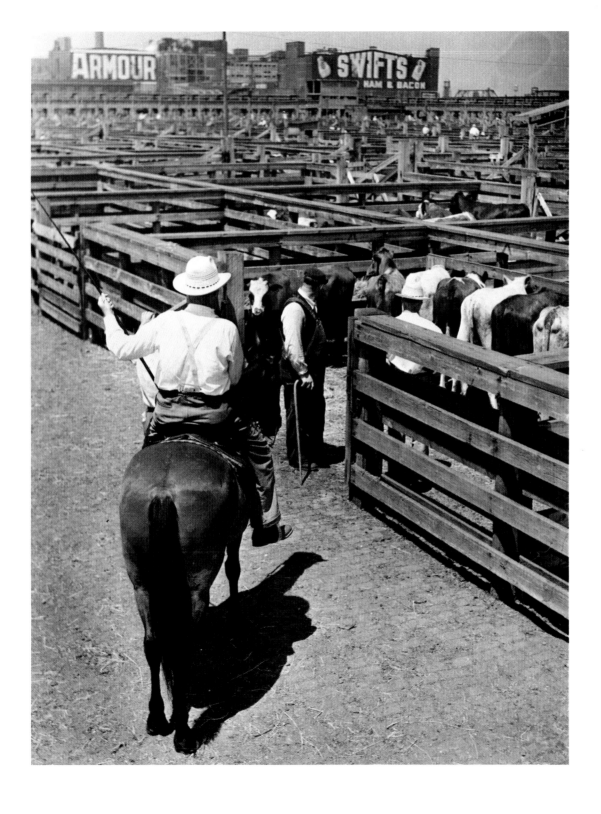

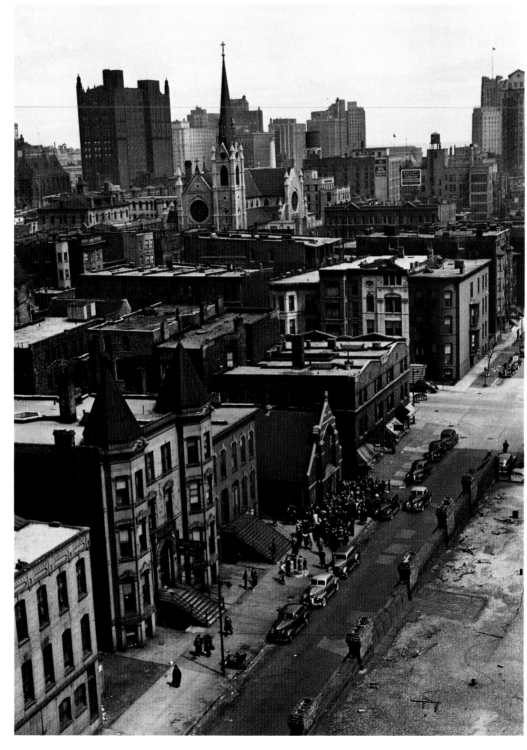

28 | [View of north side.]
Chicago. April 1942.
Jack Delano

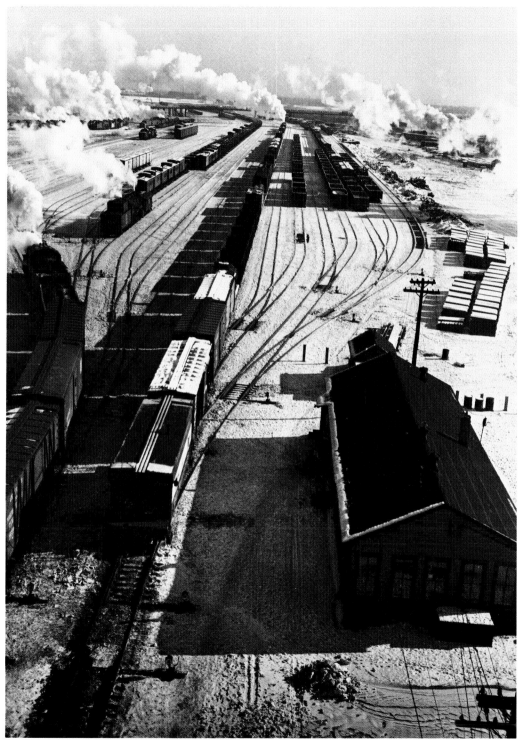

A general view of one
of the Chicago and
Northwestern
Railroad classification
yards. Chicago.
December 1942.
Jack Delano

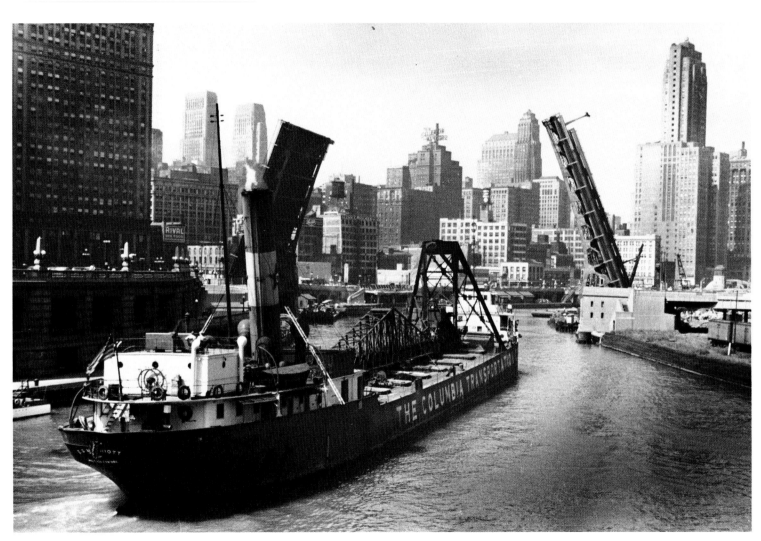

A draw bridge. Chicago. July 1941. *John Vachon*

DOWNSTATE

■ The Great Depression hit Illinois extremely hard. On 9 January 1933, when Henry J. Horner, a Democrat from Chicago, was inaugurated as governor, nearly 1.5 million of the state's residents were unemployed. This staggering figure represented almost half of the gainfully employed workers reported in the 1930 census. Hardest hit were the Black Belt of Chicago and the coal mining counties of southern Illinois, where unemployment was four times the national average. Although there was a slight movement of people "back to the land" in the 1930s, this was an unrealistic response, especially in a state where farm tenancy rates exceeded forty percent.

Charitable organizations and state and local governments were unable to care for the massive numbers of people in distress. In March 1933 the administration of Franklin D. Roosevelt responded with the New Deal. National problems were met with a series of measures to provide relief, recovery, and reform. Two years later, the Resettlement Administration (RA) and its urban counterpart, the Works Progress Administration (WPA), consolidated several New Deal programs that offered jobs and assistance to the nation's unemployed.

The photographers of the Historical Section of the Resettlement Administration came to Illinois to document the work of that agency. The earliest Illinois photograph was taken by Theodor Jung at Lake County Home-

steads. Initiated by the Department of the Interior in 1934, this project was one of nearly two hundred resettlement projects across the nation. Near Libertyville, Lake County Homesteads was planned as a project of fifty-three units constructed on ten-acre plots. The homes were built for destitute and low-income families who were expected to work as dairy and truck farmers producing food for the metropolitan area while holding part-time jobs in nearby industries. Only twelve housing units on ninety acres of land were completed by December 1940. This subsistence homestead project was ill-conceived and unsuccessful. During World War II, the federal government abandoned all such projects and sold the property to individuals through financing arrangements with the local homestead organizations. Jung's photograph from April 1936 of a house under construction is the only illustration of Lake County Homesteads and his single contribution to the Illinois file.[1]

Three other Resettlement Administration projects were located in the southern part of the state. These were attempts to take people off unproductive land and resettle them elsewhere. The submarginal land was then turned into forests, recreation areas, and public reserves. Crab Orchard, a 20,000-acre development with an 8,000-acre lake in Williamson County; Dixon Springs, a demonstration forest in Pope County; and Pere Marquette, a state park in Jersey County near the St. Louis

metropolitan area were the results. Carl Mydans visited the small towns of Robbs near Dixon Springs and Grafton near Pere Marquette. The photograph of a rock crusher preparing materials for trails and roadways at Pere Marquette was taken by Mydans in 1936.

The other photographs in this section were taken after 1937, when the RA was replaced by the Farm Security Administration (FSA). In addition to scenes of FSA borrowers on tractors and in consultation with agents, there are photographs depicting other federal agencies including the National Youth Administration (NYA). The Public Health Service contracted with Stryker to take photographs of industrial hygiene in Peoria in cooperation with the local Caterpillar plant. Arthur Rothstein reported that he got "pictures of a VD clinic, general shots of the town, some slum areas, a few whore houses."[2] Two images from Peoria represent that assignment. The Rothstein photograph from Marion County of the oil-field worker illustrates the oil boom in central Illinois during the early 1940s. Three railroad photographs taken by Jack Delano are included, one of the US Steel plant at Joliet, another of a freight train refueling at Nelson, and the last, of a train outside Chicago. Only the switchman, the railroad embankment, and the train with its plume of smoke interrupt the flat surface so typical of the Prairie State.

John Vachon's evocative scenes range across the state. Included are an elderly woman reading on her porch in Elgin, a feed store at Grayville, passengers awaiting the Burlington Zephyr in East Dubuque, the town square in Woodstock, and the Big Four restaurant in Cairo. On his last swing through Illinois, Vachon photographed Billy Williams, a squatter in Washington County. In the Land of Lincoln, a portrait of the Great Emancipator decorates the wall of Williams's shack. Years later, remembering this 1942 trip west, Vachon wrote that he was taking a "last look at America as it used to be."[3]

NOTES

1. Report on Lake County Homesteads, Box 329, Records Group 96, Records of the Farm Security Administration, National Archives, Washington, D.C.; F. L. Wellett to John F. Carter, 16 December 1935, Office Files, FSA-OWI Textual Records, Library of Congress. The photographer described the site as Libertyville Homesteads on his caption.
2. Arthur Rothstein letter to Roy Stryker, 26 May 1938, Stryker Collection.
3. John Vachon, "Tribute to a Man, an Era, and Art," *Harper's* (September 1973), 99.

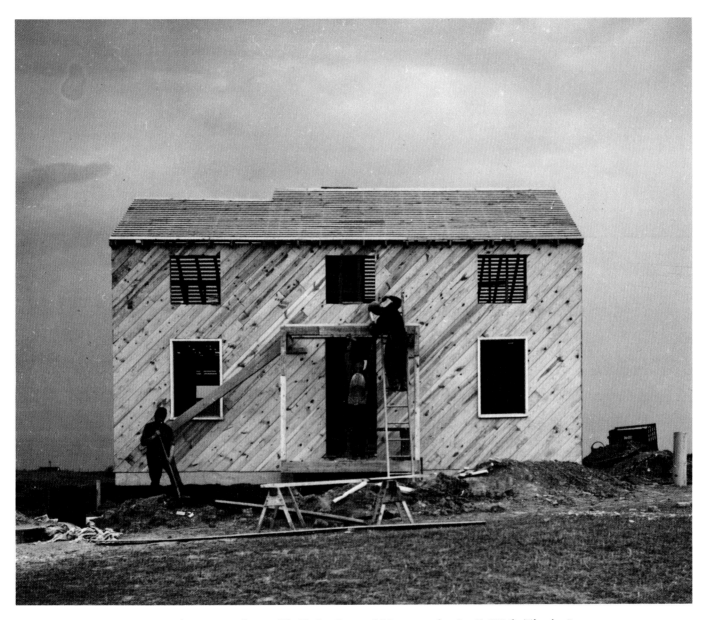

Construction of a home. Libertyville [Lake County] Homesteads. April 1936. *Theodor Jung*

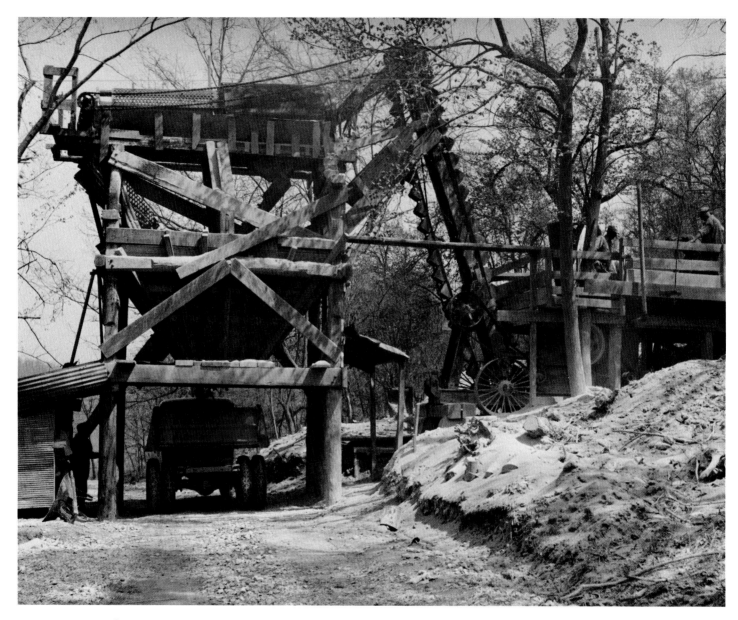

Rock crusher crushing rock to be placed on trails on the Pere Marquette recreational project. Grafton (vicinity). May 1936. *Carl Mydans*

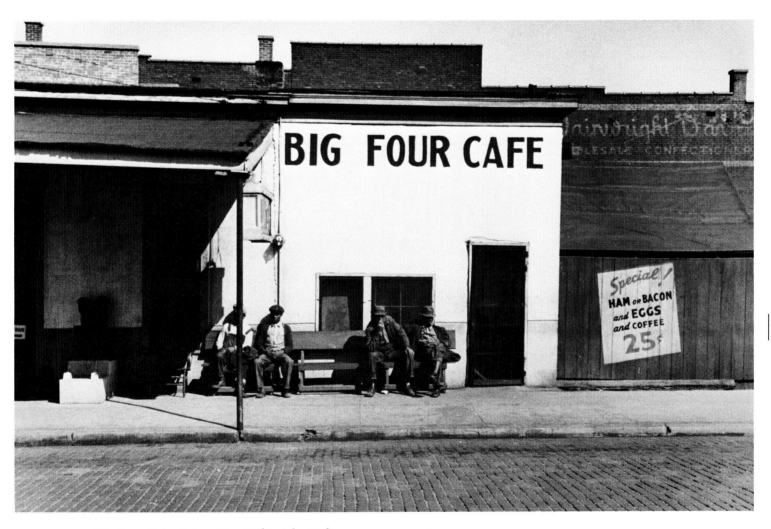

Big Four Cafe. Cairo. May 1940. *John Vachon*

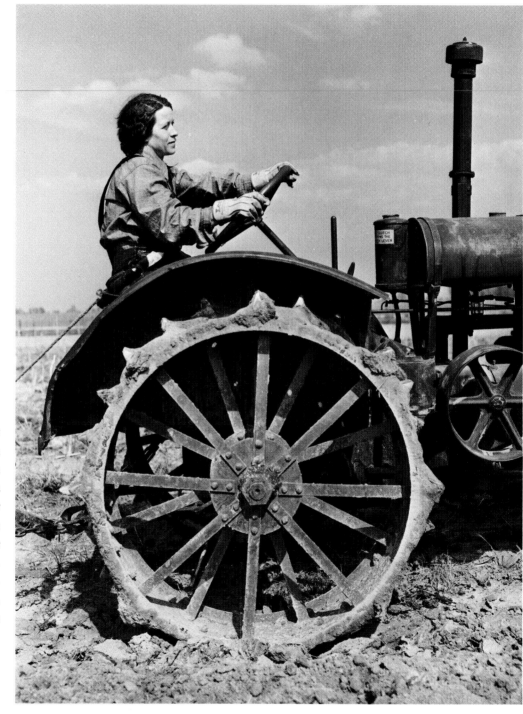

36 Farm Security
Administration
rehabilitation
borrower operating a
tractor. She and her
mother run the farm
without the assistance
of any men.
[Crawford] County.
May 1940.
John Vachon

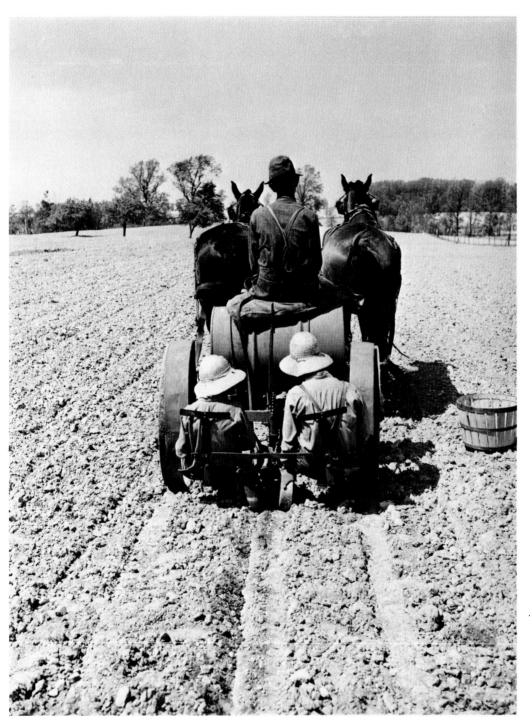

FSA rehabilitation borrower driving a tomato planter. His two little girls, sitting in the back, drop the plants into the ground and cover them up. Crawford County. May 1940.
John Vachon

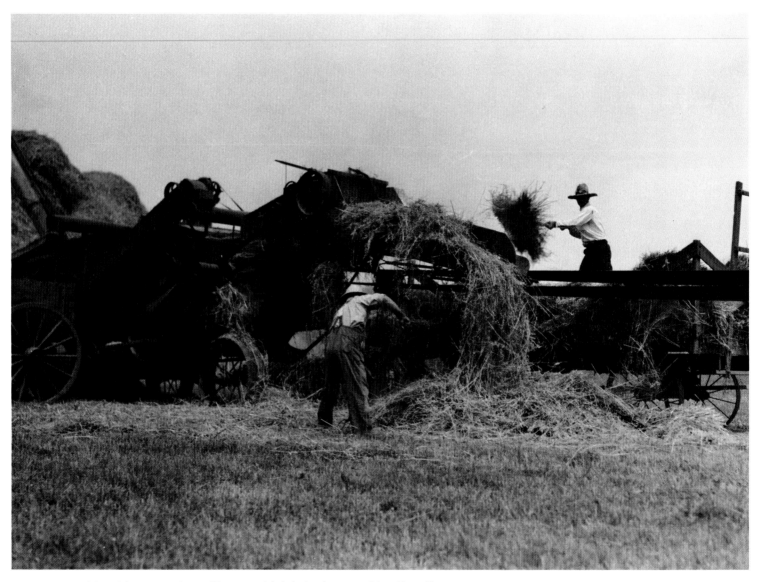

Threshing operations. Kewanee (vicinity). August 1937. *Russell Lee*

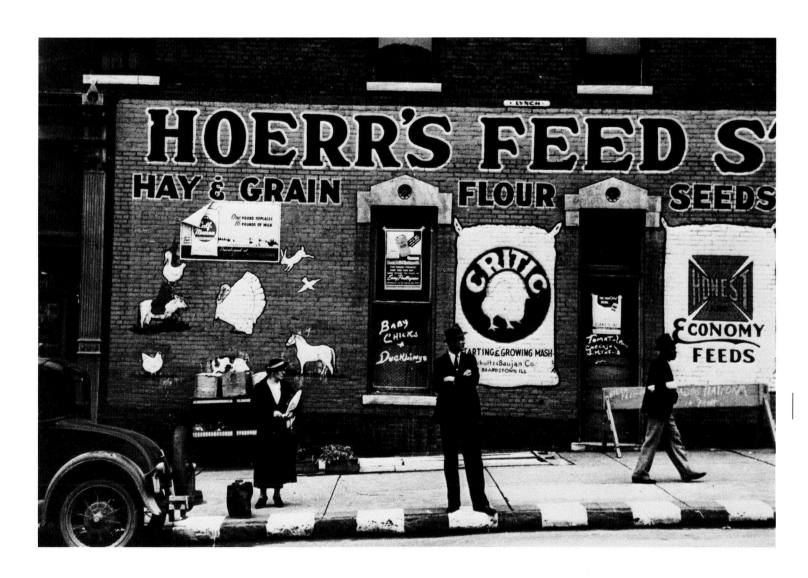

{Feed store.] Grayville. May 1940. *John Vachon*

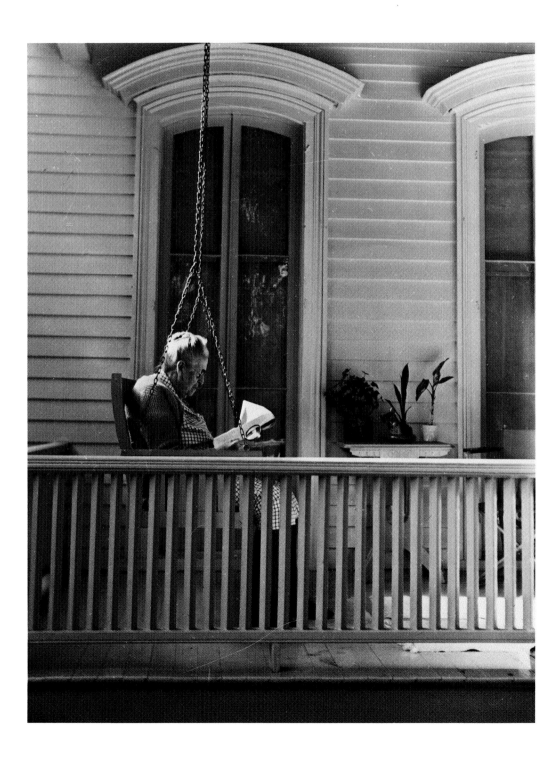

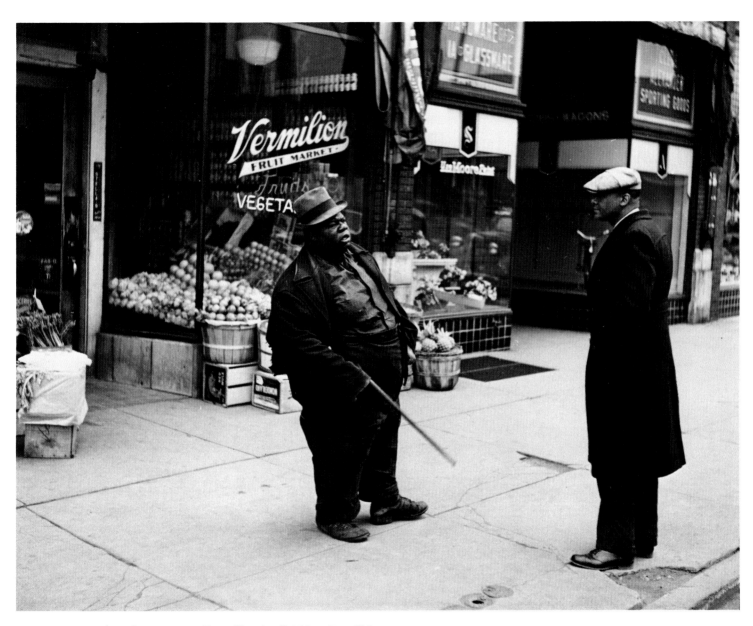

41

above: Street scene. Danville. April 1937. *Russell Lee*

opposite: Front porch. Elgin. August 1941. *John Vachon*

Town square. Woodstock. August 1941. *John Vachon*

Courthouse steps. Peoria. May 1938. *Arthur Rothstein*

Interior of William Ballou's log cabin, which was built a year after the Civil War (1866) by a Mr. Bates who made sulphur matches. Marseilles (vicinity). January 1937. *Russell Lee*

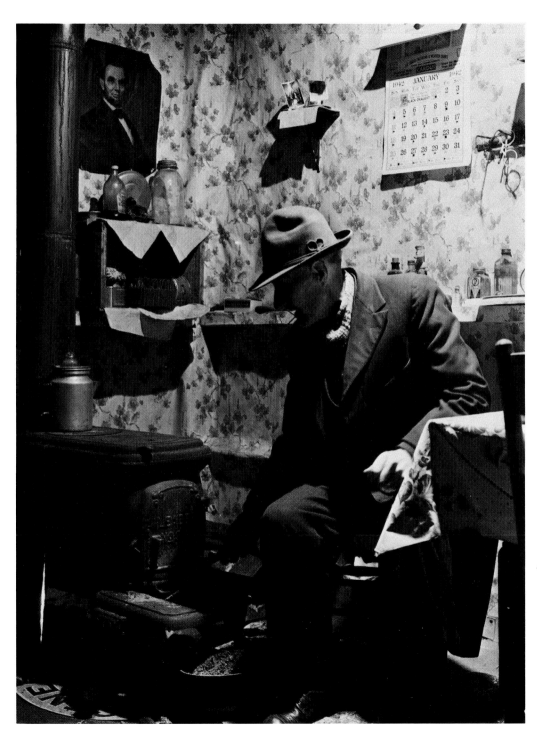

Billy Williams, sixty-
five-year-old squatter,
living in a shack he
built himself.
Washington County.
February 1942.
John Vachon

Man leaving prostitute's house. Peoria. May 1938. *Arthur Rothstein*

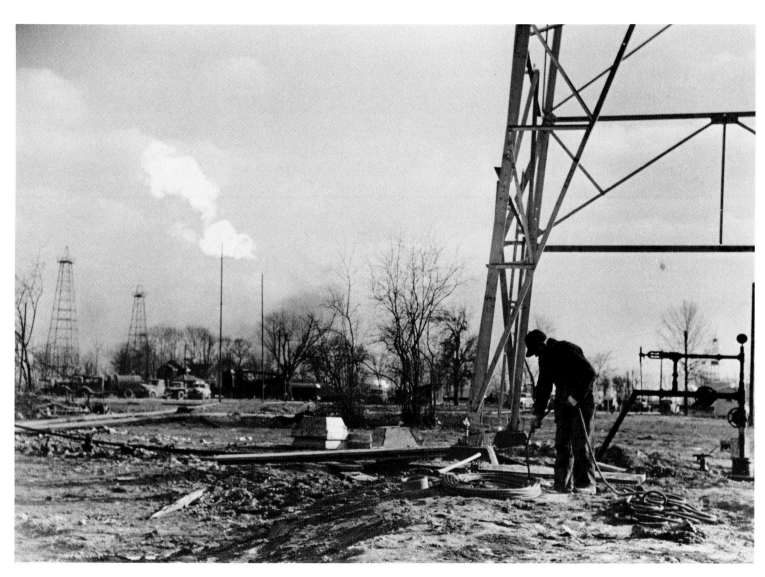

Oil-field worker. Marion County. February 1940. *John Vachon*

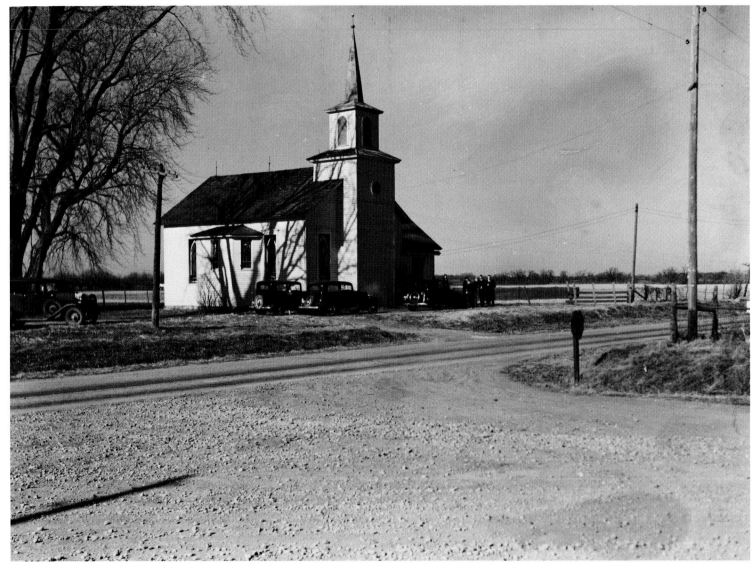

A typical rural Illinois community church. Perrytown Township, Mercer County.
November 1936. *Russell Lee*

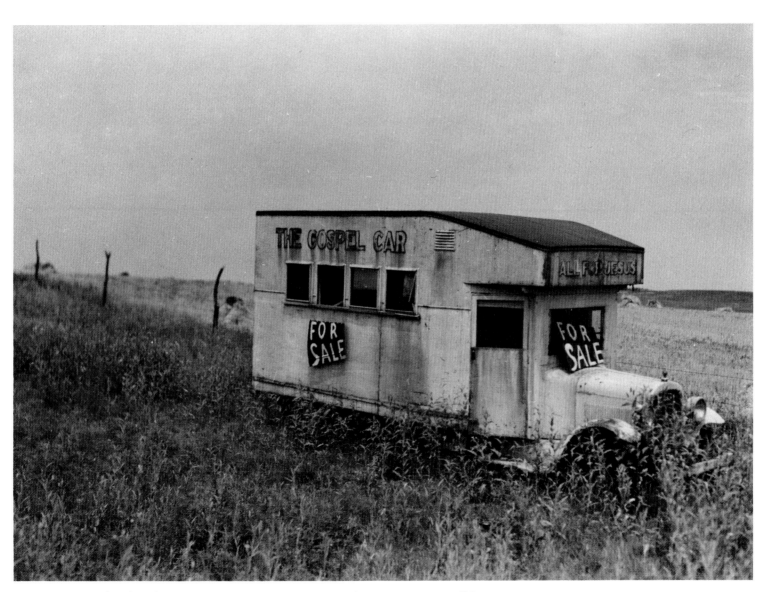

Abandoned "Gospel Car." Dewanee (vicinity). August 1937. *Russell Lee*

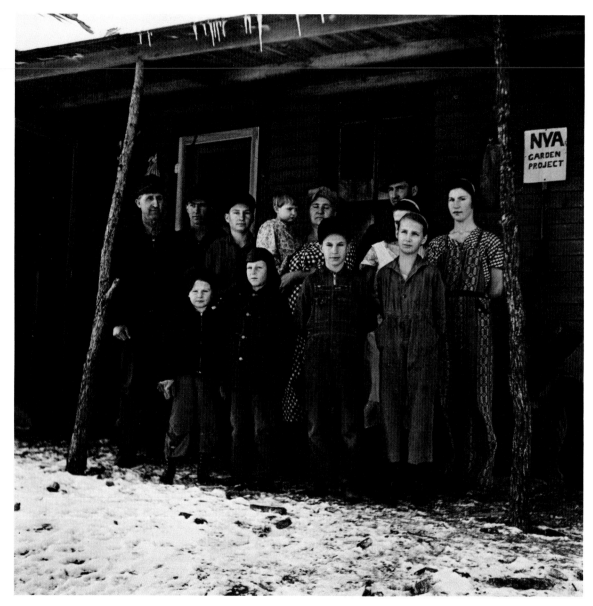

James Simmons's family. Marseilles (vicinity). January 1937. *Russell Lee*

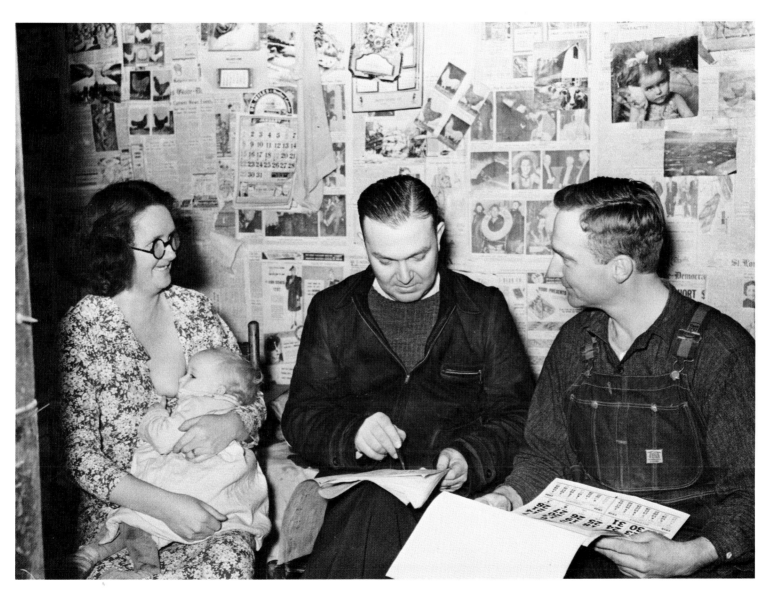

On the eighty-acre tenant farm of an FSA rehabilitation client. FSA rehabilitation supervisor with Opal Shaw and his wife. Gallatin County. January 1939. *Arthur Rothstein*

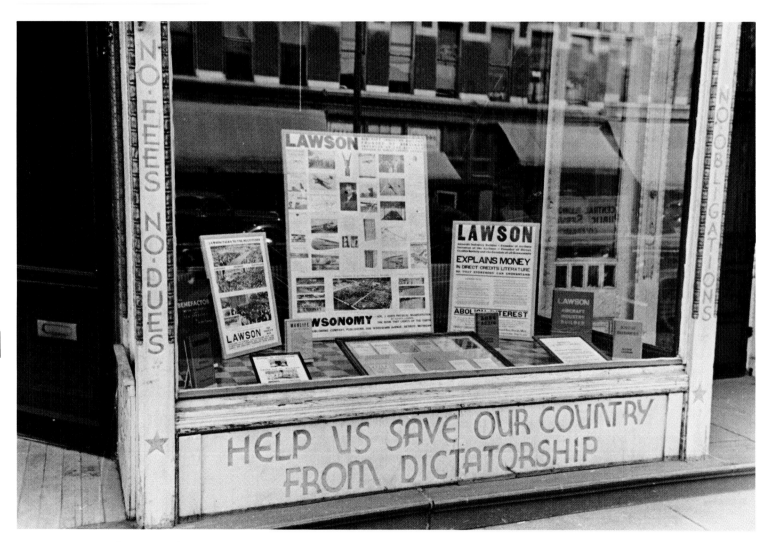

Headquarters of Lawsonomy. Springfield. June 1938. *Russell Lee*

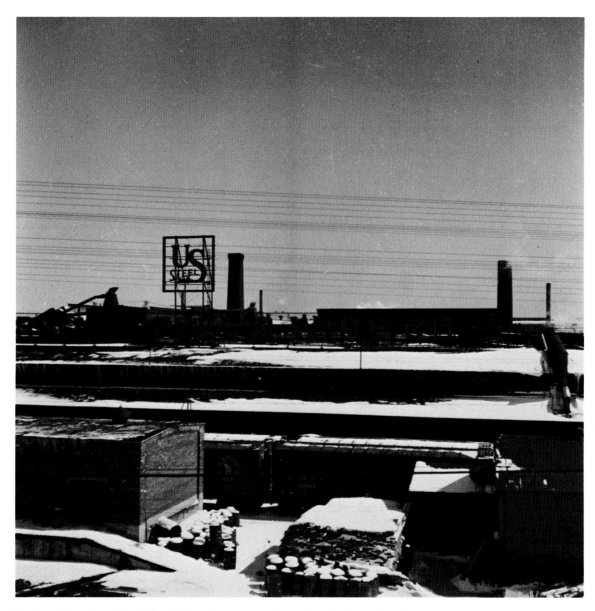

Passing the wire mill of the US Steel company along the Atchison, Topeka, and
Santa Fe Railroad between Chicago and Chillicothe, Illinois. Joliet.
March 1943. *Jack Delano*

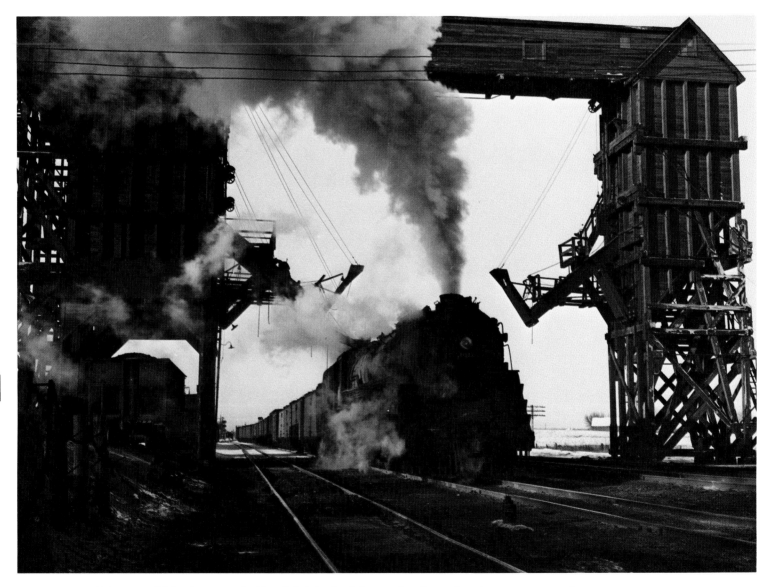

Chicago and Northwestern Railroad freight [train] stopping for coal and water en route from Clinton, Iowa, to Chicago. Nelson. January 1943. *Jack Delano*

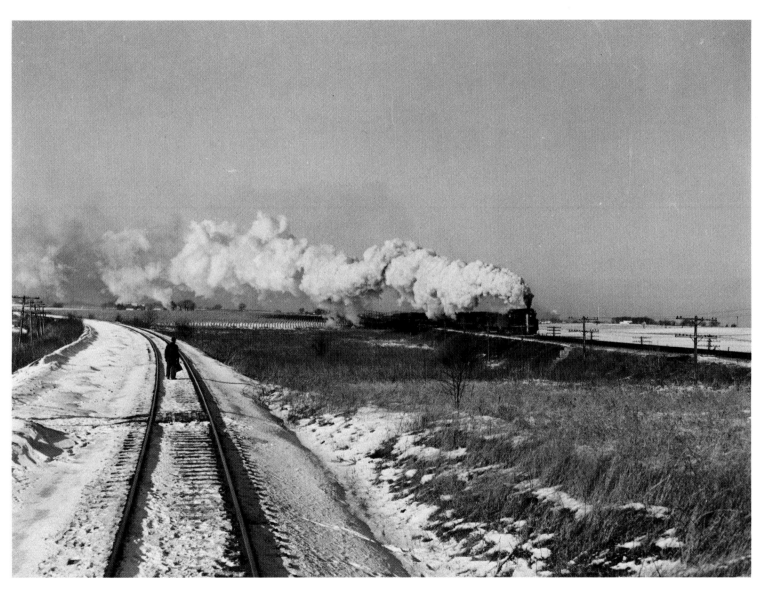

Brakeman standing with a flag waiting for a Chicago and Northwestern Railroad passenger train to go by so that his train can get on the main line in Illinois. [West of Proviso.] January 1943. *Jack Delano*

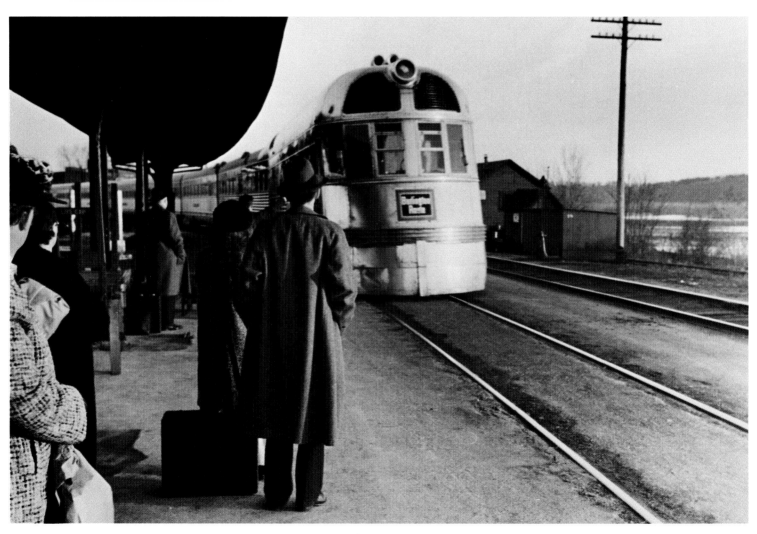

The Burlington Zephyr. East Dubuque. April 1940. *John Vachon*

THE GREAT FLOOD OF 1937

■ Illinois is bordered by the Mississippi River on the west and by the Ohio River on the south, and residents who live along these natural boundaries are accustomed to flood conditions. In December 1936 rain and snow began falling in the Ohio River valley and continued through the month of January. Southern Illinois, where normal rainfall for this period was less than three inches, received more than nineteen. The result, the Great Flood of 1937, was a disaster of such magnitude that records were broken up and down the length of the Ohio River.

Russell Lee was visiting his wife's family in Aledo and taking pictures of tenant farmers in Iowa, Indiana, and Illinois when reports of flooding attracted national attention. He wrote to Roy Stryker, "Have been reading a lot [about] the floods in southern Indiana and Illinois. Do you want any pictures on the subject?" Stryker replied positively, noting that Lee should not duplicate the coverage of news photographers and movie news cameramen. Instead he should concentrate on the aftermath, the devastation to "farm buildings, houses, land and so on." In Posey County, Indiana, where the Wabash River joins the Ohio, he photographed rural destruction; then Lee traveled west to Shawneetown.[1]

Located on the flood plain, this historic community had served as the gateway to the Prairie State. In 1817 Morris Birkbeck had written about the "pertinacious adhesion" of the residents to the site: "As the lava of Mount Etna cannot dislodge this strange being from the cities which have been repeatedly ravished by its eruptions, the Ohio, with its annual overflowings, is unable to wash away the inhabitants of Shawnee Town."[2] One hundred twenty years later, the river breached the protective levee and an avalanche of water swept over Shawneetown. Flood damage was widespread across southern Illinois; eight Illinois counties were largely under water and the American Red Cross reported that 73,876 homes were flooded. Harrisburg, some twenty miles from the Ohio River, was inundated by waters that backed up the Saline River. At the southernmost tip of Illinois at the confluence of the Mississippi and the Ohio rivers, the town of Cairo was under siege. Pressure was relieved by opening the old fuse plug levee on the Missouri side. The river crested at 59.62 feet on 30 January, four inches below the top of the hastily constructed three-foot sandbag and timber addition to the levee. Cairo boasted that it was the only city below Cincinnati on the lower Ohio River to withstand the Great Flood.

Property damage in southern Illinois was estimated at $75 million. Evacuation and relief efforts were aided by the Army, National Guard, Coast Guard, Red Cross, WPA, Resettlement Administration, and state and local agencies. In Cairo, the WPA assigned men to the

flood project and denied relief funds to those who did not work.[3] Refugee camps were set up across southern Illinois to care for the homeless. The waters receded slowly and many were unable to return home until late February. They found buildings overturned, rooms filled with oozing mud, and priceless personal treasures—books, photographs, and mementos—gone. At Shawneetown, Russell Lee reported that only twenty houses were fit for habitation.[4] While decision makers on the national level shaped legislation that became the Flood Control Act of 1937, the citizens of Shawneetown decided to relocate their town some four miles distant from the marauding river. Many refused to move and two communities were the result, one called Old Shawneetown and the other simply Shawneetown.

Describing the more than fifty photographs from Shawneetown, Lee wrote that he took some typical "news" pictures including the director of the camp "holding a couple of babies." His strongest impression was of the "backward and almost degenerate nature" of the people—descended from "early English and French stock," they had "experienced a great deal of intermarriage."[5] From stranded livestock at Cache and the defense of Cairo to aftermath views of the Tent City at Shawneetown, Russell Lee photographed scenes of this natural disaster across southern Illinois. His ability to put people at ease, his attention to detail, and his skill with flash equipment are apparent in these photographs of the Great Flood of 1937.

NOTES

1. Russell Lee letter to Roy Stryker, 20 January 1937; Stryker letter to Lee, 23 January 1937, both in Stryker Collection.

2. Morris Birkbeck, *Notes on a Journey in America*, reprint of 1817 edition (Ann Arbor, MI: University Microfilms, 1966), 122.

3. Recollections of Edward L. Stricker, Oral History Project, Cairo Public Library.

4. This was also reported by historian Richard L. Beyer, "Hell and High Water," *Journal of the Illinois State Historical Society* (March 1938), 14.

5. Lee letter to Stryker, 15 April 1937, Stryker Collection. Lee badly underestimated the population of Shawneetown when he reported 350 people. A twenty-seven-page WPA report listed the population as 1,650 with 14.8 percent black. Only 246 of the 586 families were able to support themselves. *Shawneetown, Illinois: A Survey of Factors Related to the Shawneetown Resource Project* (Chicago: Illinois State Housing Board, October 1937).

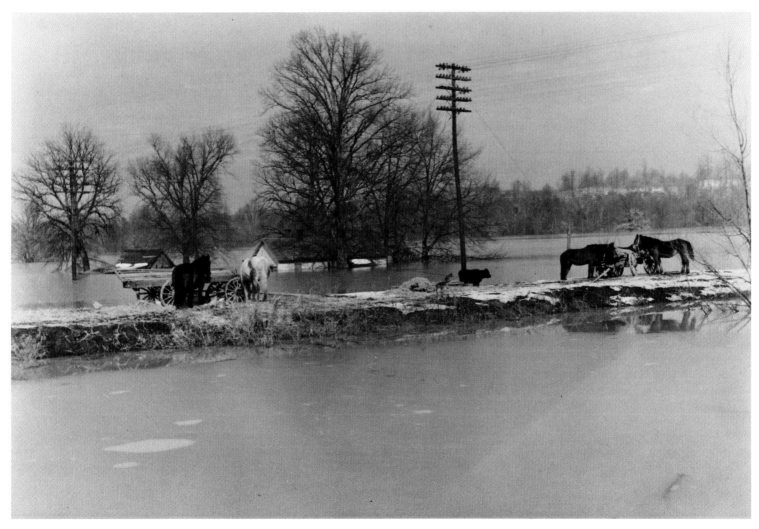

Livestock on a levee at a flooded farm. Cache. February 1937. *Russell Lee*

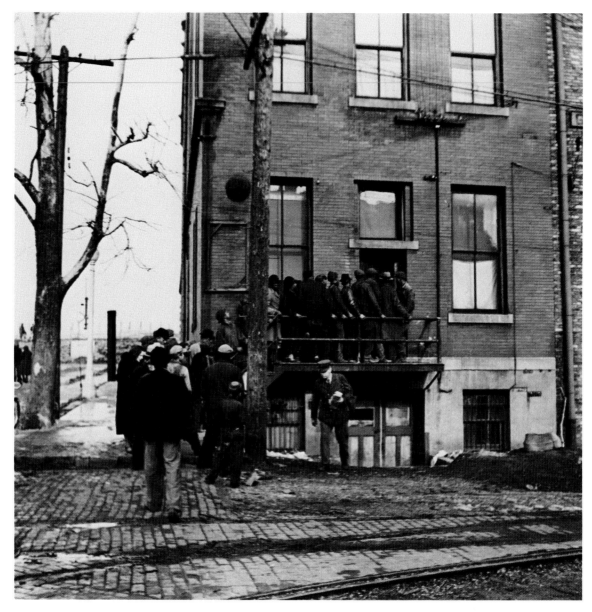

Mail is delivered even during the flood, while Work Projects Administration workers
line up for work. Cairo. February 1937. *Russell Lee*

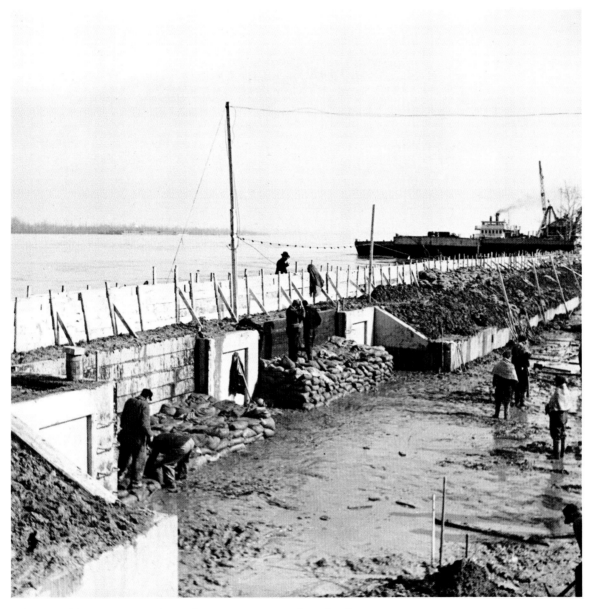

Piling sand bags along the levee during the height of the flood.
Cairo. February 1937. *Russell Lee*

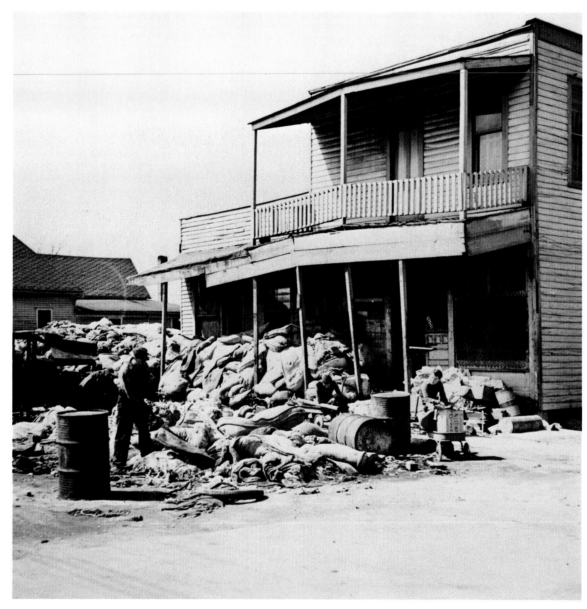

Debris from the flood. Harrisburg. April 1937. *Russell Lee*

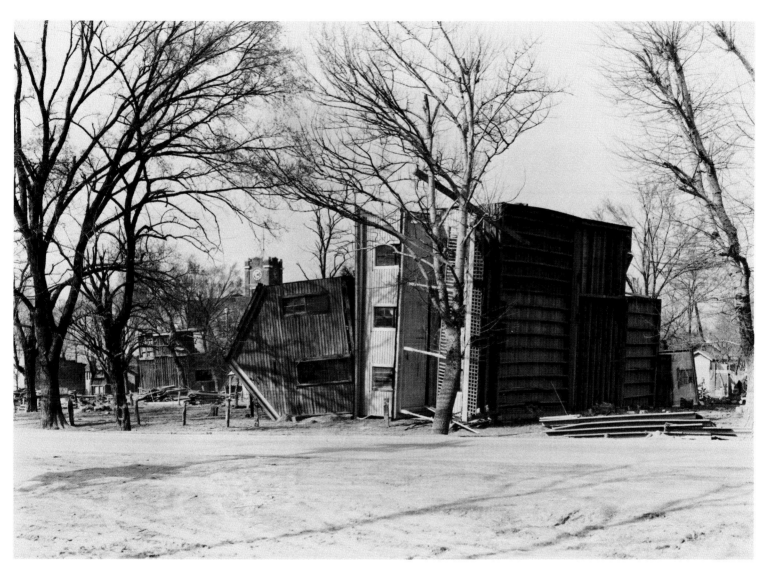

Houses overturned by the 1937 flood. Shawneetown (vicinity). April 1937. *Russell Lee*

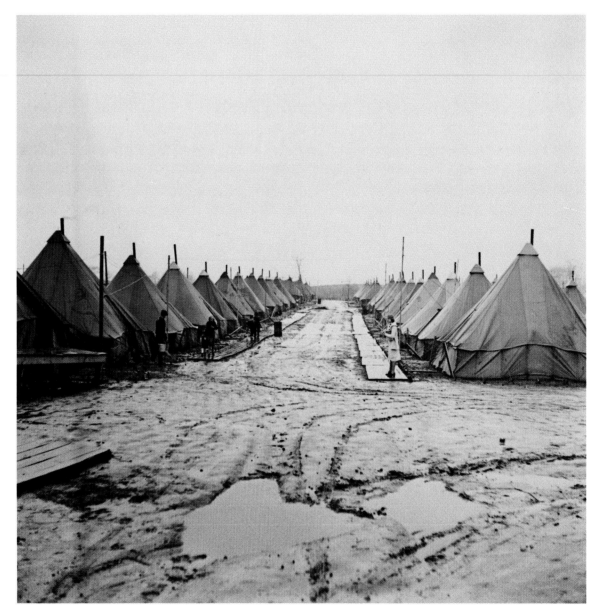

Tent City, Shawneetown (vicinity). May 1937. *Russell Lee*

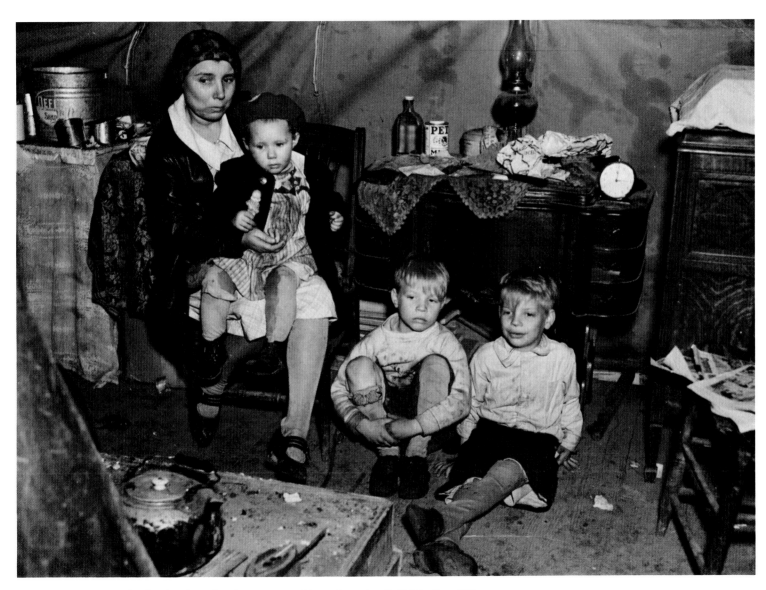

Part of a flood refuge family in a tent. Tent City. April 1937. *Russell Lee*

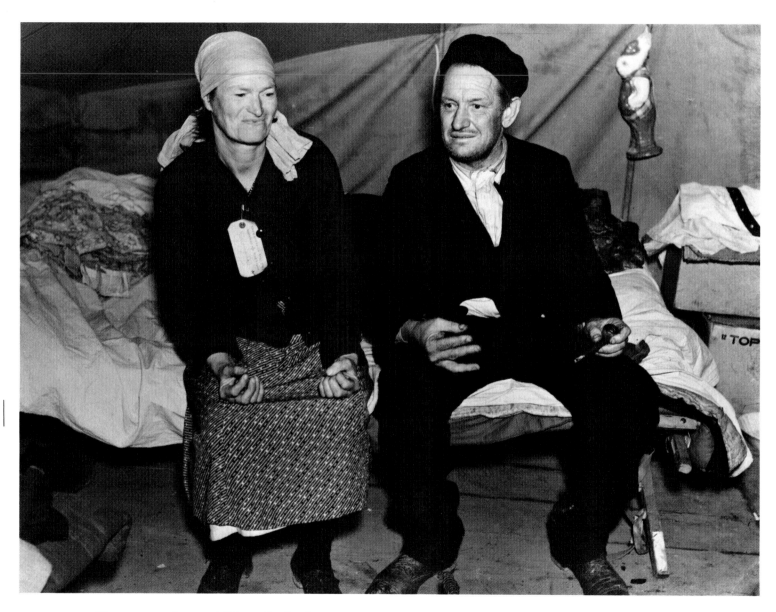

The parents of seven children, flood refugees in a camp. Tent City. April 1937. *Russell Lee*

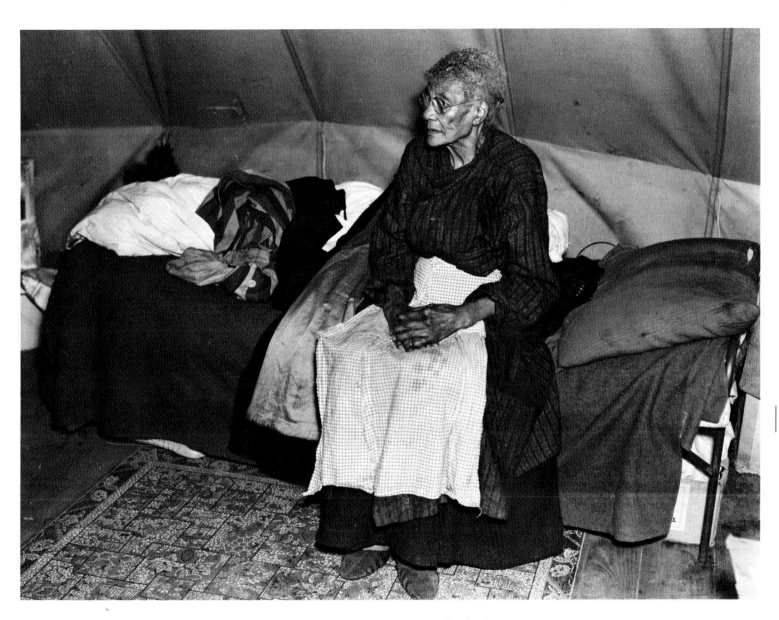

Ellen McAllister, ninety-one years old, the oldest resident in a flood refugee camp.
Tent City. April 1937. *Russell Lee*

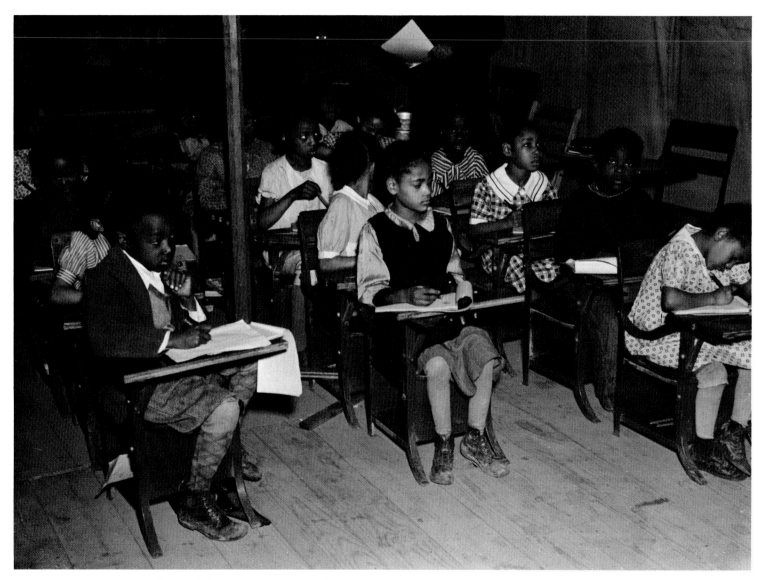

Negro school. Tent City. April 1937. *Russell Lee*

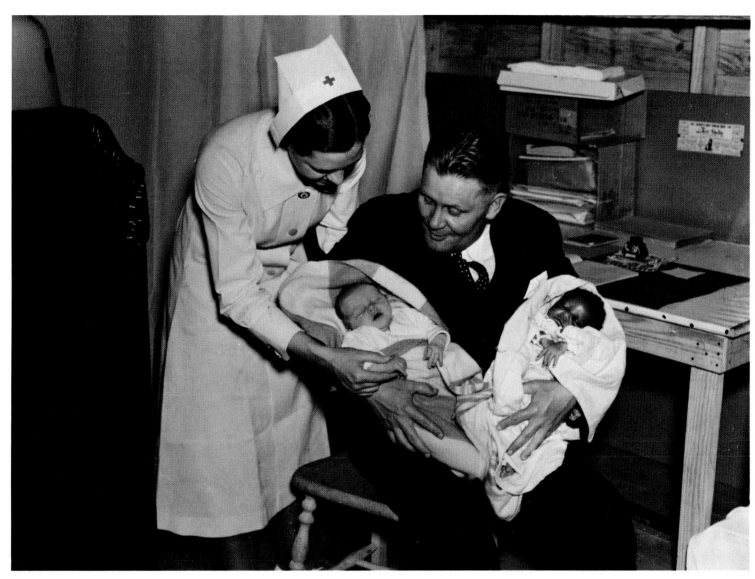

The district manager of the American Red Cross is holding the first [white and Negro] children born at the flood refugee camp. Tent City. April 1937. *Russell Lee*

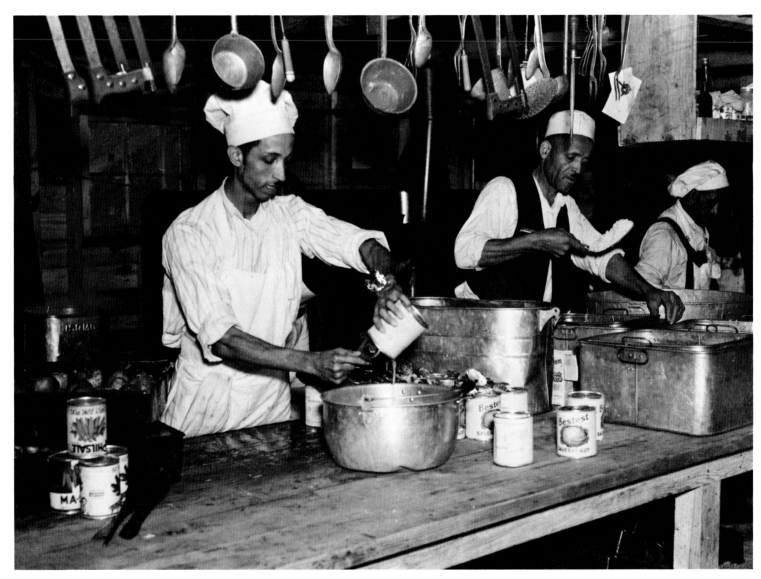

Preparing dinner for the 650 flood refugees encamped at Tent City. April 1937. *Russell Lee*

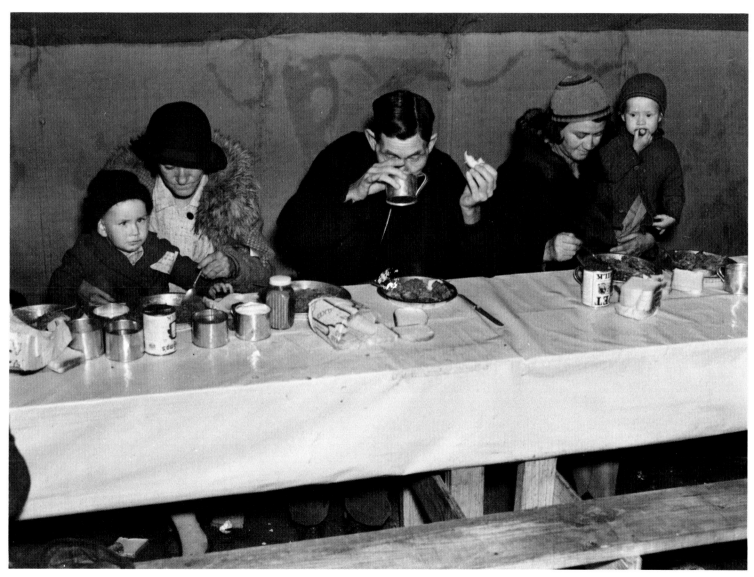

People quartered at Tent City eating in large tents from long wooden tables.
Shawneetown (vicinity). [April?] 1937. *Russell Lee*

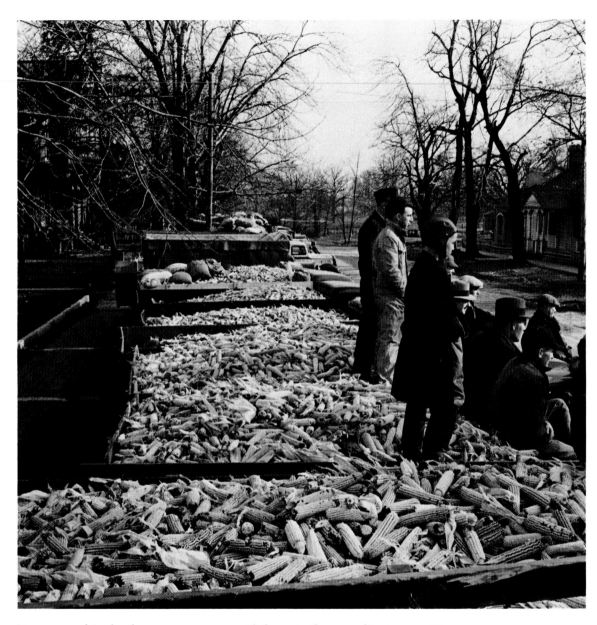

Twenty truckloads of corn were sent as a gift from the farmers of Livingston County to southeastern Illinois flood area. Carmi (vicinity). February 1937. *Russell Lee*

DISTRESS IN
SOUTHERN ILLINOIS

■ While most of the United States was beginning to recover from the nation's worst depression, southern Illinois remained one of the most distressed regions in the nation throughout the 1930s. To the north of a line running from Vincennes, Indiana, to East St. Louis, early travelers encountered a vast, rich, tall-grass prairie that seemed endless. South of this line was an area called Egypt, perhaps meaning "promised land" to these first settlers. In reality, the southern third of the state was characterized by forests, intermittent prairie, and rolling hills. The poor soil in this semiglaciated extension of the Arkansas Ozarks limited crop yields to half of the state average.

But beneath the surface lay rich deposits of coal. Within twenty years of its discovery near Herrin in 1896, the Illinois coal field trailed only Pennsylvania in coal production. Stretching from Springfield west to East St. Louis and back to Harrisburg in a large C, the principal field consisted of thirteen counties. The industry was centered in Franklin, Saline, and Williamson counties. Signs that the boom was over began to appear as early as 1926. Cheaper coal from nonunion mines in Kentucky and West Virginia, new fuels in the form of oil and natural gas, and improved mining technology brought mine abandonments and rising unemployment. Herrin saw its mines reduced from sixteen to one. By the time of the Great Crash in 1929, the disintegration of the local coal industry had "left the three counties economically prostrate."[1]

There was no improvement during the 1930s; as late as 1938 and 1939 as much as fifty percent of the population was dependent on public assistance. In the towns, the banks collapsed and empty stores dotted the business district. To document the situation in this economically wrecked area left "derelict" and abandoned by private industry, the Work Projects Administration commissioned a research monograph. Entitled *Seven Stranded Coal Towns*, it was a study of "an American depressed area." Arthur Rothstein was placed on assignment to photograph conditions in an area where three out of every four jobs the coal mines had provided were gone. No new industry had been attracted to the region. The gravity of the situation was described in the WPA study:

> Thus, intense local unemployment has become almost a normal state of things. Thousands of good workers have had no jobs for many years. Thousands of youth, blocked from entering industry, have reached their most productive years without ever having held a job. Nearly half the people are dependent on public aid year after year, and intense poverty is common.[2]

Arthur Rothstein arrived in January 1939 and wrote to Roy Stryker that, traveling through in a hurry, you would "never think you were in a problem area." Movies were crowded, trains were on time, and "people were merry in taverns." But a closer look at "the facts" indicated the miners who were working averaged 130 days per year at six dollars per day. Sixty-five percent of the people in the three counties were either working for the WPA or on direct relief. When he asked some children what they wanted to do when they grew up they would say, "I want to be a WPA worker like Daddy."[3] Twenty years earlier, virtually every boy had gone into the mines at the end of the eighth grade.

The photographs taken by Rothstein included views of the seven towns selected for the study: West Frankfort, Zeigler, Carrier Mills, Eldorado, Bush, Herrin, and Johnston City. He also visited the black community of Colp and the former company town of Freemanspur. At Cambria he covered a revival meeting at the First Apostolic Church.[4] Rothstein visited a meeting of the United Mine Workers led by officers who "look and act like the worst kind of bureaucrats."[5] The only health care facility in the county was the privately operated forty-bed Herrin Hospital. Its owner, Dr. Murrah, is depicted giving an injection to a young girl, an example of the national fear of sexually transmitted diseases that led to the passage of the National Venereal Disease Control Act in 1938. The movie theater at Eldorado and the Oke-Doke Tavern in rural Williamson County illustrate entertainment in southern Illinois.

The remaining photographs are renditions of coal mining. They include scenes of primitive "gopher hole" mines producing coal for home use and of steam-powered shovels, one removing the overburden and the other working in the pit at a strip mine. The images from Old Ben Mine #8 are of underground mining. The electric lamps and electric loaders are examples of modern technology in the industry. After seeing the negatives, Stryker wrote that Rothstein had "picked up some excellent stuff"; these photographs from southern Illinois confirm this appraisal.[6]

World War II brought about a revival in the coal industry. The construction of a $38 million ordnance plant at Crab Orchard Lake boosted the region. After the war, several new industries were attracted to southern Illinois and helped to establish a more diverse and prosperous economy.

NOTES

1. Brown and Webb, *Seven Stranded Coal Towns*, xxiv.
2. Roy Stryker letter to O.B. Dryden, 11 January 1939, Stryker Collection; Brown and Webb, *Seven Stranded Coal Towns*, iii–iv.
3. Arthur Rothstein letter to Roy Stryker, 11 January 1939, Stryker Collection.
4. This church is still active today. Members of the congregation can identify virtually every person, including the woman in the print dress, a visiting evangelist named Pearl Champion, on the three photographs taken by Rothstein.
5. Rothstein letter to Stryker, 11 January 1939, Stryker Collection.
6. Roy Stryker letter to Arthur Rothstein, 24 January 1939, Stryker Collection.

A farm on which a "gopher hole" mine has been placed, with agriculture giving way to coal mining. Williamson County. January 1939. *Arthur Rothstein*

Strip coal mine encroaching upon farm land. Carterville. January 1939. *Arthur Rothstein*

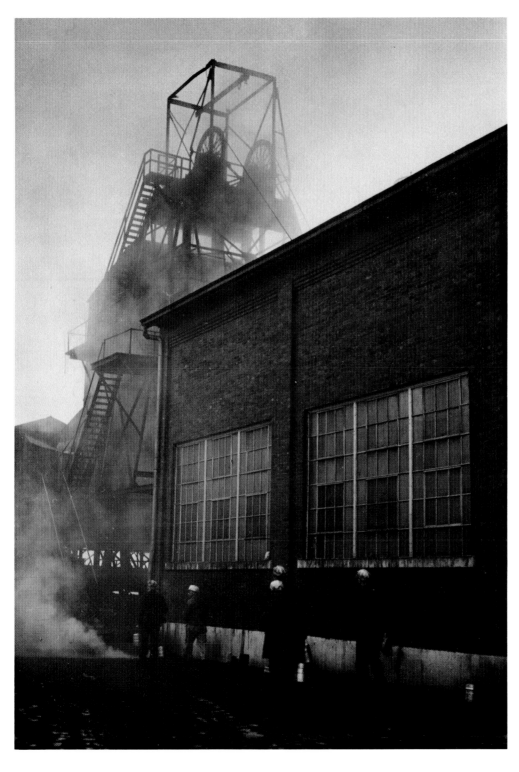

Old Ben Mine #8.
Miners on their way
underground at 7 a.m.
West Frankfort.
January 1939.
Arthur Rothstein

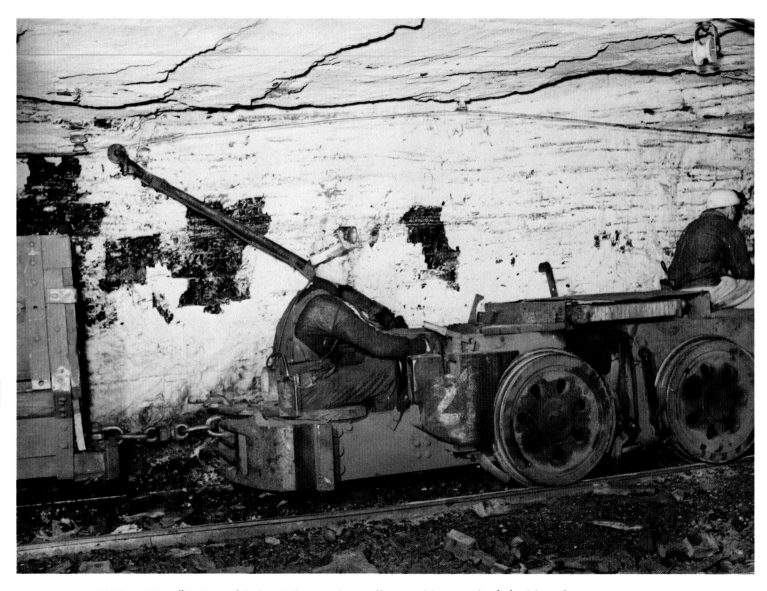

Old Ben Mine #8. Powerful electric locomotives pull up to thirty cars loaded with coal through the entries of the mine. West Frankfort. January 1939. *Arthur Rothstein*

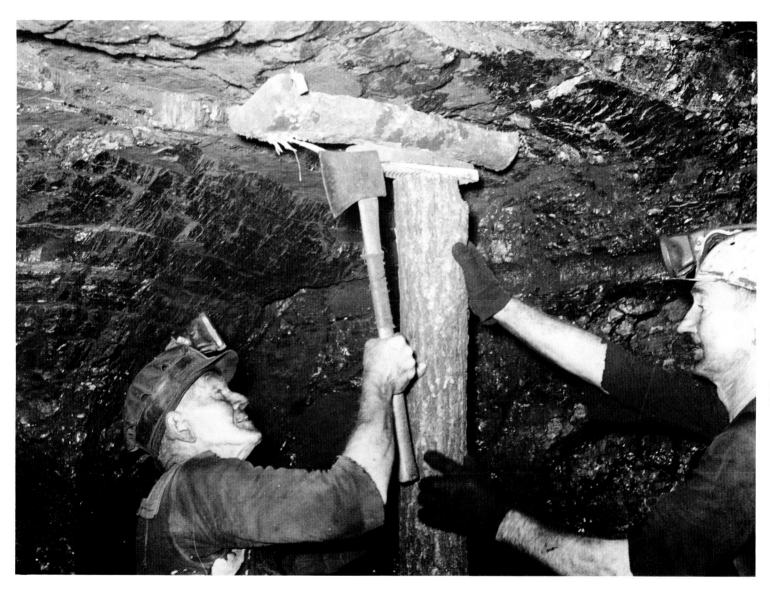

Old Ben Mine #8. Miners shoring up the roof of the mine. West Frankfort.
January 1939. *Arthur Rothstein*

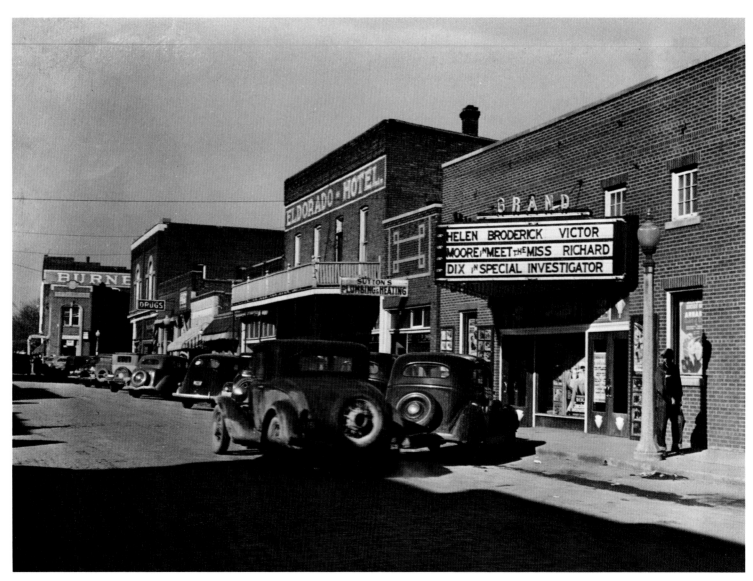

80

Shopping center. Eldorado. January 1939. *Arthur Rothstein*

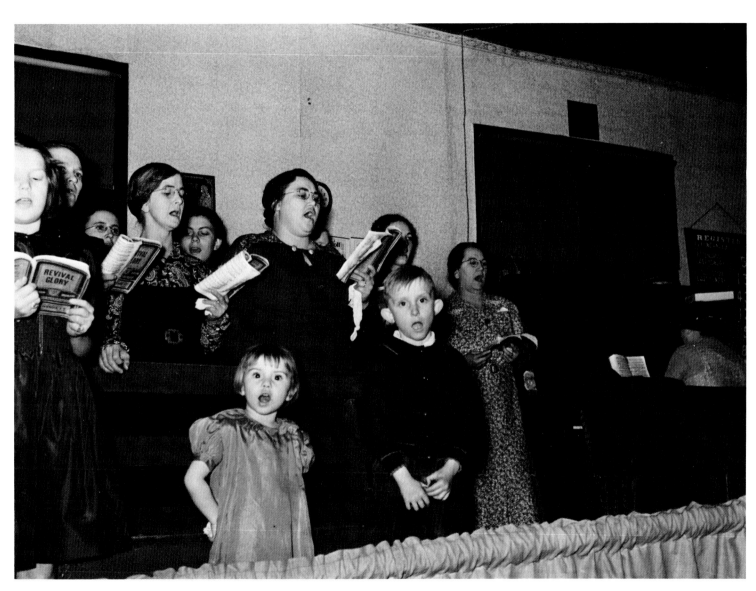

Choir singing at revival meeting in Pentecostal church. Cambria.
January 1939. *Arthur Rothstein*

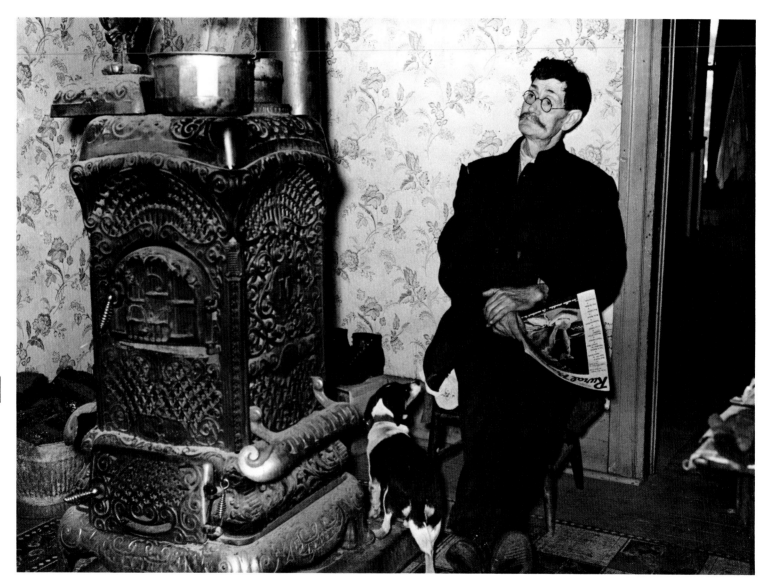

Unemployed mine worker. Bush. January 1939. *Arthur Rothstein*

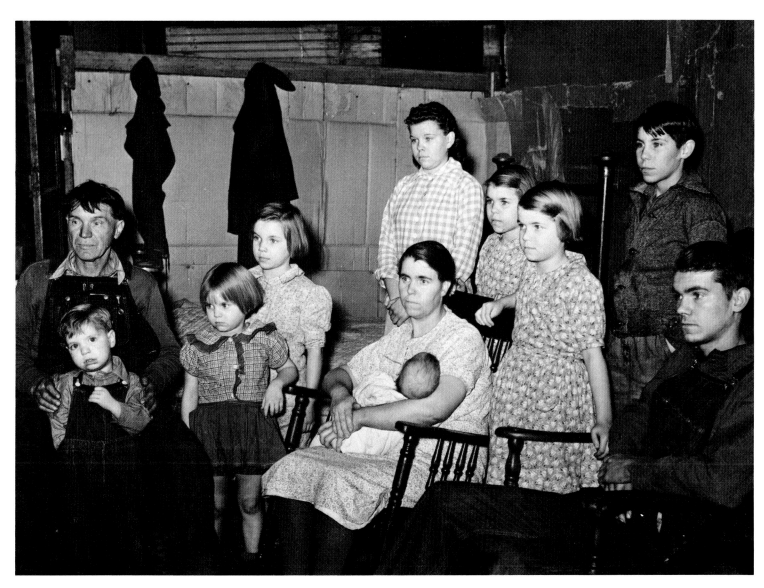

An unemployed miner and his family who are on relief. Zeigler. January 1939. *Arthur Rothstein*

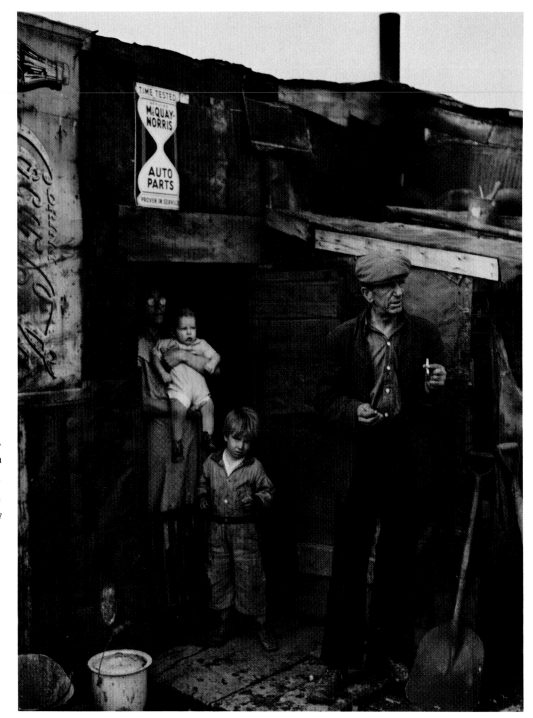

84 | A family on relief,
living in a shanty on
the city dump. Herrin.
January 1939.
Arthur Rothstein

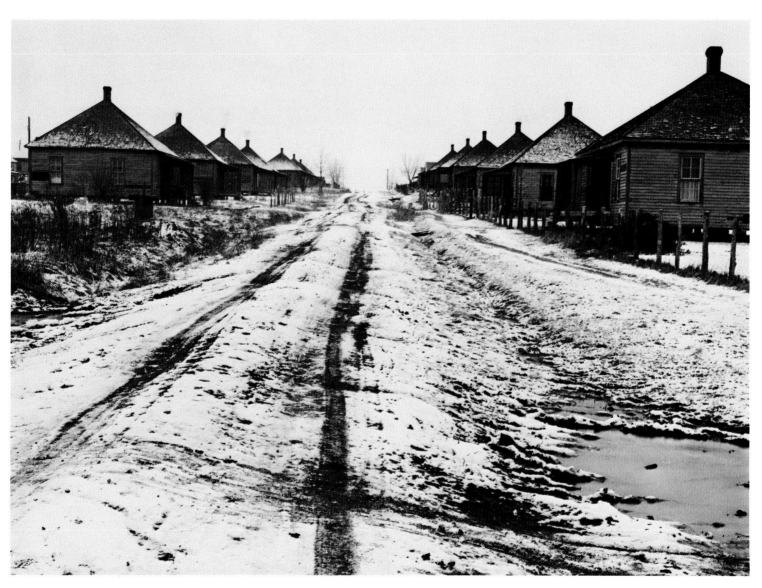

Miners' homes. Freemanspur. January 1939. *Arthur Rothstein*

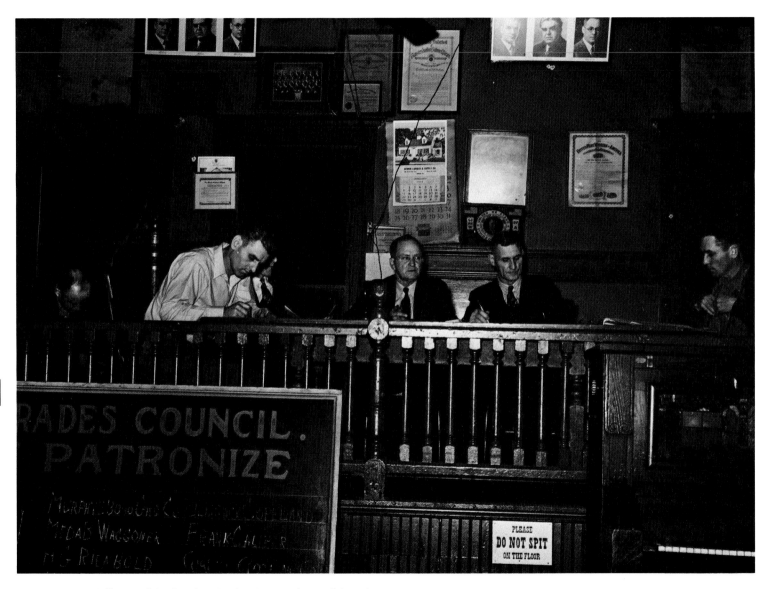

Officers of the local United Mine Workers of America at a meeting. Herrin.
January 1939. *Arthur Rothstein*

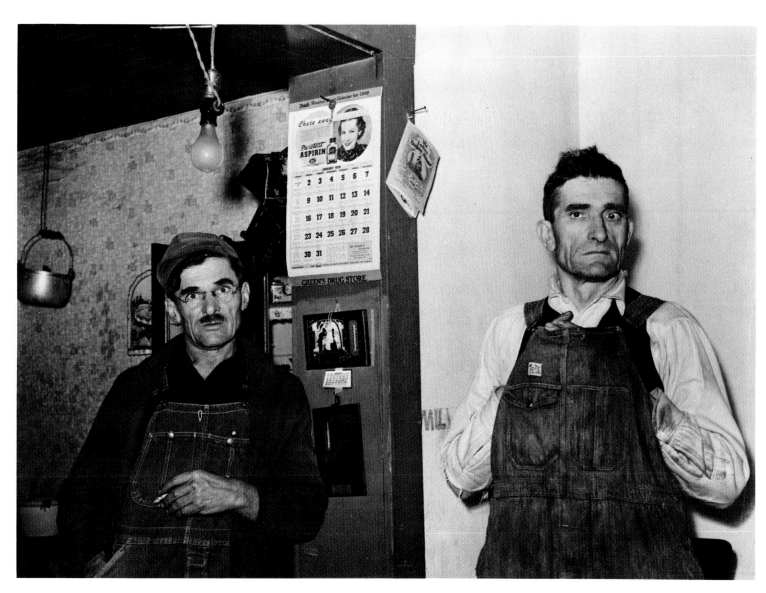

Former coal miners who are now working for the Work Projects Administration.
Zeigler. January 1939. *Arthur Rothstein*

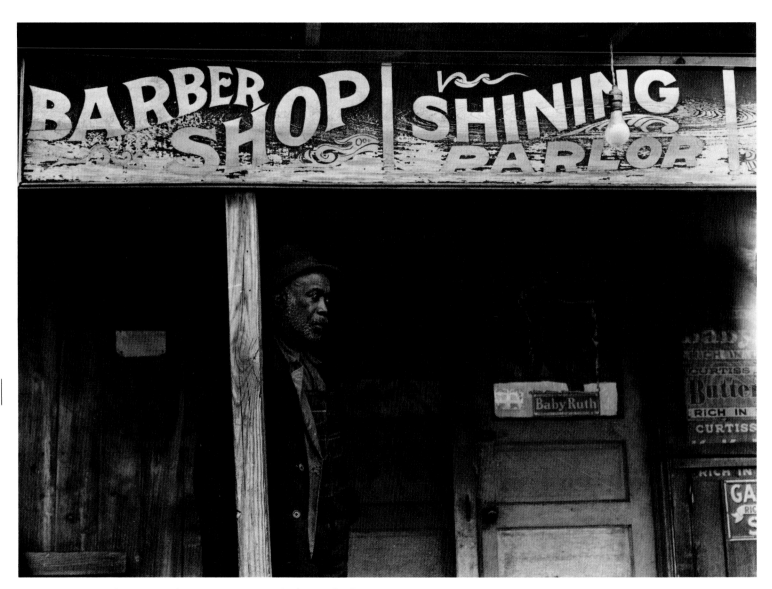

88

Coal miner. Colp. January 1939. *Arthur Rothstein*

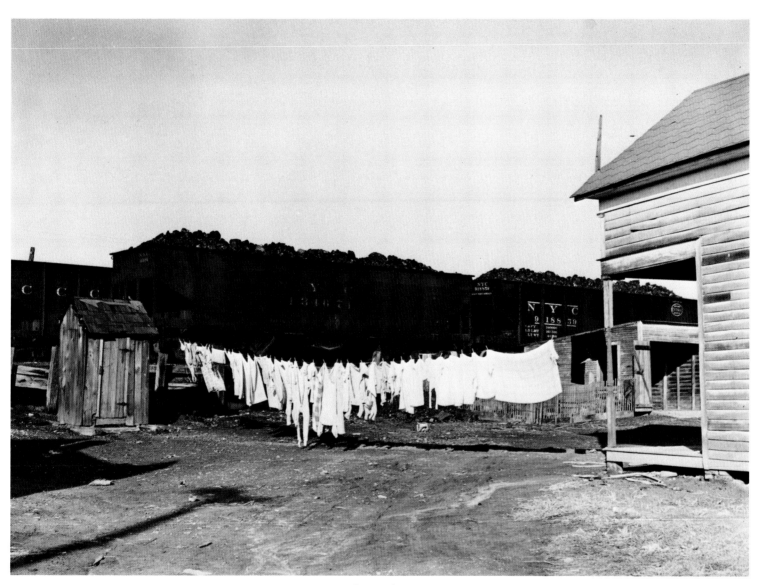

Clean clothes. Carrier Mills. January 1939. *Arthur Rothstein*

89

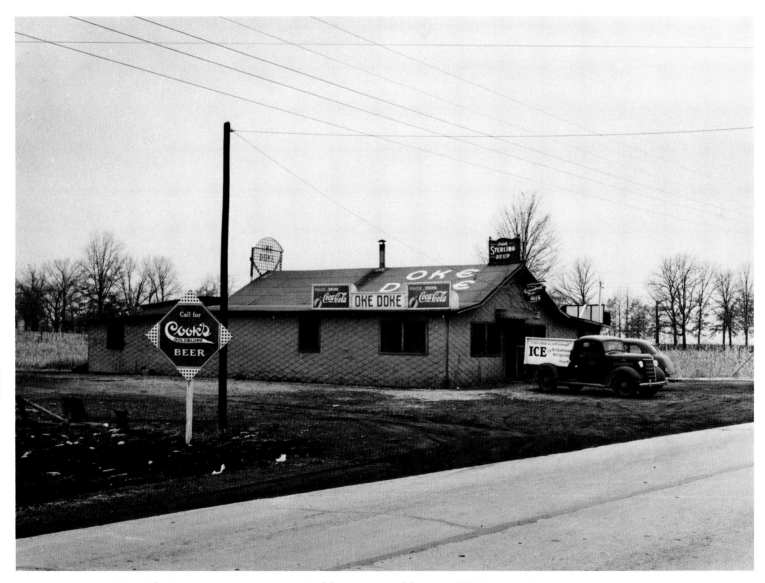

A night club along the highway patronized by miners and farmers. Williamson County.
January 1939. *Arthur Rothstein*

Interior of the Oke-Doke dance hall patronized by farmers and miners. Williamson County. January 1939. *Arthur Rothstein*

92

A doctor at the Herrin
Hospital, a private
institution, giving
neoarsphenamine
treatment under the state
program of combating
syphilis. Herrin.
January 1939.
Arthur Rothstein

Miner's home. Carrier Mills. January 1939. *Arthur Rothstein*

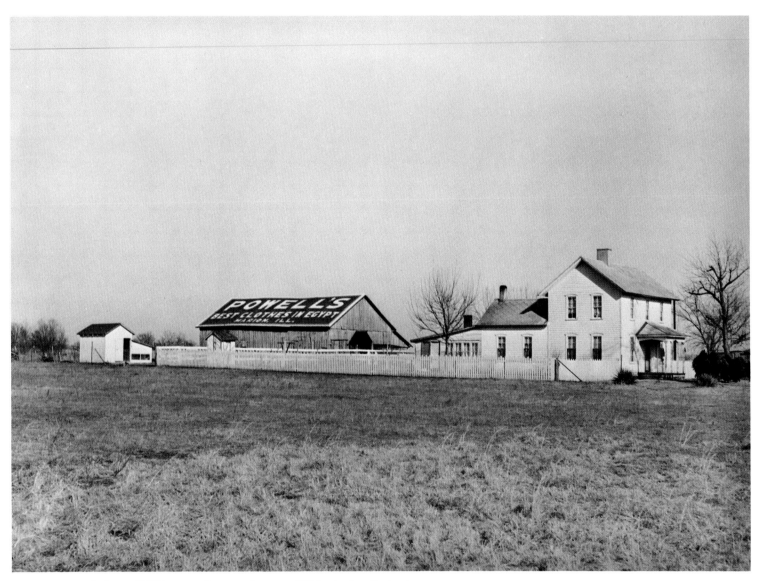

94

A farm. Williamson County. January 1939. *Arthur Rothstein*

THE BLACK BELT

■ Edwin Rosskam joined the staff of the Historical Section in 1938. As photo editor, he selected photographs and prepared layouts for exhibits and publications. His first book project related to the FSA was *Hometown*, a collection of FSA photographs that featured small-town life with text by the novelist Sherwood Anderson. An entrepreneur, Rosskam understood the appeal of visual images and the popularity of cameras, photo magazines, and picture books in the depression decade. He left Stryker's staff after convincing Viking Press to produce a book on the movement of blacks from the rural South to the cities of the industrial North. Almost overnight in 1939, Richard Wright had become America's best-known black writer with the success of his best-selling novel, *Native Son*. Rosskam was delighted when Wright agreed to write the text for *Twelve Million Black Voices*.[1]

Wright was a native of Mississippi who moved to Chicago in 1927 when he was nineteen years old. His personal experiences in the Black Belt were reflected in the tragic story of Bigger Thomas. In 1937 Wright left the city for New York. When Rosskam and he reviewed the FSA files for the photographs to illustrate their book, they were satisfied with the strong representation of rural life. Like other New Deal agencies, the RA/FSA had been sensitive to the needs of poor blacks as well as of poor whites. As employees of the FSA, the photog-raphers reflected this orientation in the field. Examples can be seen in Russell Lee's and Arthur Rothstein's pictures from southern Illinois. At Shawneetown, Lee photographed the first black and first white children born at Tent City, students from the "Colored School" continuing their education, and a 91-year-old black flood refugee. Rothstein included the black community of Colp in his mining pictures. Approximately ten percent of the captioned photographs in the FSA-OWI Collection include black subject matter, a percentage that was close to the percentage of blacks in the American population at the time.[2]

Sharecroppers and hired hands were well represented in the FSA files, but Rosskam and Wright recognized the need for more urban scenes. Wright chose Chicago where white attitudes had confined blacks into an increasingly concentrated ghetto. By 1941 the physical boundaries of the Black Belt were fixed as new migrants continued to pour in. Of the 337,000 blacks in Chicago, over three-fourths lived in areas that were more than ninety percent black. Not only did Wright know the Black Belt, but he also was aware, as a former WPA staff writer in Chicago, of the extensive research done by the Cayton-Warner project. He came back to meet with Horace Cayton and to study the research files in April 1941. While there, Wright introduced Russell Lee and Ed Rosskam to Cayton, who

helped them to photograph the rich diversity of life in Black Metropolis.

The Black Belt, or Bronzeville, was an area seven miles long and one and one-half miles wide bounded by Twenty-second and Sixty-third streets between Wentworth and Cottage Grove. Five smaller enclaves— Englewood, Morgan Park, Lillydale, South Chicago, and Oakwood—completed the residential housing pattern open to blacks. Through intimidation and legal devices such as restrictive covenents, blacks were confined to the urban ghetto. For the large numbers of blacks fleeing the South, the result was incredible overcrowding, bad sanitation, deteriorating buildings, and high costs for shelter and other basic necessities.

Driving through the Black Belt on South Parkway (Martin Luther King Drive) and Forty-seventh Street, the two major thoroughfares, was deceptive. As Rosskam noted, the shops on Forty-seventh looked prosperous and the stone buildings on South Parkway between "the 40ties and the 60ties" looked substantial outwardly. But inwardly, the area was "a slum in the process of becoming." Deteriorating rapidly, the population density approached 90,000 per square mile, more than four times that of white areas across Cottage Grove only blocks away. This section of the slum was hidden: other areas looked as if they "had been bombed." In the Maxwell Street section and along LaSalle, Dearborn, and Federal "leaning tenements stare blindly through broken, boarded or papered windows past sagging wooden outside stairways upon empty lots where children play in the rubble of a decade's collapse and demolition and in months-old piles of garbage."[3]

Lee's photographs, together with a few contributed by Rosskam and several taken by Jack Delano a year later, present Chicago's urban ghetto in exceptional detail. The grim reality of life in the slum is evident; so, too, is the defiant attitude toward the South of the recent migrants. In Wright's words, "We'd rather be a lamppost in Chicago than the president of Dixie!"[4]

NOTES

1. Edwin Rosskam interview with Richard Doud, 3 August 1965, Archives of American Art, Smithsonian Institution.
2. Nicholas Natanson, "Politics, Culture, and the FSA Black Image," *Film and History* 17, no. 2 (May 1987), 30.
3. "The Face of the Black Belt," Supplementary Reference Files, FSA-OWI Textual Records.
4. Wright, *Twelve Million Black Voices*, 88.

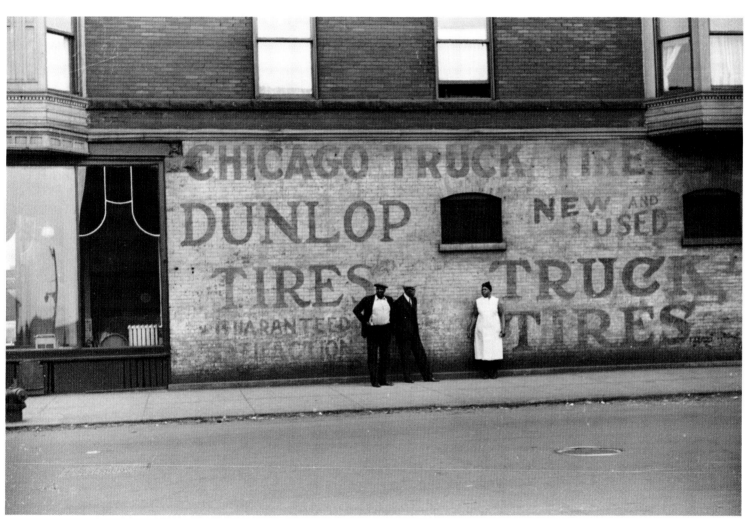

Black Belt. Chicago. April 1941. *Edwin Rosskam*

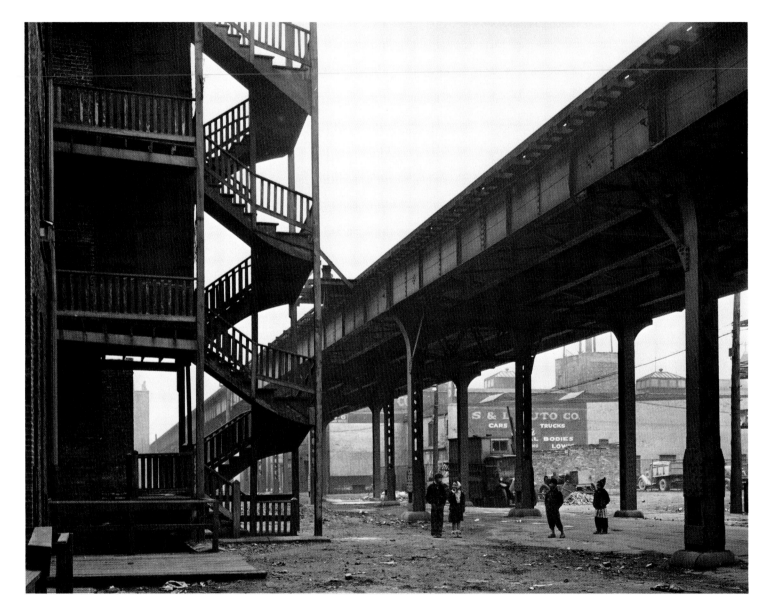

Children playing under the elevated on the south side. Chicago.
April 1941. *Russell Lee*

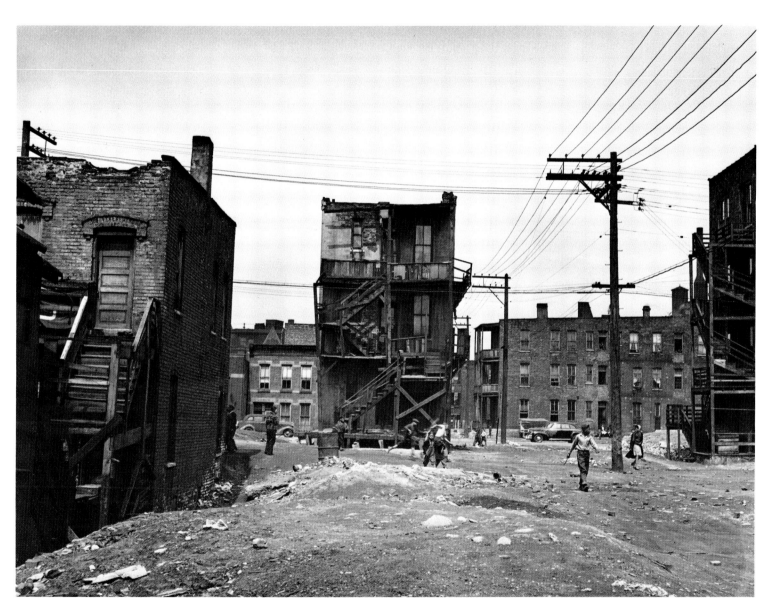

Housing for Negroes. Chicago. April 1941. *Russell Lee*

100 | Hall of the second
floor of a building
rented as a rooming
house to Negroes.
Chicago. April 1941.
Russell Lee

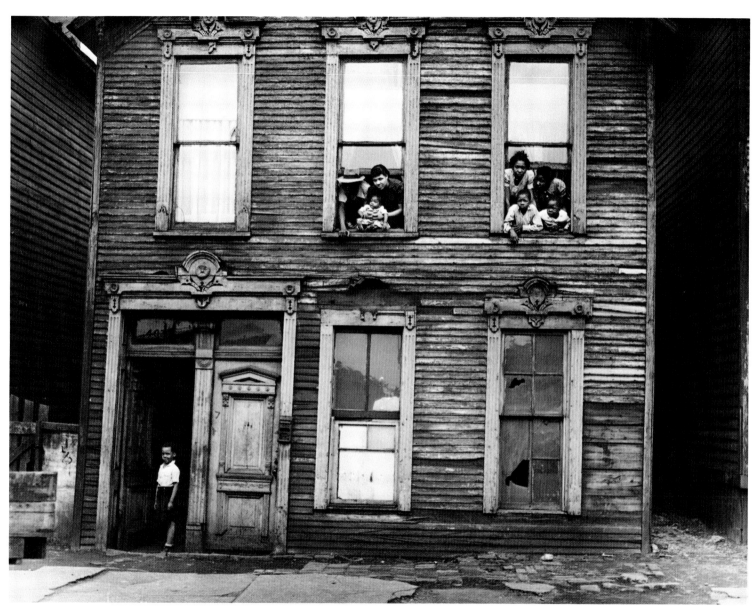

House in a Negro section. Chicago. April 1941. *Russell Lee*

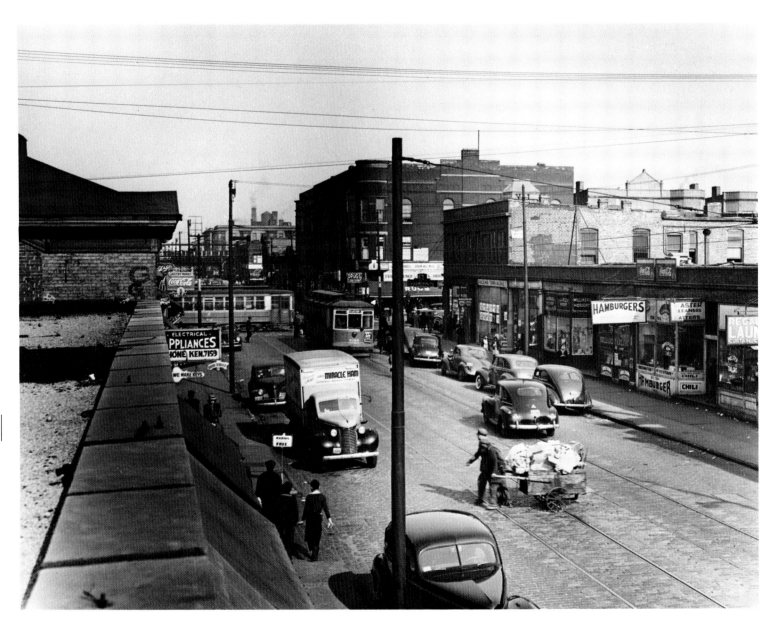

Forty-seventh street. Chicago. April 1941. *Russell Lee*

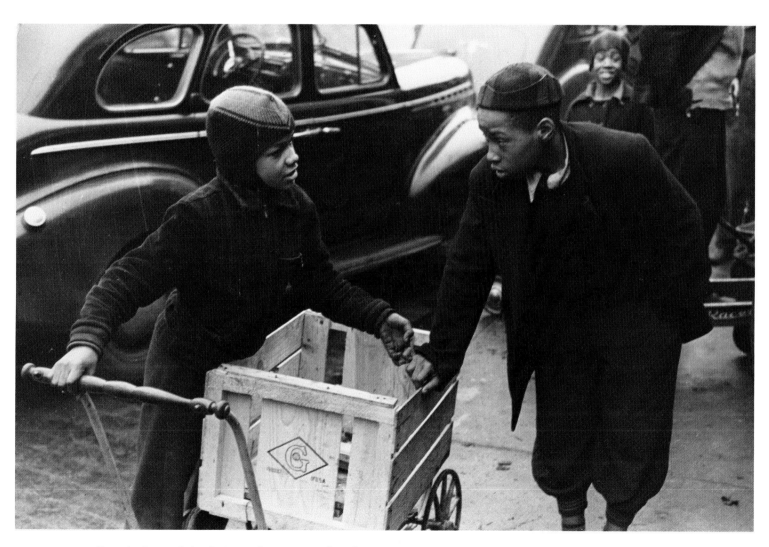

103

Boys in front of the A&P market waiting for jobs to cart shoppers' groceries home. Chicago. April 1941. *Russell Lee*

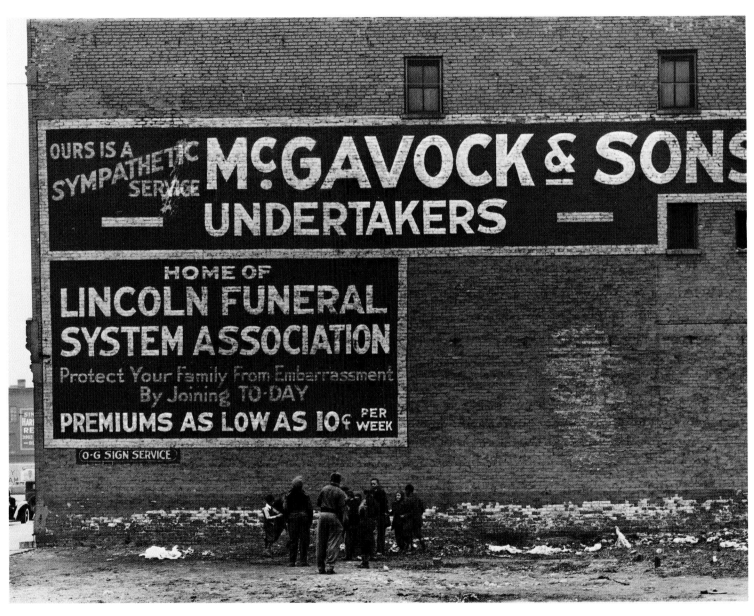

Sign. Chicago. April 1941. *Russell Lee*

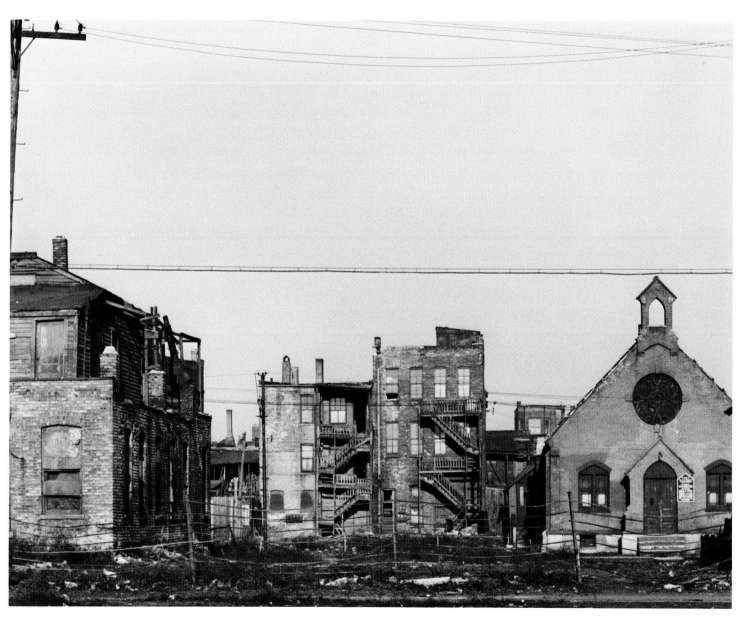

Scene in a Negro section. Chicago. April 1941. *Russell Lee*

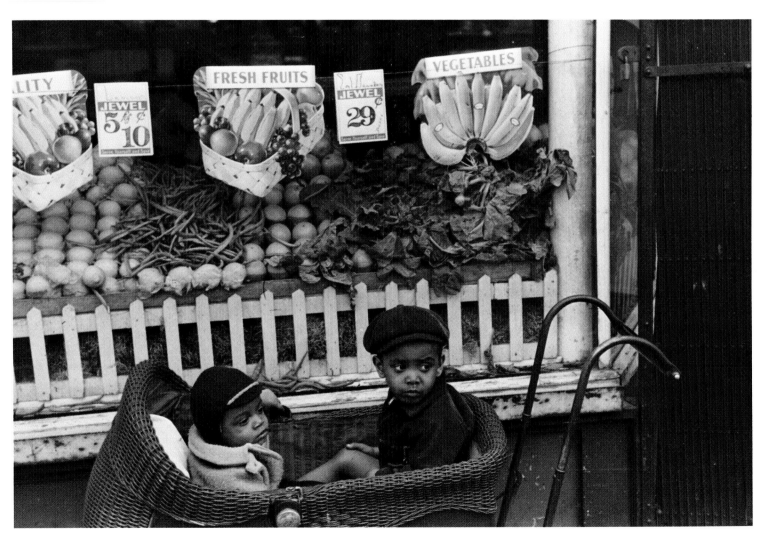

Children in front of grocery store. Chicago. April 1941. *Russell Lee*

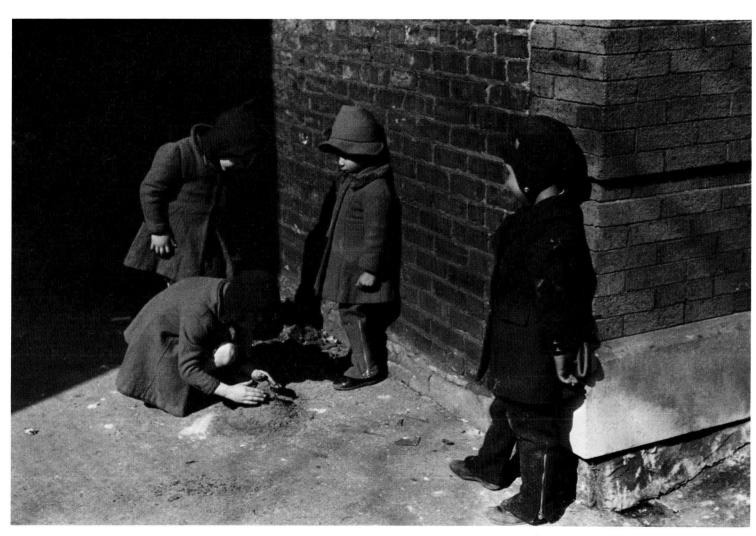

This is where the Negro and white sections meet on the south side. The white and Negro children sometimes play together. Chicago. April 1941. *Russell Lee*

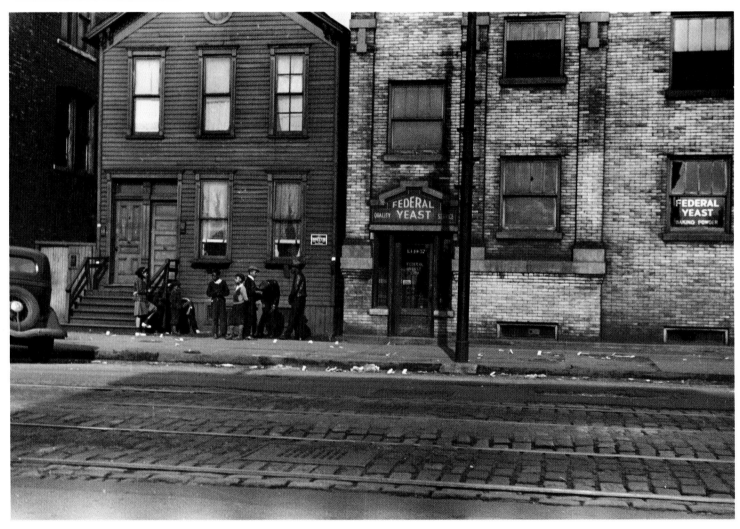

Black Belt section on the south side. The papers littering the sidewalk are "policy slips."
Chicago. April 1941. *Russell Lee*

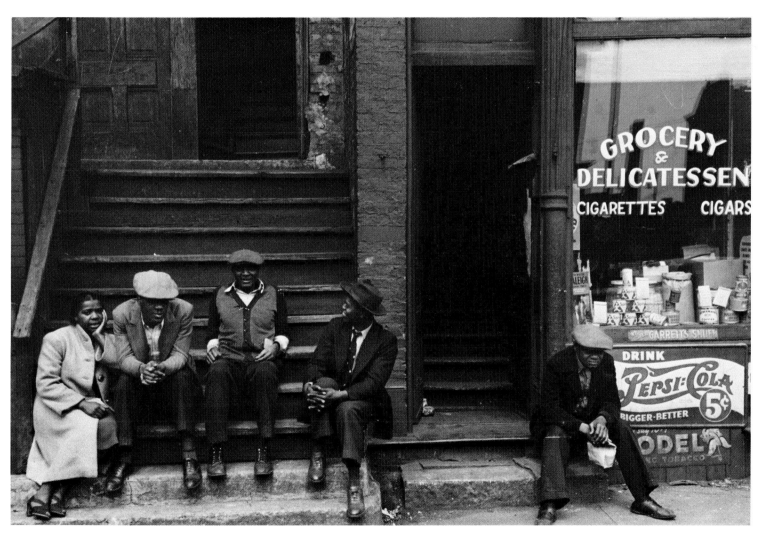

People sitting on front porchs in the Negro section. Chicago. April 1941. *Russell Lee*

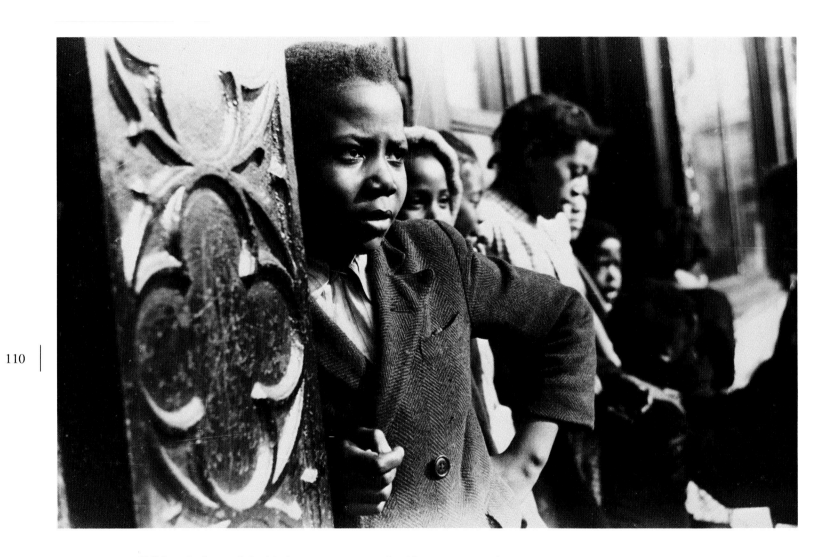

Children in front of the kitchenette apartment building in the Black Belt. Chicago. April 1941. *Edwin Rosskam.*

STAYING ALIVE

■ *Black Metropolis* was published in 1945 as World War II ended. The original data had been gathered in the late 1930s by twenty researchers, financed by the Works Progress Administration. This Cayton-Warner research project combined the sociology approach of Horace R. Cayton, who had studied with Robert Park at the University of Chicago, and the community studies techniques of W. Lloyd Warner, who emphasized firsthand observation. In his introduction, Richard Wright remarked that no other community in America had been studied so intensely as Chicago's south side. The book has come to be regarded as a classic study of life in the urban ghetto.

Despite the color of their skin, Russell Lee and Edwin Rosskam worked as participant-observers during the two weeks they spent in Chicago. They recorded on film impressions that supplemented the written analyses of the Cayton-Warner researchers. Had *Black Metropolis* been illustrated, the Lee-Rosskam photographs would have complemented the words magnificently. The major themes of that study, the "five axes of life" in the black community, offer an organizing pattern for the Lee and Rosskam pictures. As discussed in the chapter "Bronzeville," these five dominating interests or centers of orientation around which individual and community life revolve were Staying Alive, Having a Good Time, Praising God, Getting Ahead, and Advancing the Race.

Staying Alive centered on the matter of survival and addressed the lifestyles of the great majority of urban blacks. Blacks had come to Chicago in the Great Migration from the South that began in the 1890s and intensified during and after World War I. Just as others came from abroad, they came north seeking opportunity. They found jobs as domestic help and as unskilled laborers in the stockyards and steel mills to the west and south of the Black Belt. When the depression hit America, as last hired these black workers were the first fired. By 1939, when blacks constituted ten percent of the city's population, forty percent of those on relief in Chicago were Negroes. Five out of every ten Negro families depended on some form of government aid for their subsistence. In the words of a state commission on the Condition of the Urban Colored Population, the depression had reversed the positive trend of an expanding economy in the twenties with a devastating impact and "turned the Negro people with more than its share of the gainfully employed into a population predominantly dependent upon government relief." As Cayton and Drake observed, for many blacks the 1930s seemed a temporary setback; for others newly arrived from the south, "a $55-a-month WPA check was a net gain when compared with a debt of a bale or two of cotton."[1]

Whether recently arrived or not, blacks were ad-

versely affected by the crowded conditions of life in the Black Belt. Single family houses served large, extended families such as the eleven-member family seen in one of Lee's photographs. The father, a former house painter, had no employment except occasional WPA work for seven years. Dependent on a single monthly relief check, all of the children suffered from some form of malnutrition.[2] To meet the demand for places to live, houses and apartment buildings were turned into "kitchenettes." A six-room apartment that rented for fifty dollars per month became six one-room households each with a hot plate, an icebox, and a bed. A single bathroom now served six families. Each unit rented for eight dollars per week, increasing the landlord's income to $192 per month. The same pattern happened with larger residential buildings. With kitchenettes, a structure that once held sixty families might now hold as many as three hundred. Black Belt housing was more than ninety percent absentee owned. Given the demand for space, rents were kept high and there was little incentive to improve the property. Cayton described kitchenettes as a menace to both health and morals. Wright, who told America about the tragic consequences of growing up in this environment with the rats, vermin, and inhuman crowding in the pages of *Native Son*, denounced kitchenettes in *Twelve Million Black Voices*. He described them as "the funnel through which our pulverized lives flow to ruin and death on the city pavements, at a profit."[3]

The selections in this chapter feature families on relief, WPA workers, and people earning a living. The young man holding a baby in one of the pictures taken by Lee is a high school student who was one of eleven people related to four adults (three sisters and a brother) living in the same household.[4] Lee's skill with flash bulbs is evident in these interior views. Also apparent is Lee's sense of humor as seen in the photograph of children, armed with a hammer, eating homemade biscuits.

NOTES

1. Cayton and Drake, *Black Metropolis*, 89.
2. "Relief Family," Supplementary Reference Files, FSA-OWI Textual Records.
3. Wright, *Twelve Million Black Voices*, 111.
4. "Recent Immigrants," Supplementary Reference Files, FSA-OWI Textual Records.

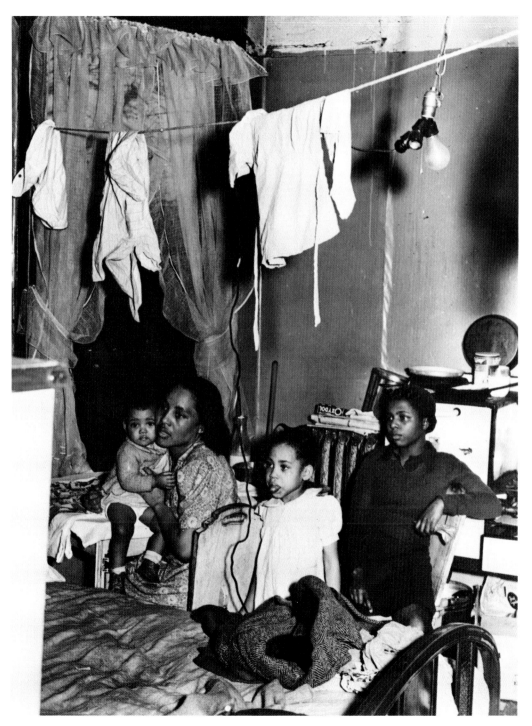

Negro family living in crowded quarters. Chicago. April 1941.
Russell Lee

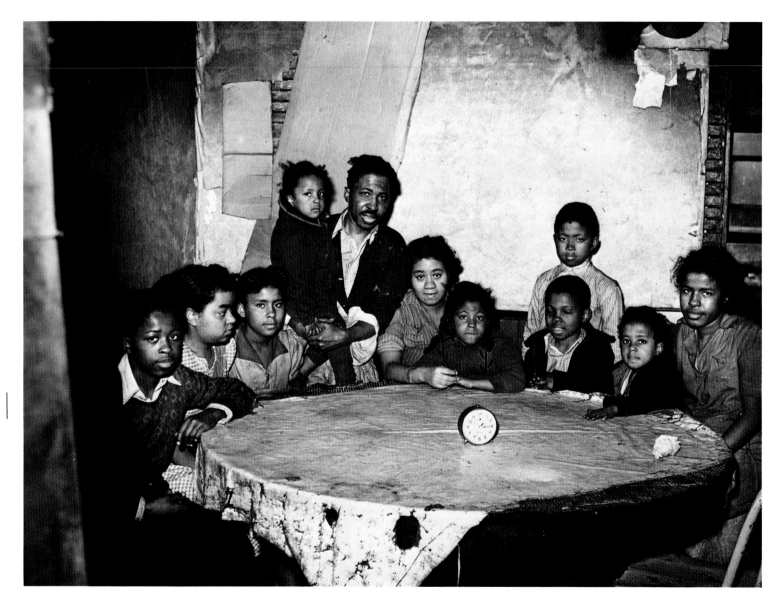

Family on relief. Chicago. April 1941. *Russell Lee*

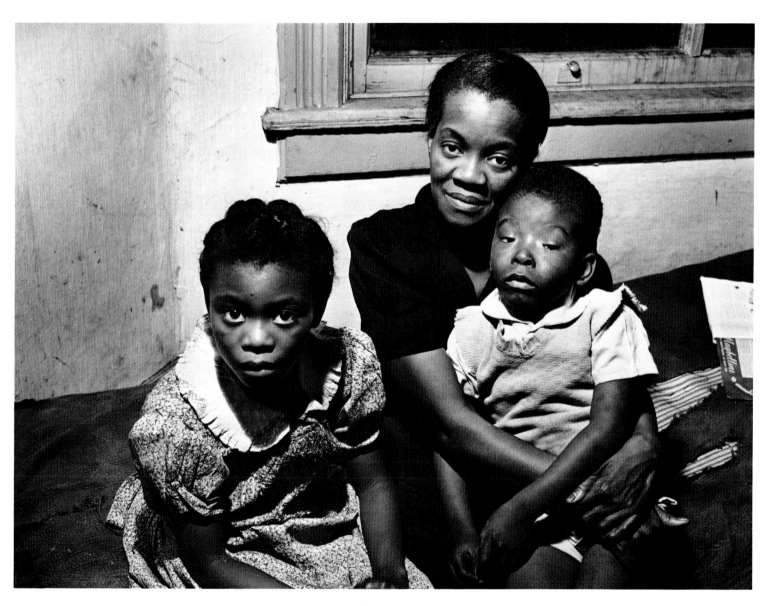

Mother and two children who are relief clients. Chicago. April 1941. *Russell Lee*

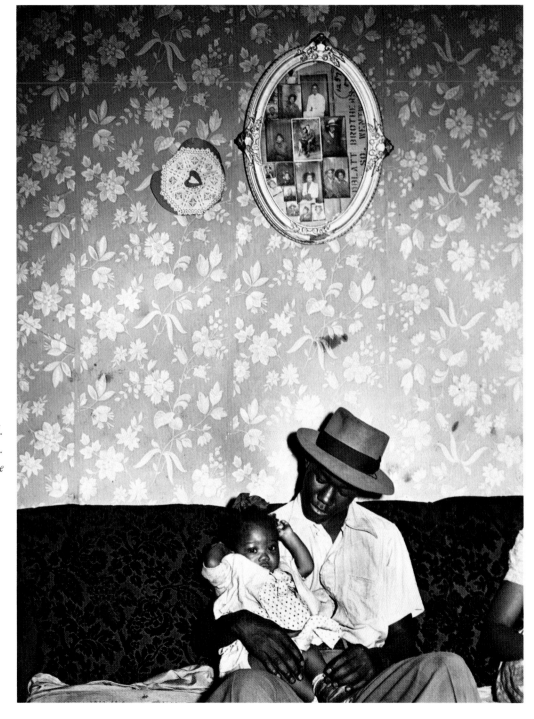

Family on relief.
Chicago. April 1941.
Russell Lee

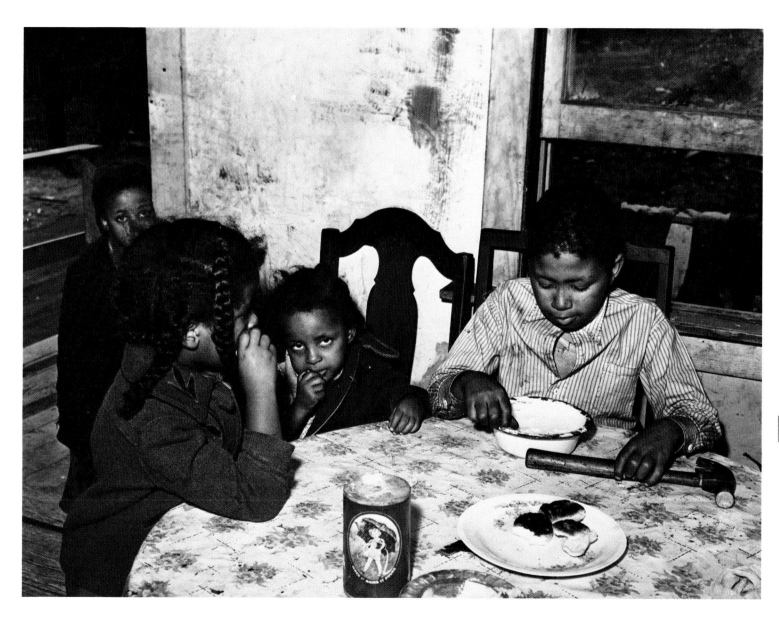

Children eating biscuits. This family is on relief. Chicago. April 1941. *Russell Lee*

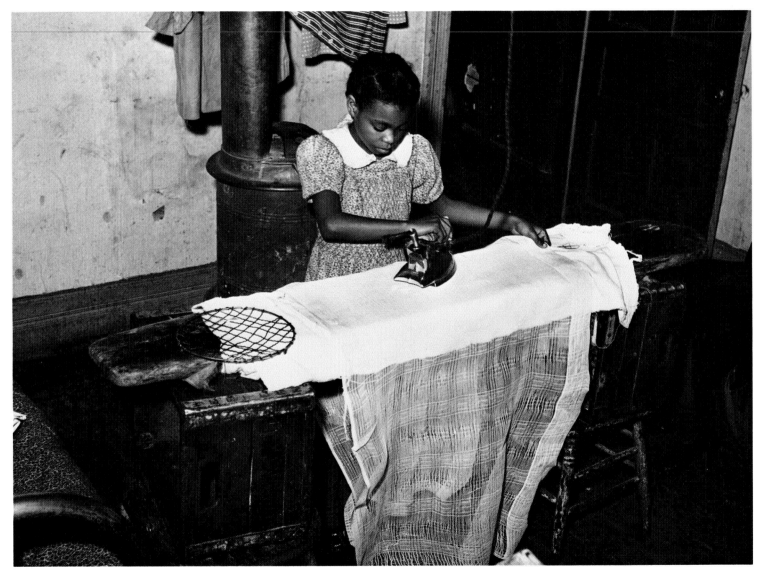

Little girl, whose family is on relief, ironing. Chicago. April 1941. *Russell Lee*

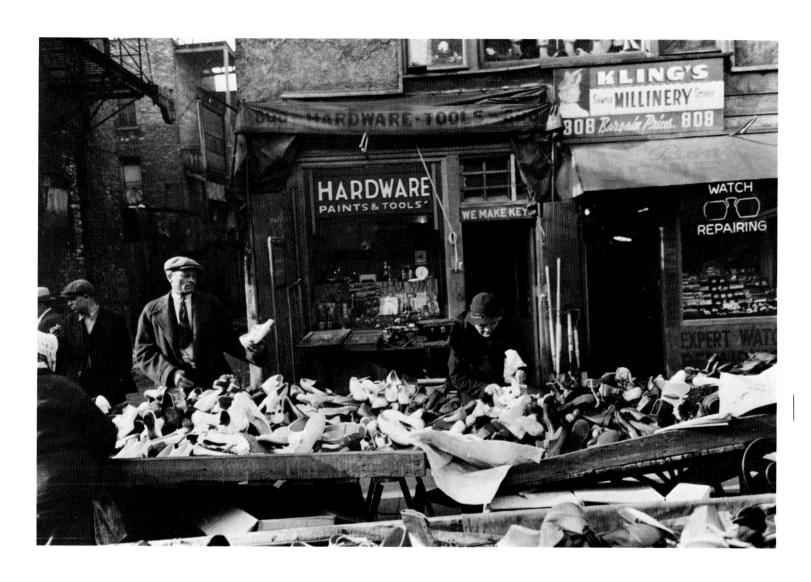

People shopping for shoes on Maxwell Street. Chicago. April 1941. *Russell Lee*

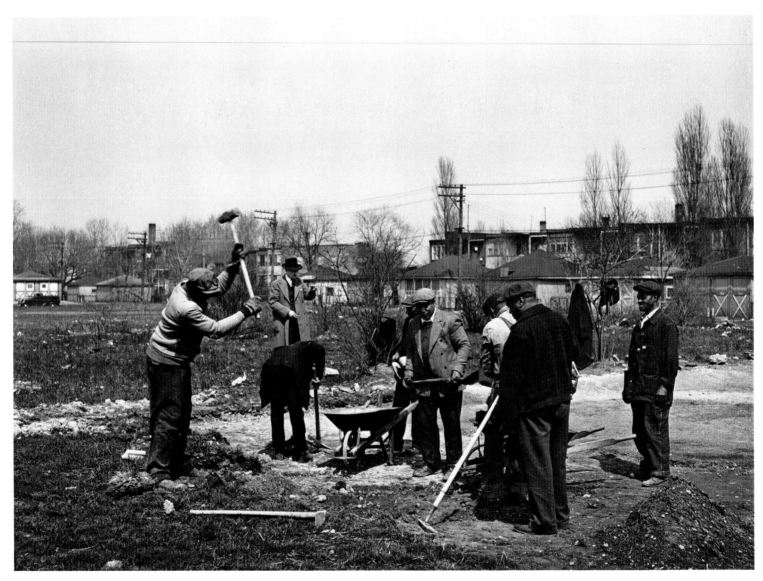

Negroes working for a WPA project. Chicago. April 1941. *Russell Lee*

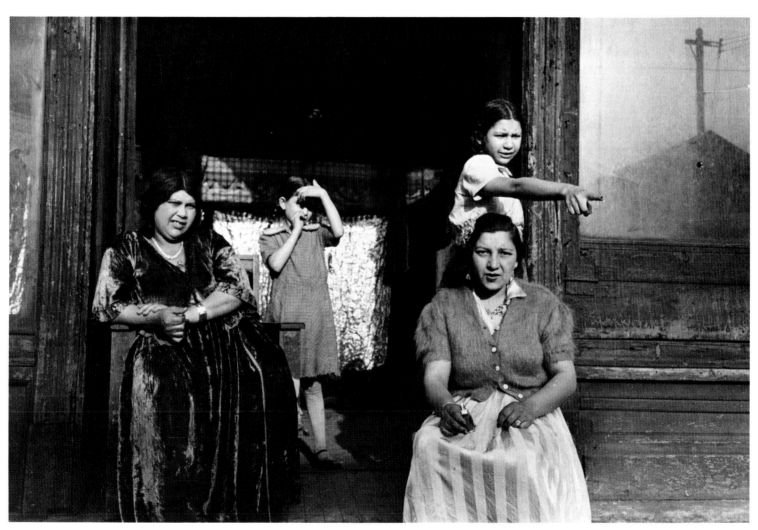

Gypsies living on the south side. Chicago. April 1941. *Russell Lee*

Candy stand run by a Negro on the south side. Chicago. April 1941. *Russell Lee*

HAVING A GOOD TIME

The residents of the Black Belt were limited in their opportunities to pursue better jobs, receive higher incomes, and buy houses—the residential symbols of success in American society. Confined to a segregated ghetto and restricted to a set of jobs at the lowest rungs of the occupational ladder, the masses centered their interests on the immediate present or upon life after death. In the words of the authors of *Black Metropolis*, their activities found expression in "having a good time" and "praising God." People in the ghetto enjoyed recreation and leisure in the same manner as white Americans did. They watched movies, attended athletic events, and went to taverns. For some, bowling, dancing, and roller skating were popular pastimes; others simply relaxed at home.

Numerous neighborhood taverns catered to low-income Negroes; many sought escape there from the lack of privacy and the bleakness of their crowded living quarters. The photographs from these neighborhood bars are remarkably candid. In such settings, blacks relaxed because they were removed from the constant social pressures requiring deference in a predominantly white world. The photographers also visited the popular State Street area between Thirty-first and Thirty-fifth streets. Chicago had been a jazz mecca of the nation during the 1920s when Joe "King" Oliver, Louis Armstrong, and other jazz greats entertained for black and tan audiences. In the depression decade, upper-class blacks and whites continued to enjoy such music played at the Royal Garden, the Dreamland, the Smart Cafe, the Plantation, and the Cafe de Champion. Another popular establishment was Morris's Perfect Eat Shop at 410 East Forty-seventh Street. Ernest Morris hired light-skinned waitresses to "attract the big spenders to his place." Dating back to the 1920s when the area developed as the "Black Broadway" of the ghetto, the Perfect Eat Shop was one of the few black-owned businesses at street level in this busy commercial area.[1]

The lower class had plenty of time but little money to spend. Nevertheless, a major form of entertainment was "policy," or "poor man's roulette." In Bronzeville, there were more than five hundred policy stations where persons could bet on lottery numbers. Policy slips were sold door-to-door three times a day, explaining the large amount of paper littering the street depicted in one of the Lee photographs in the section "The Black Belt." For many ghetto residents, policy became a cult; for a few it was big business. During the 1930s, these gamblers, or "policy kings," emerged as owners of legitimate enterprises. The most successful were the Jones brothers—Eddie, George, and McKisseck—who employed as many as 250 people at their main office at 4724 Michigan. This number did not include the people who operated the policy stations or the "runners," the sales-

men who sold the policy slips. At the height of their career, it was estimated that the Jones brothers grossed $25,000 per day. In 1937 the Jones brothers opened the first black-owned variety store, a Ben Franklin, in the heart of the business district.[2] These men were considered "race heroes" who provided models of success. Policy was a form of public entertainment; for the policy kings, it was a lucrative business enterprise that was tolerated by the police and the city administration. Years later, this type of gambling was legalized with the state-run Illinois lottery.

The boxing scene was photographed at the Good Shepherd Community House where Horace Cayton served as director. Opened in 1940, one year later Good Shepherd was considered to be "the world's largest Negro settlement house." Langston Hughes, the playwright, was a good friend of Horace and his wife Irma. A regular visitor, Hughes established a theater company, the Skyloft players, at the Community House in the fall of 1941.[3] Painting classes, dances, and lectures were part of the regular schedule at this facility. Other social service agencies and many of the black churches also served as entertainment centers for the residents of Black Metropolis.

Motion pictures were one of the most popular pastimes in the 1930s. The two entertainment centers pictured, the Regal Theater and the Savoy Ballroom, were located on busy Forty-seventh Street. The roller skating scene was taken at the Savoy, which also served as a dance emporium and as an auditorium for big-name entertainment. Built in 1927, the Regal had the appearance of a castle from the France of Louis XIV. It was an elegant "palace" where band leaders and singing groups such as Duke Ellington, Cab Calloway, and the Mills Brothers performed. Lee's photographs tell us the featured films and the white movie stars playing at the Regal; the long lines of patrons waiting to purchase tickets illustrate the popularity of this form of escape.

NOTES

1. Dempsey J. Travis, *The Autobiography of Black Chicago* (Chicago: Urban Research Institute, 1981), 73.
2. Travis, *Autobiography*, 36–37.
3. Arnold Rampersad, *The Life of Langston Hughes: I Dream a World* (New York: Oxford University Press, 1988), 2: 32–33.

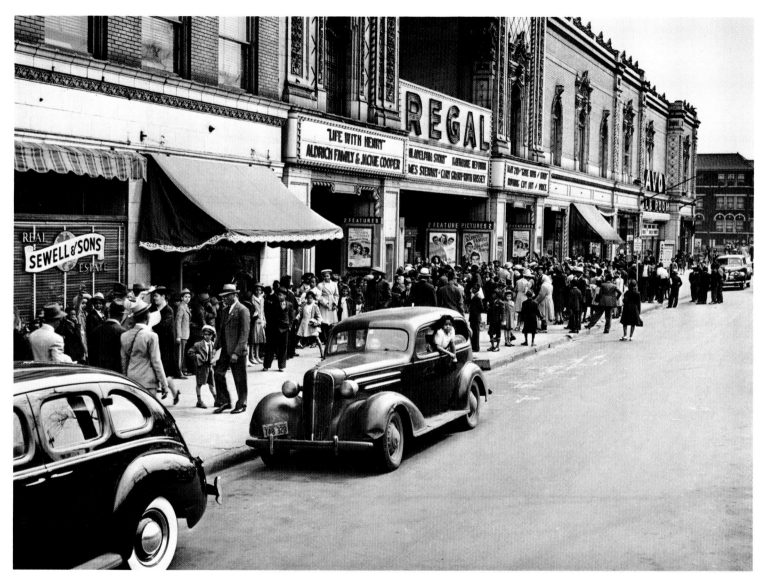

The movies are popular in the Negro section. Chicago. April 1941. *Russell Lee*

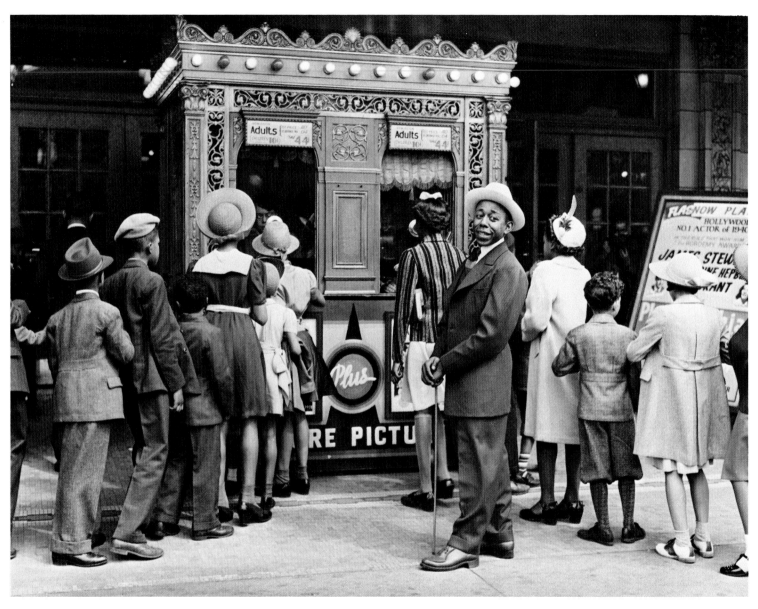

In front of the moving picture theater. Chicago. April 1941. *Russell Lee*

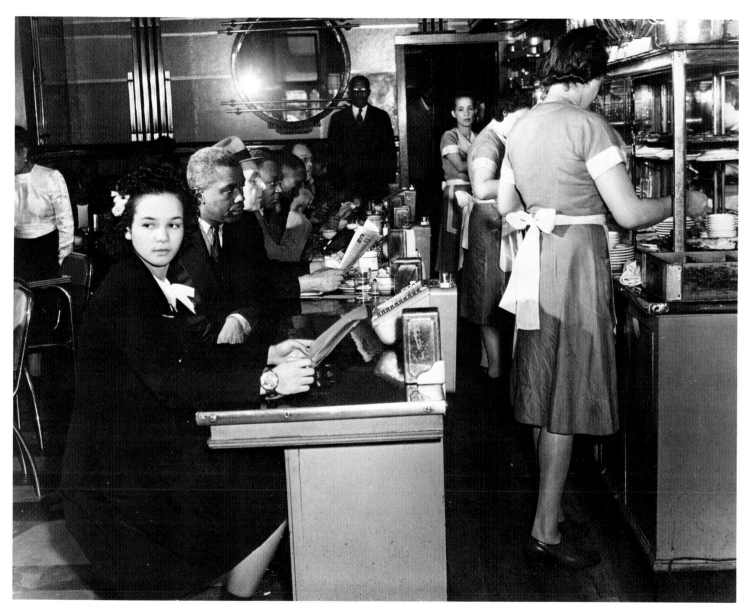

In the Perfect Eat Shop, a restaurant on Forty-seventh Street near South Park, owned by Mr. E. Morris. Chicago. April 1942. *Jack Delano*

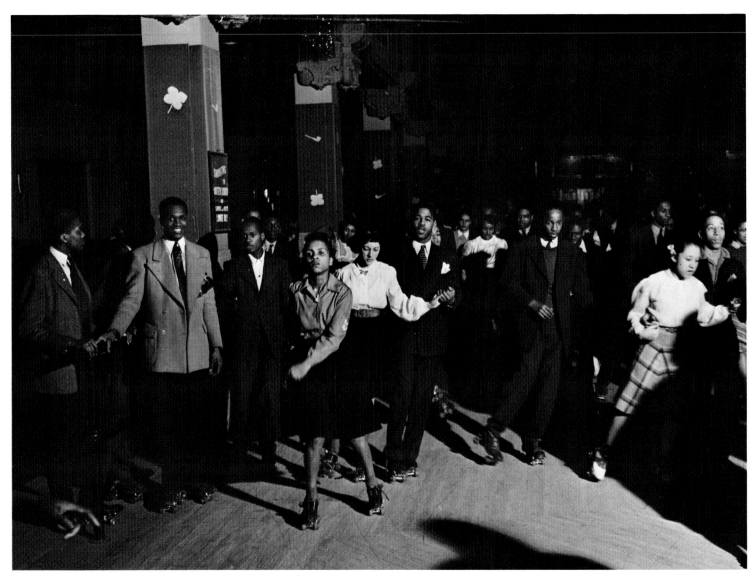

Roller skating on Saturday night. Chicago. April 1941. *Russell Lee*

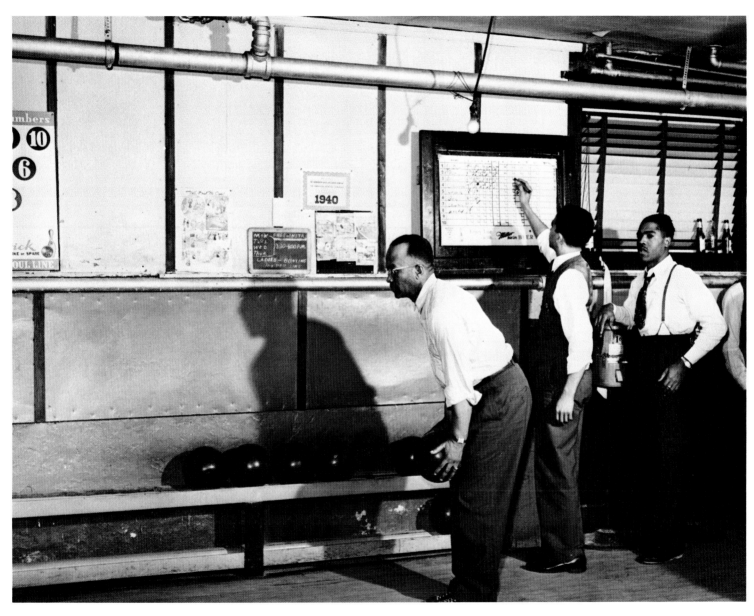

Bowling alley on the south side. Chicago. April 1941. *Russell Lee*

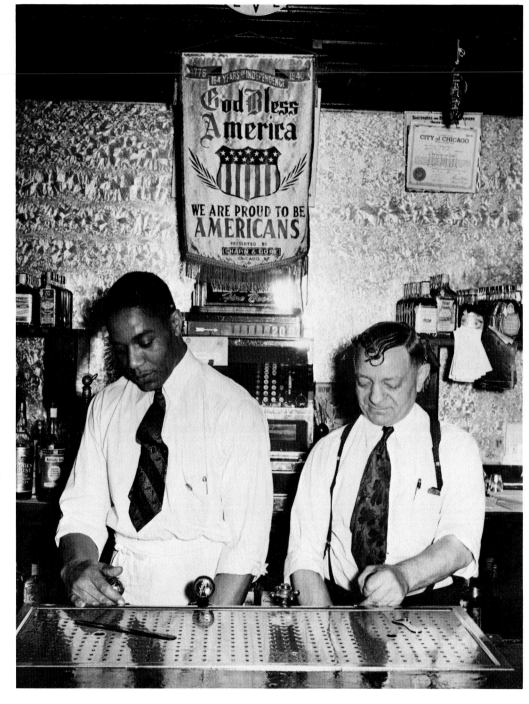

Bartender and owner of a tavern on the south side. Chicago. April 1941. *Russell Lee*

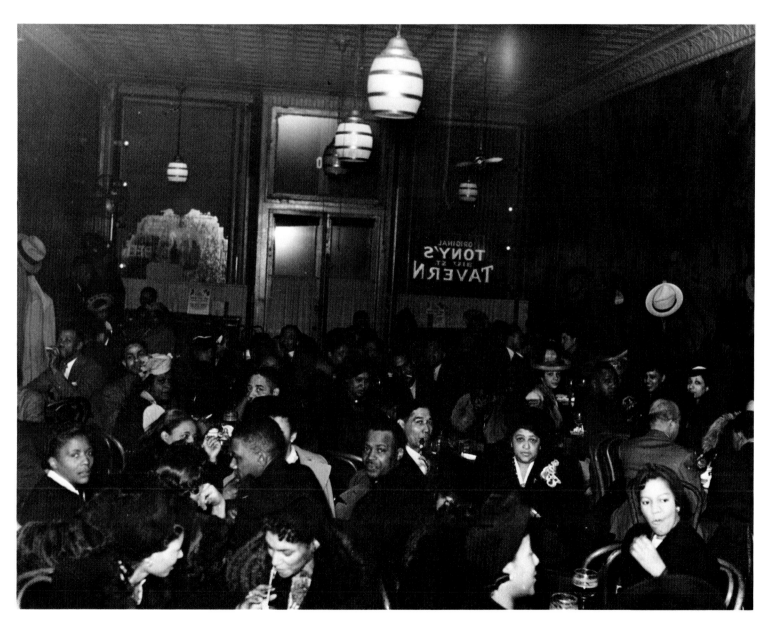

Tavern on the south side. Chicago. April 1941. *Russell Lee*

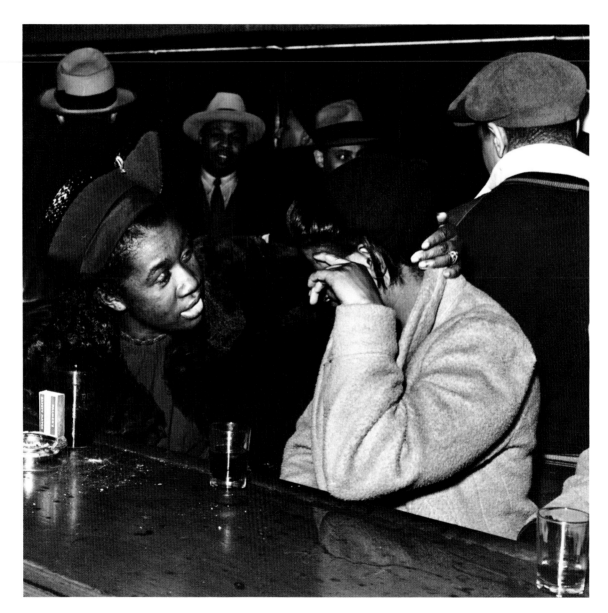

Scene at a bar on the south side. Chicago. April 1941. *Russell Lee*

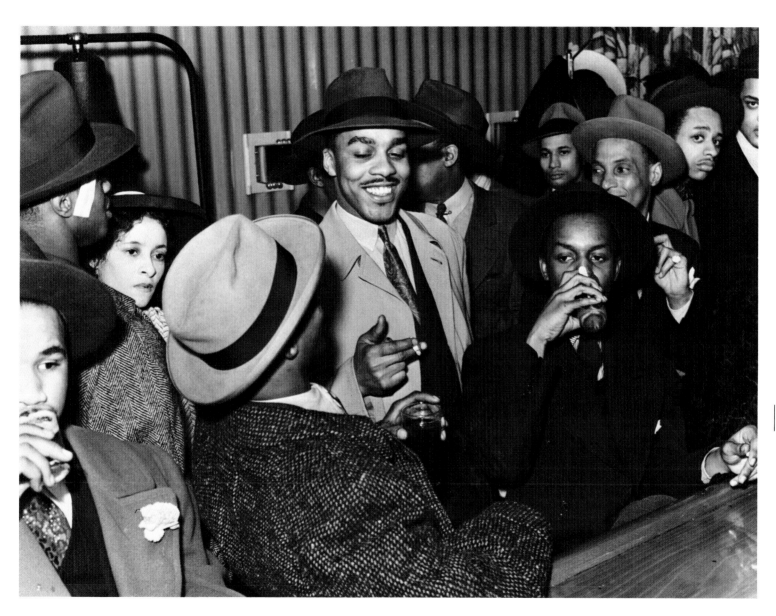

133

Saturday night in a bar room on the south side. Chicago. April 1941. *Russell Lee*

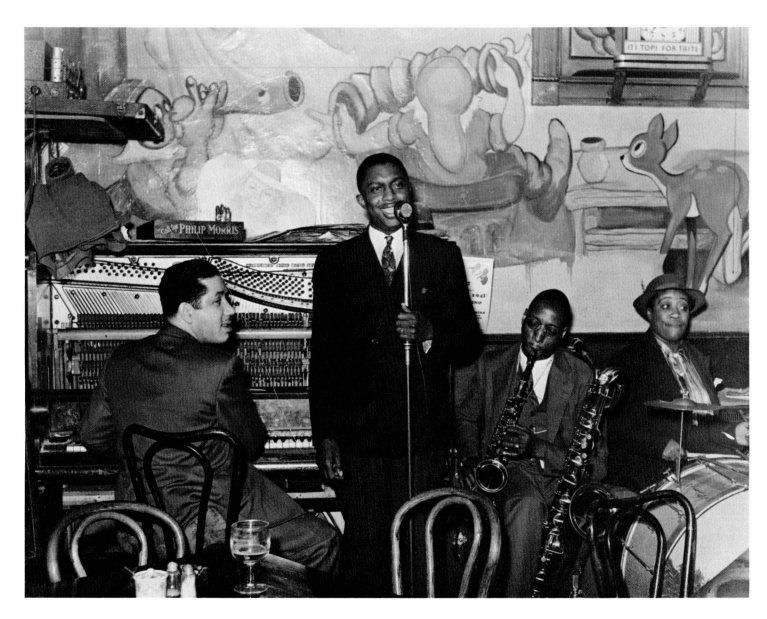

Entertainers at a Negro tavern. Chicago. April 1941. *Russell Lee*

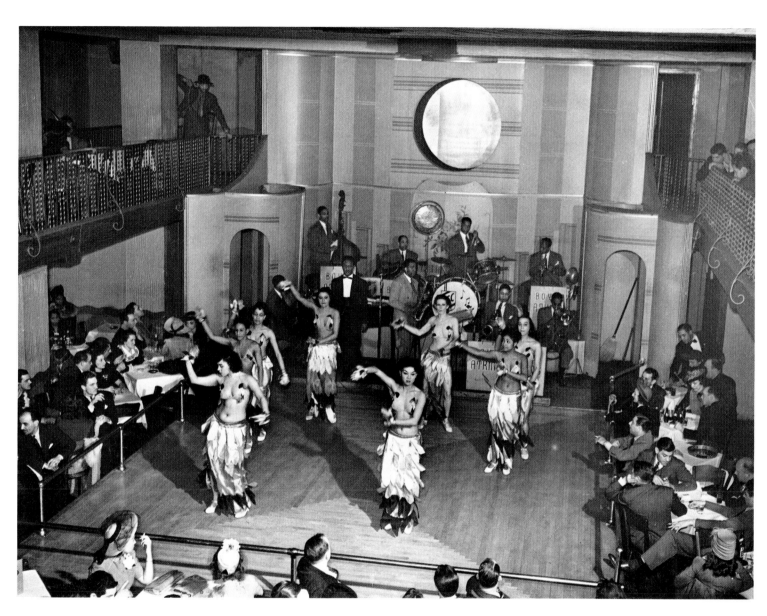

Negro cabaret. Chicago. April 1941. *Russell Lee*

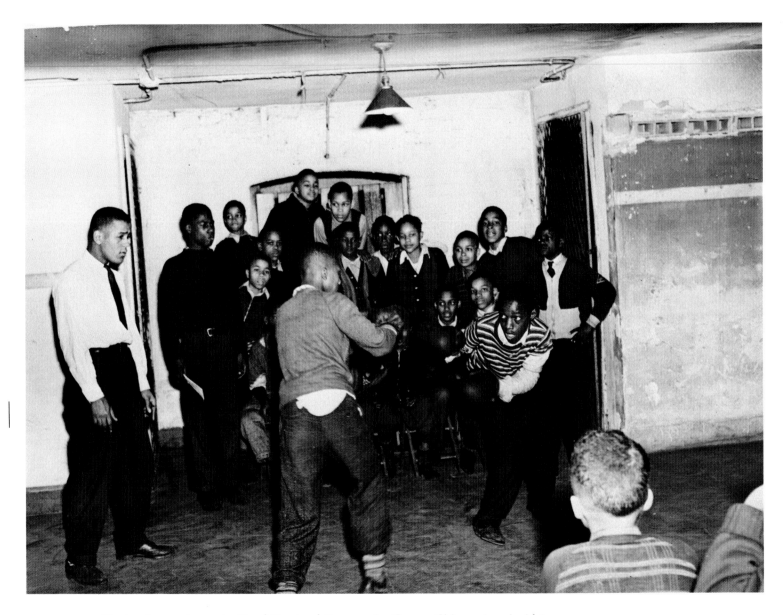

Boxing is popular at the Good Shepherd Community Center. Chicago (south side).
April 1941. *Russell Lee*

PRAISING GOD

■ Almost five hundred churches representing more than thirty denominations dotted the south side of Chicago. While there were a few large churches with memberships in the thousands, three-fourths were small storefront churches with congregations of less than twenty-five members. The Baptists were the strongest denomination, with more than two hundred churches and approximately two-thirds of the 200,000 persons who claimed church membership.[1]

Russell Lee visited several black churches on Easter Sunday in 1941. The next spring Jack Delano expanded the file by photographing all-black St. Elizabeth's, one of the three large Roman Catholic churches in Black Metropolis. As the caption indicates, one black priest, Father Smith, served on the pastoral staff at St. Elizabeth's. The solemnity of the Mass is revealed in the selection included here. Cayton and Drake observed that one of the primary attractions of the Catholic church was its parochial school system, which offered an alternative to the severely overcrowded conditions in the Chicago public schools. Overall, less than ten percent of the churchgoers in the Black Belt were members of congregations associated with predominantly white denominations. Most belonged to all black congregations called "race churches" by the authors of *Black Metropolis*.[2]

Storefront churches were an indicator of the extent of crowding in the ghetto. The Lord was praised in vacant stores, houses, abandoned theaters, and remodeled garages. Often these churches were located in rundown, low-rent business areas and in undesirable residential settings. The high cost of property and the lack of available edifices encouraged the proliferation of these makeshift arrangements. One street had ninety storefront churches in a three-mile stretch. The popularity of these fundamentalist churches with their moral strictures against gambling, dancing, and drinking, and the admonition to "live free from sin" seems ironic in light of the frequency of neighborhood taverns and the success of "policy" among the lower classes in the Black Belt.

Storefront churches were strongly centered on the leadership of the ministers. Those who were able to take their congregations from shabby surroundings to established church buildings were recognized as "heroes" in the black community. Cayton and Drake noted that the preachers were the major performers in the service. They presented inspirational sermons and encouraged the shouting of words of support and encouragement. Singing of gospel hymns was another essential part of the religious service. Lee's photographs of the interiors of Pentecostal and Baptist churches are remarkable in their presentation of intimate scenes of black congregations at worship.

The churches were centers of community life. Larger

churches hosted meetings, plays, concerts, socials, and movies. Organized sports programs were often a part of congregational activity. The lower-status smaller churches tended to concentrate on prayer and hymn singing. Cayton and Drake described Sunday mornings in Bronzeville as colorful occasions: "little knots of children and adolescents, in their Sunday best, began to gather" outside the churches. Two such adolescent groups, photographed by Lee, are depicted in this section. The streets around all the larger churches and many of the smaller were lined with rows of "freshly polished" automobiles. On Easter morning, it was impossible after 10:45 a.m. to secure a seat for the 11:00 service at any of the five largest Protestant churches, each with a seating capacity of more than 2,500 persons.[3] The relationship between what is the law and what is accepted behavior is seen in the photograph of young men selling Easter lilies beside the official sign "No Peddlers Allowed."

NOTES

1. Cayton and Drake, *Black Metropolis*, 412–13.
2. Ibid., 413–14.
3. Ibid., 416–17.

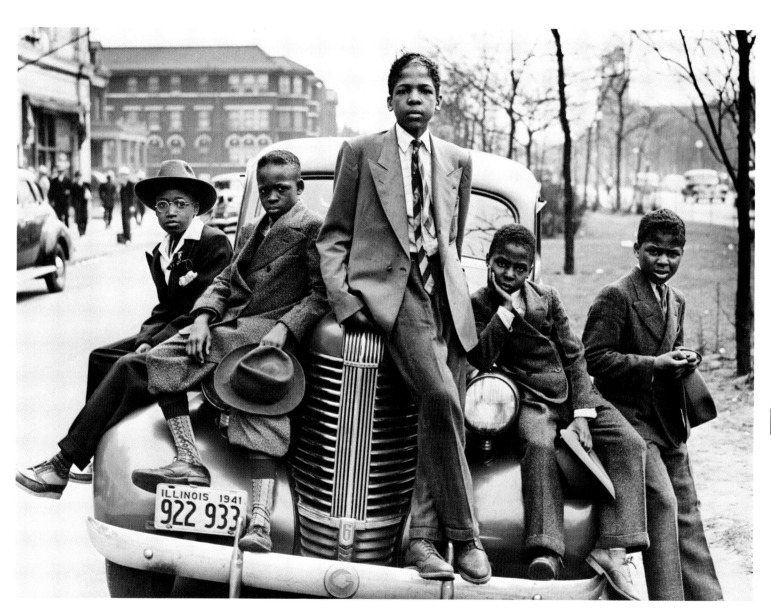

Negro boys on Easter morning on the south side. Chicago. April 1941. *Russell Lee*

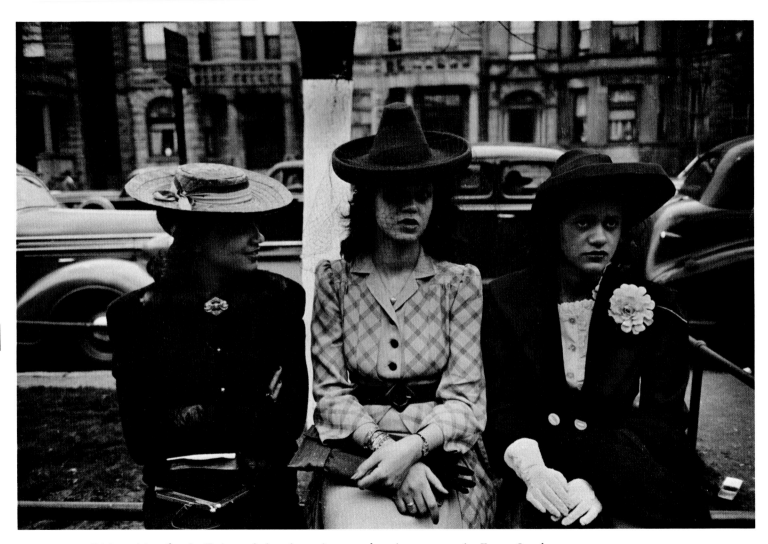

Girls waiting for the Episcopal church service to end so they can see the Easter Sunday processional. Chicago (south side). April 1941. *Russell Lee*

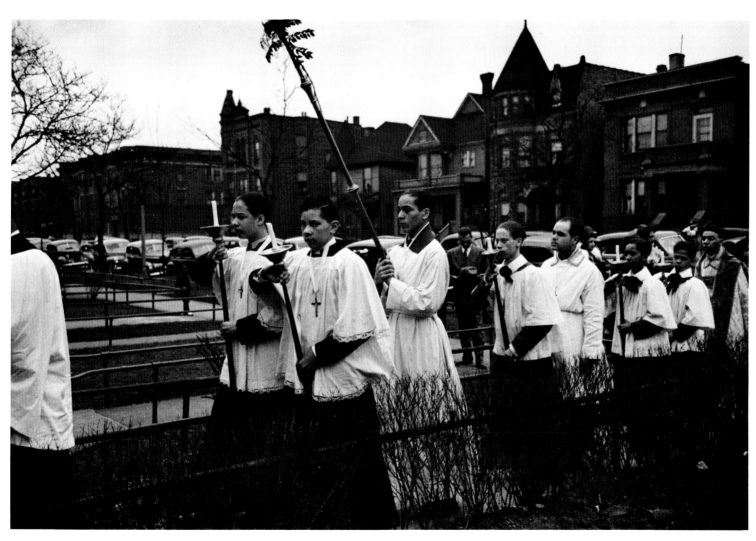

Part of the Easter Sunday processional of an Episcopal church. Chicago (south side).
April 1941. *Russell Lee*

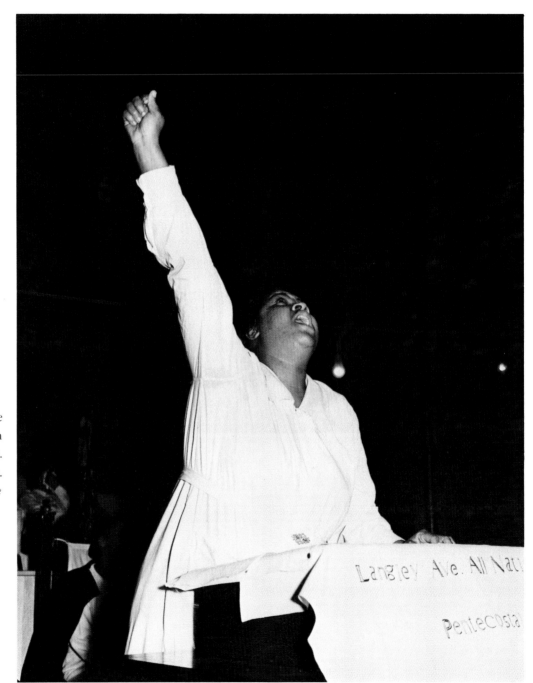

142 | One of the leaders of the Pentecostal church on Easter Sunday testifying. Chicago (south side). April 1941. *Russell Lee*

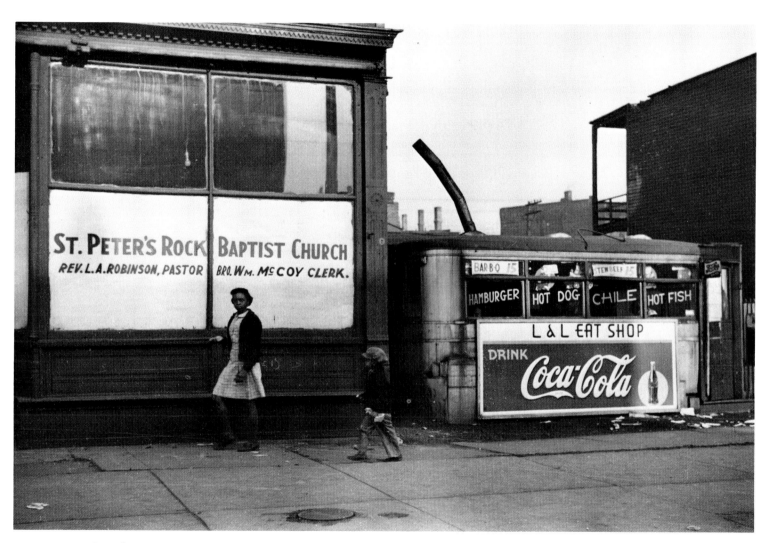

Storefront Baptist church and lunch wagon. Chicago (south side). April 1941. *Russell Lee*

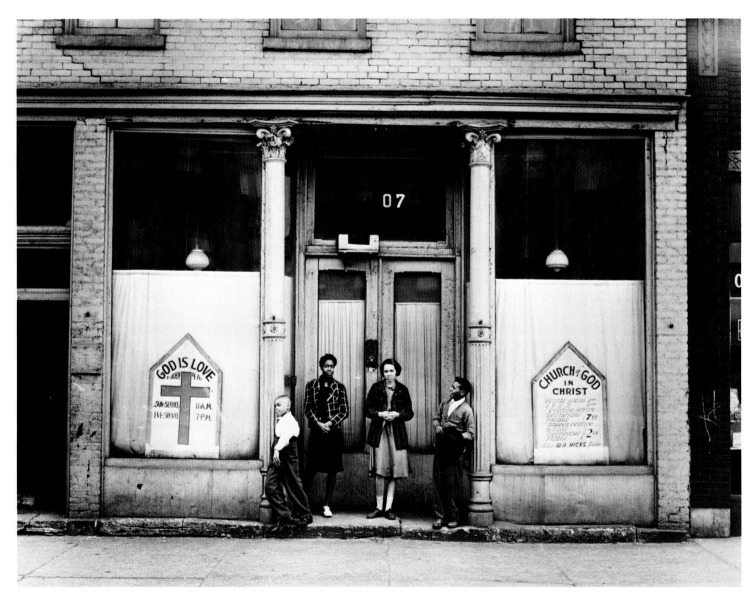

Storefront Baptist church. Chicago (south side). April 1941. *Russell Lee*

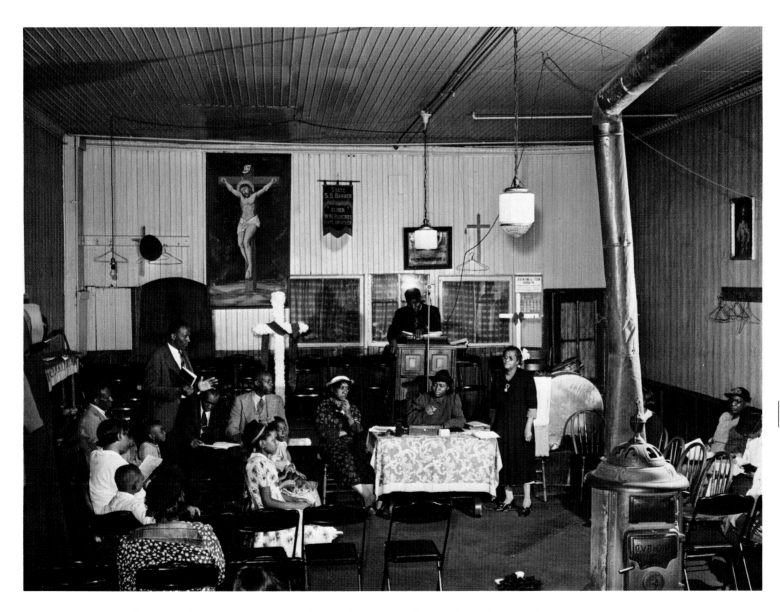

Storefront Baptist church during services on Easter morning. Chicago (south side).
April 1941. *Russell Lee*

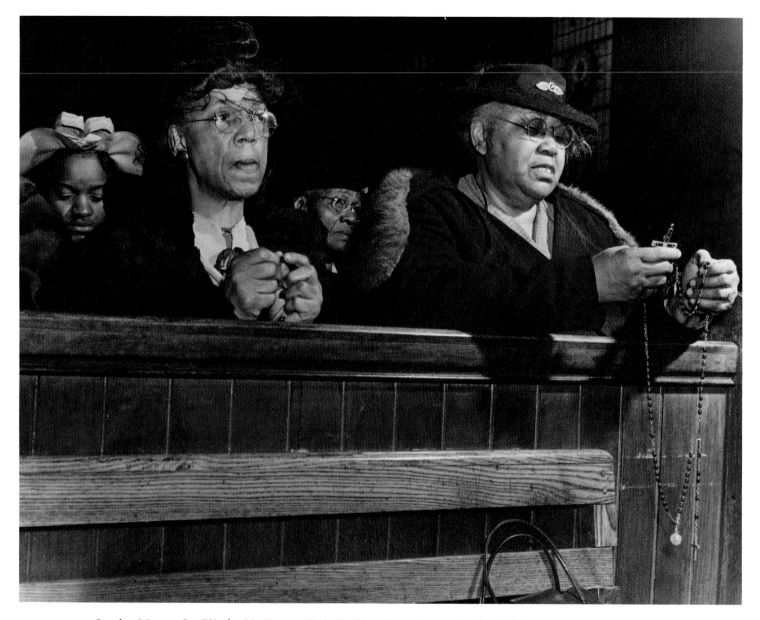

Sunday Mass at St. Elizabeth's Roman Catholic Church on the south side. All the pastors here are white with the exception of Father Smith. The congregation is made up entirely of Negroes. Chicago. March 1942. *Jack Delano*

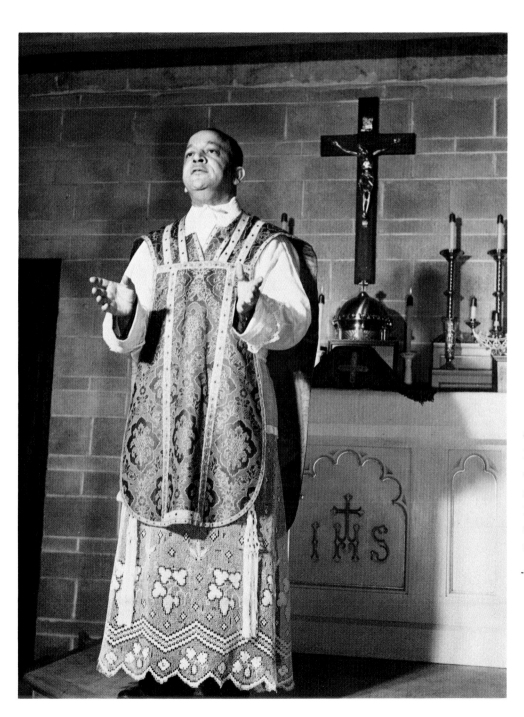

Church service at a
Negro Roman Catholic
church on the south
side. Father Smith,
Negro pastor,
conducting Mass.
Chicago. March 1942.
Jack Delano

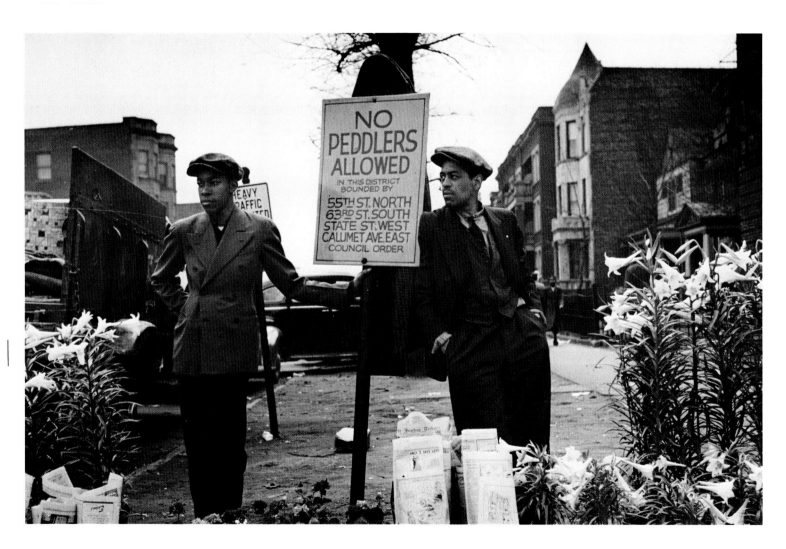

Peddlers on Easter morning on Garfield Boulevard. Chicago. April 1941. *Russell Lee*

GETTING AHEAD

■ For thousands of migrants, the movement from the rural South to the urban North represented "getting ahead." Cayton and Drake used this same theme to express upward mobility within the black community of Chicago. Although opportunity was greater in the North, the pattern of segregation placed limits on where blacks could live and the kind of work they could pursue. The result was a class structure skewed toward a significantly larger lower class among blacks than within white society. Using education, housing, and occupation as criteria, the authors of *Black Metropolis* indicated that sixty-five percent of the Negro population of Chicago was in the lower class, which was fifteen percent higher than the comparable percentage for the total population of the city. Thus life in the Black Belt tended to center on the basic themes of survival, enjoying life, and praising the Lord.

Those who did get ahead not only succeeded in improving their own lot, but also "advanced the race" as they moved to the middle and upper classes. The most notable of these were considered "race heroes," the business and political leaders of the Black Belt. Cayton and Drake called those motivated to get ahead "strainers" and "strivers." Like other Americans, they displayed their wealth through conspicuous consumption. Membership in the "correct" social organizations and churches helped confirm their upper-class identity.

The clearest example in the photographs of those "on the rise" is the prosperous male posed with a photograph of his parents. The caption on another image describes him as "the best dressed Negro in Chicago." Others at the top of the social pyramid were doctors, lawyers, teachers, ministers, and executives. They had achieved positions that set them apart from the conditions of poverty and restricted opportunity typical of life for the vast majority of Black Belt residents.

The images selected for this section reflect a variety of occupations and settings related to the theme "getting ahead." One important factor was education. Cayton and Drake noted that most lower middle-class adults were aware of the limits on their own social mobility; "they see the key to success as 'education' plus hard work and drive this point home to their children."[1] The picture of students in front of Wendell Phillips High School represents this point. Not only does it document the students, but it also depicts the profession of photography by including the camera in the foreground. The Vachon photograph of a rent strike illustrates the demand of black custodians for union recognition while they also protested the quality of buildings in the Black Belt.

There were 300 black doctors in Chicago's Black Belt. Jack Delano took a series of photographs at Provident Hospital, the city's only major health care facility

for blacks. Located at Fifty-first Street and Vincennes Avenue, it was one of ten Negro hospitals approved by the American Medical Association as a major training site for health care professionals, including nurses and doctors. Provident Hospital, faced with soaring debt, closed its doors in 1987. Lee and Rosskam spent a day with Dr. Arthur G. Falls, the physician with the "consultations—cash" sign on his desk. As with all doctors in the ghetto, his patients were mostly relief cases. The incidence of disease and infant mortality was much higher in Bronzeville than in other sections of the city. The captions noted that Dr. Falls lived in a single-family residential area outside the Black Belt.[2]

In his study of black enterprise, E. Franklin Frazier noted that there were approximately 2,600 Negro businesses in Chicago in 1938.[3] Lee photographed some of these, including barber shops, undertakers, grocery stores, and taverns. Two musicians, Red Sounders and Oliver Coleman, were photographed by Jack Delano. The images suggest the "typical" American middle-class family of husband, wife, and one or two children. The crowding of the slums portrayed in the section "Staying Alive" is not evident here, nor are such scenes evident in the city's first public housing project built for blacks, the Ida B. Wells Homes. Completed in January 1941, the Wells project and one of its families are discussed in the next section.

NOTES

1. Cayton and Drake, *Black Metropolis*, 666.
2. "The Day of a Negro Doctor," Supplementary Reference Files, FSA-OWI Textual Records.
3. E. Franklin Frazier, *Black Bourgeoisie: The Rise of a New Middle Class in the United States* (New York: Collier Books, 1962), 52.

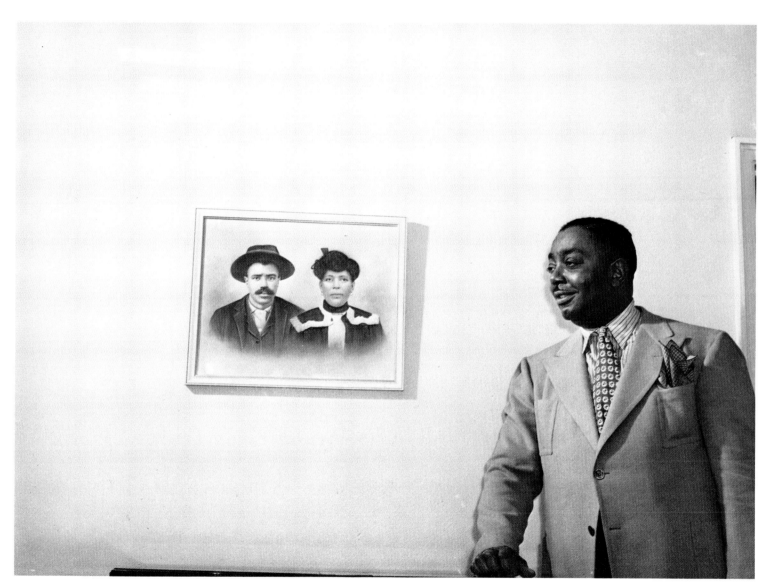

Prosperous Chicagoan posing next to a photograph of his parents. Chicago. April 1941. *Russell Lee*

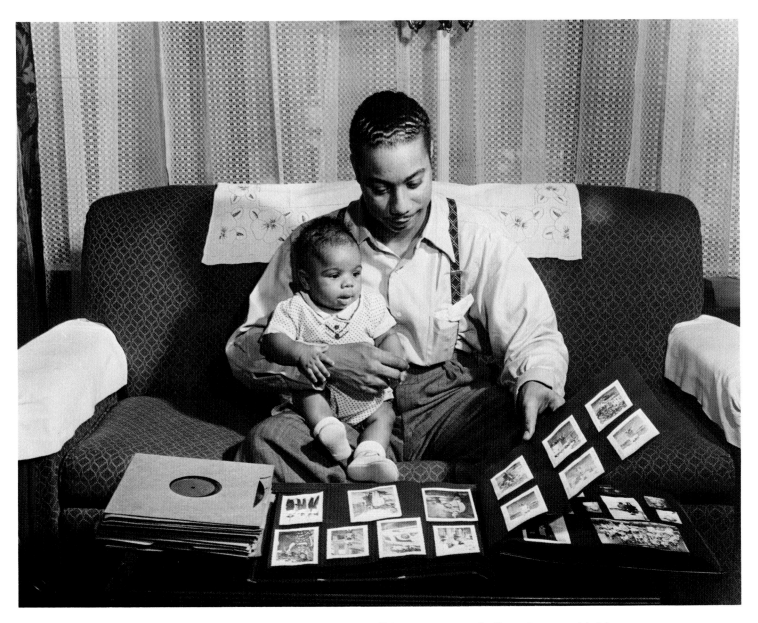

Mr. Oliver Coleman, drummer, in the living room of his apartment on Indiana Avenue with his five-month-old son, looking at a scrapbook that has many photographs of bands with which he has played. Chicago. April 1942. *Jack Delano*

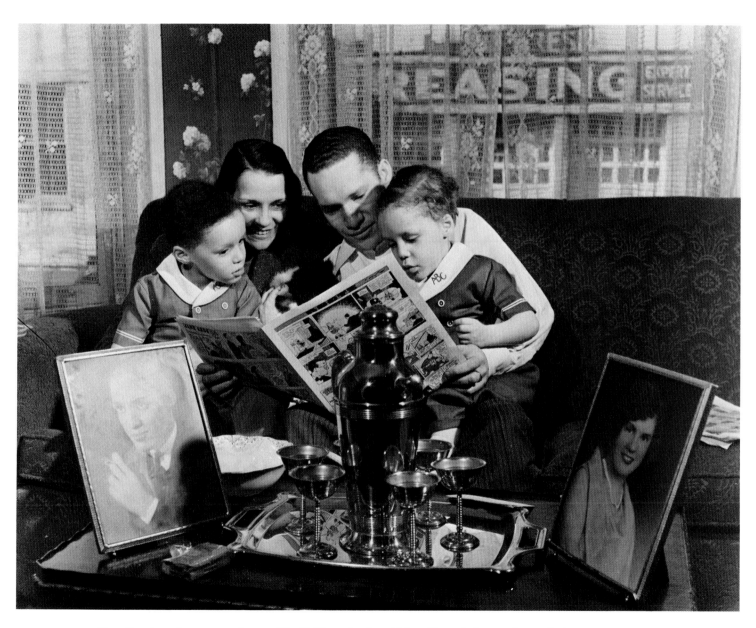

On a Sunday afternoon at home, "Red" [Sounders] and his wife read the comics to their children and puppy whose name is "Blitz." Chicago. April 1942. *Jack Delano*

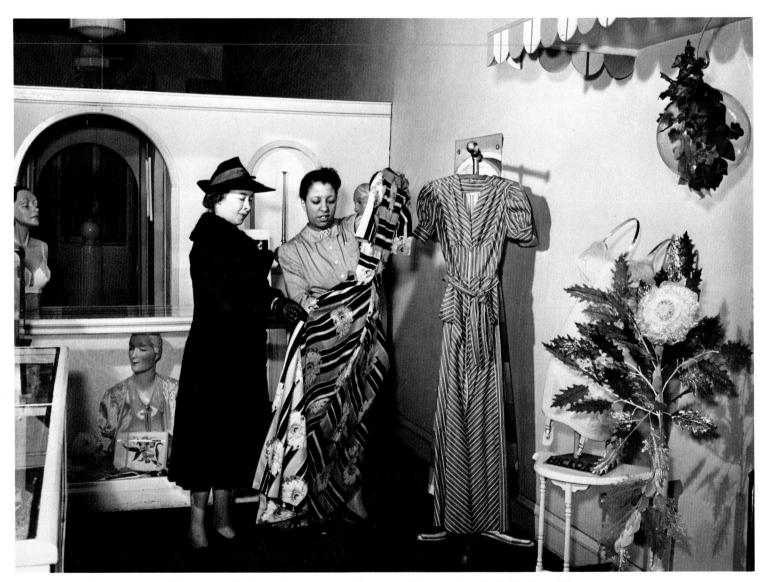

Dress shop on Forty-seventh Street that caters to Negroes. Chicago. April 1941. *Russell Lee*

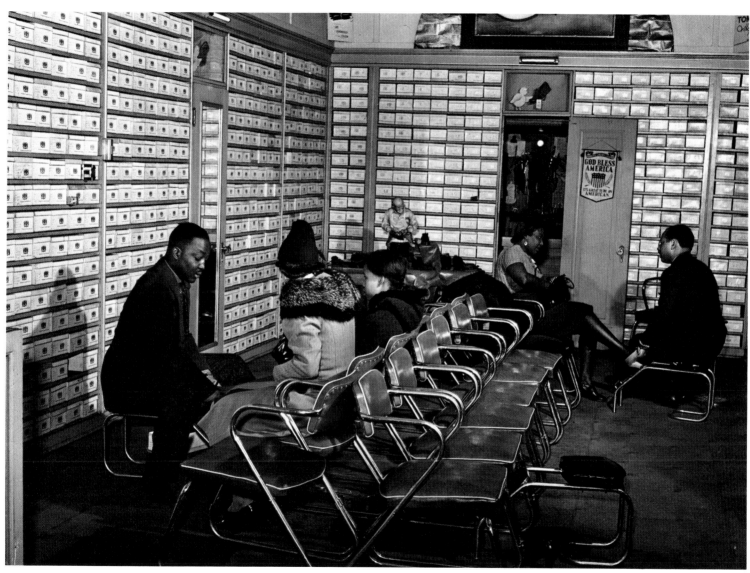

Shoe store on Forty-seventh Street. Chicago. April 1941. *Russell Lee*

155

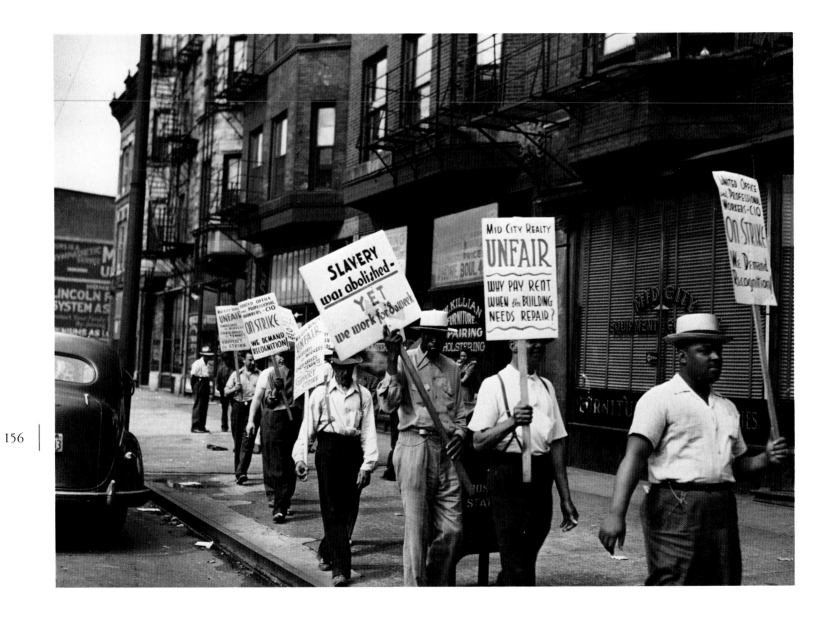

Picket line in front of the Mid-City Realty Company. South Chicago. July 1941. *John Vachon*

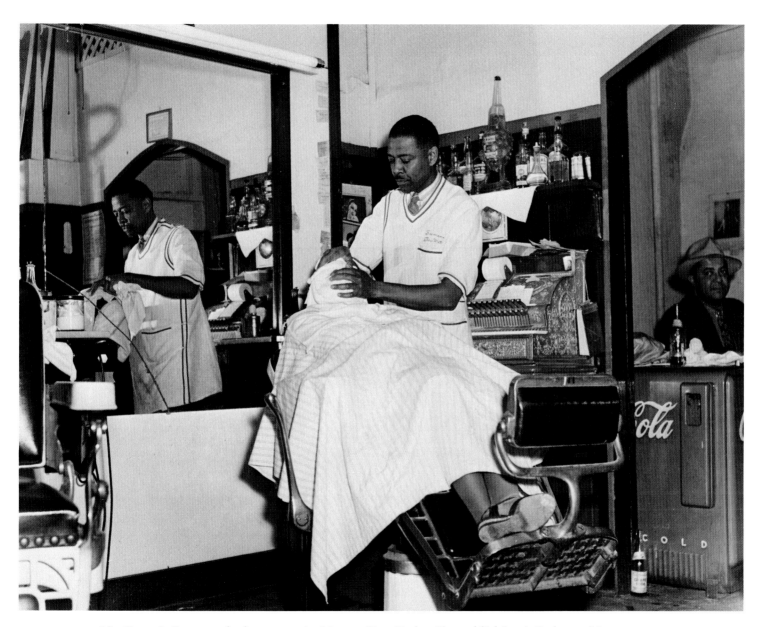

Mr. Oscar J. Freeman, barber, owns the Metropolitan Barber Shop, 4654 South Parkway. Mr. Freeman has been in business for fourteen years. Chicago. April 1942. *Jack Delano*

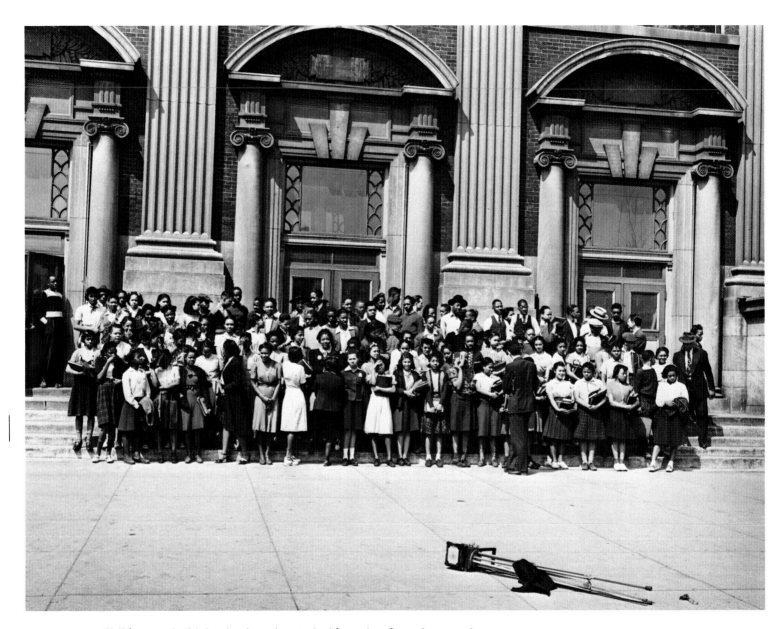

Children at the high school on the south side posing for a photograph.
Chicago. April 1941. *Russell Lee*

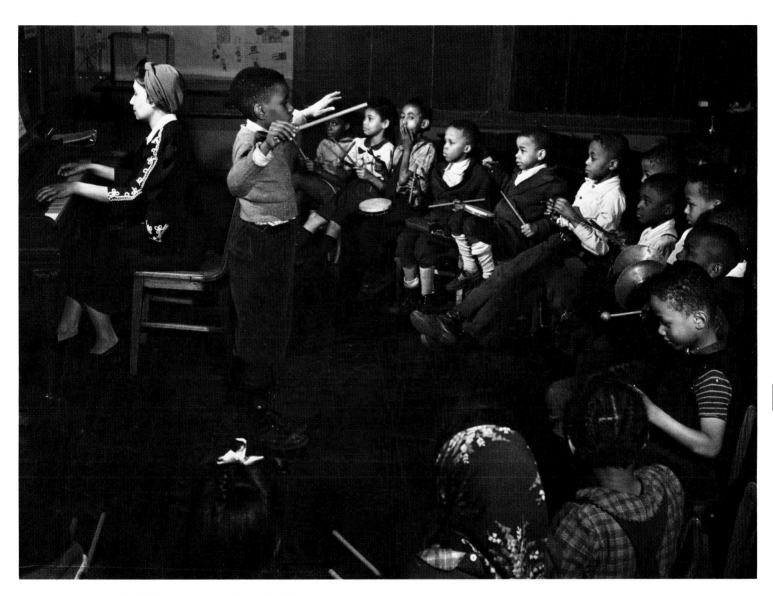

Ida B. Wells housing project. A children's rhythm band in a music class.
Chicago. April 1942. *Jack Delano*

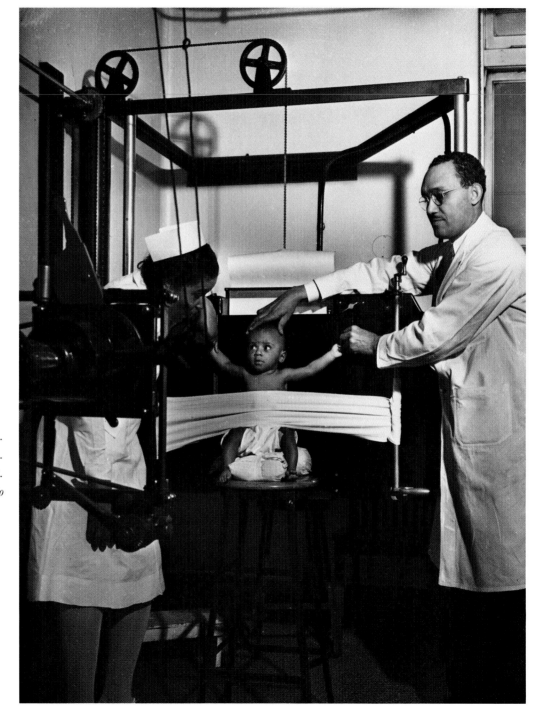

Provident Hospital.
Baby being X-rayed.
Chicago. April 1942.
Jack Delano

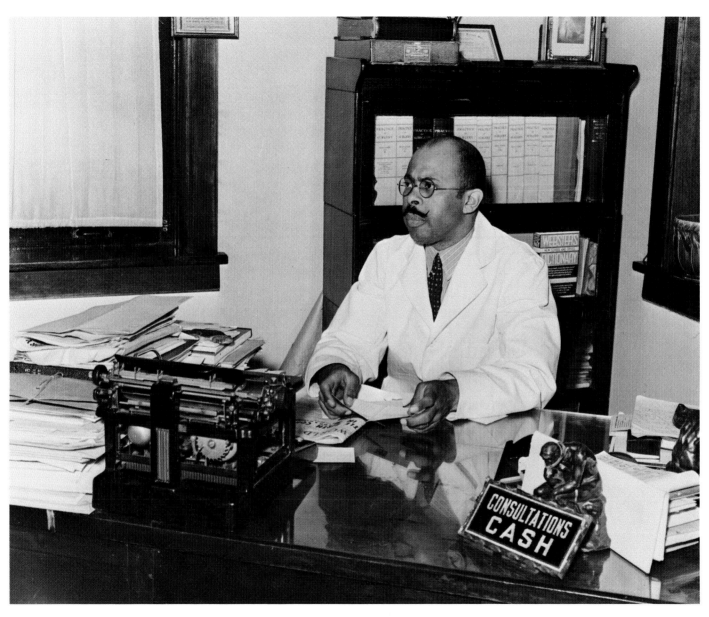

Doctor in his office on the south side. Chicago. April 1941. *Russell Lee*

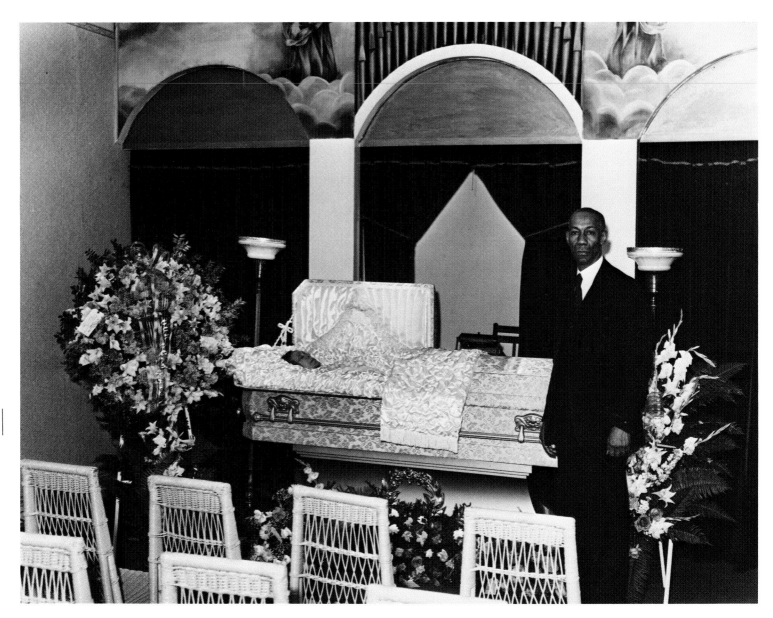

Undertaker before funeral service on the south side. Chicago. April 1941. *Russell Lee*

163

Marriage license and the Lord's Prayer above a bed in a Negro home.
Chicago. April 1941. *Russell Lee*

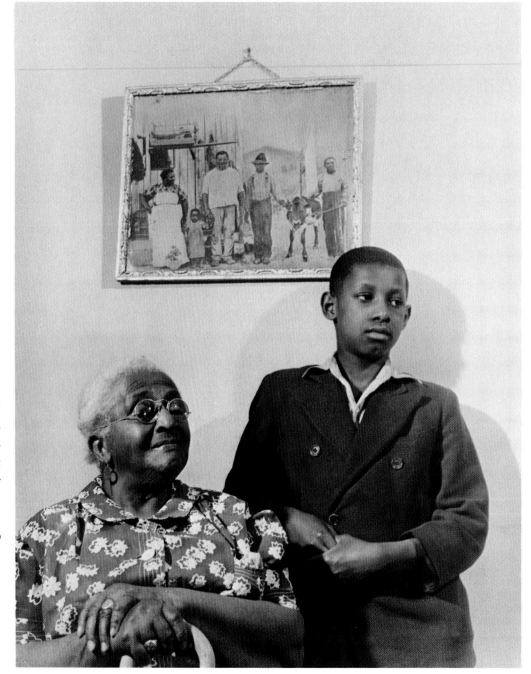

164 | Ida B. Wells housing project. Mrs. Ella Patterson, 102 years old, the oldest resident at the project, and her great-grandson. Chicago. April 1942.
Jack Delano

TWO FAMILIES

■ The photographs of the Ray Carr and Daniel Senise families were taken during the war years by Jack Delano. Sensitive to the need for images that documented the contributions of ethnic groups to the defeat of Japan and Germany, he selected a family of Afro-American descent from the Ida B. Wells housing project in the Black Belt and a family of Italian heritage from suburban Blue Island.

The Carrs lived in one of four public housing projects built during the New Deal years in Chicago. Three earlier projects, the Jane Addams Houses, Julia C. Lathrop Homes, and the Trumbull Park Homes, were built for whites. To comply with federal regulations, the Addams project included sixty black families in accord with the racial composition of the neighborhood. Initiated by the Public Works Administration in 1934, the Wells project was built under the auspices of the Chicago Housing Authority, a five-member not-for-profit corporation established in 1937. The project was named for Ida B. Wells, a civil rights advocate who migrated to Chicago from Tennessee during the World's Fair in 1893. On a forty-seven-acre tract in the Black Belt located between Thirty-seventh and Thirty-ninth streets, South Parkway, and Cottage Grove Avenue, it was a project for blacks only. Playgrounds, athletic fields, a community building, and 124 residential buildings of two, three, and four stories were con-structed. Eighteen thousand applications were received for the 1,662 apartments. Unlike the other three projects, families on direct relief, initially seventeen percent, were accepted as were another 23.5 percent who were WPA workers. Only "complete families" with children, such as the Carrs, were eligible; however, a few elderly persons such as 102-year-old Mrs. Ella Patterson were assigned two-room apartments.[1]

Ray Carr was a junk dealer whose ownership of a truck was noted by the photographer. Carr, his wife, and his three children—Jelna, Grace, and Ralph—shared a four-room apartment. As the captions indicate, each of the children had future ambitions; thirteen-year-old Jelna to be a doctor; Grace, an artist; and Ralph, an aviator. Jelna was the mayor of the children's governmental council, called Wellsville. Although the Wells complex was a marked improvement over existing housing in the ghetto, the project served to further concentrate those Americans segregated by color within the boundaries of the Black Belt.

During the 1920s, suburbs like Cicero, Berwyn, and Evanston experienced explosive growth made possible by improved transportation in the form of street railways and automobiles. The Senise family lived at 2439 Orchard Avenue in the southwestern suburb of Blue Island. A veteran of World War I, Mr. Senise was a conductor on the Illinois Harbor Belt Railroad. He

supervised a five-man crew that operated at the railroad's Blue Island switching yard. Born in Chicago of Italian parents, he was married to a Louisiana native who came north while a child.

Daniel Senise was a blue-collar worker whose weekly income averaged fifty-three dollars. The Senises occupied the first floor of a two-story home that they bought in 1927 for $7,500. The second floor was rented to a young couple. Two children, Bobby, eleven, and Jerry, thirteen, lived at home; their older brother Jack, twenty, was an aviation cadet in the U.S. Army. Jerry worked two hours daily after school at a meat market and planned to enlist in the Marines when he reached age seventeen. Bobby was a paper boy, a safety patrolman, and played the trumpet in the school band. Mrs. Senise was active in several organizations and was a volunteer at St. Francis Hospital. As Delano's general description concluded: "The Senises are a friendly, likeable family. Mrs. Senise does a good job of running her home and raising the children. . . . Mr. Senise knows his job thoroughly and is liked and respected by all his fellow workers."[2]

The photographs in this chapter are arranged to indicate the complementary nature of the two families. Although Delano took more than fifty pictures of the Senises and provided a descriptive three-page text, there are only thirteen photographs of the Carrs, one of several families he covered on his visit to the Black Belt. The importance of captions in documentary photography is apparent in these images. Delano's notes on the Carrs enable us to understand a great deal about the family even without a general descriptive text. The captions expanded the photographer's opportunity to take imaginative pictures. Further, the captions help the readers interpret and understand the photographs.

NOTES

1. Devereux Bowly, Jr., *The Poorhouse: Subsidized Housing in Chicago, 1895–1976* (Carbondale: Southern Illinois University Press, 1978), 18–33. Mrs. Patterson is seen in the section "Getting Ahead."
2. "General Caption on the Senise Family," copy from the personal files of Jack Delano.

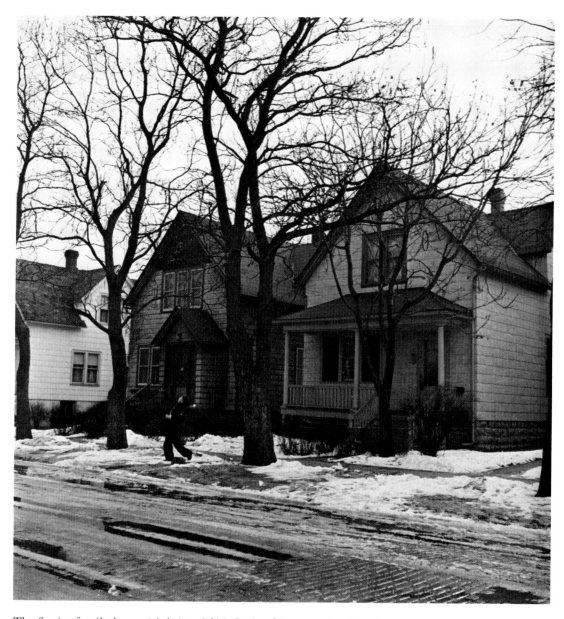

The Senise family home (right) at 2439 Orchard Street. Blue Island.
February 1943. *Jack Delano*

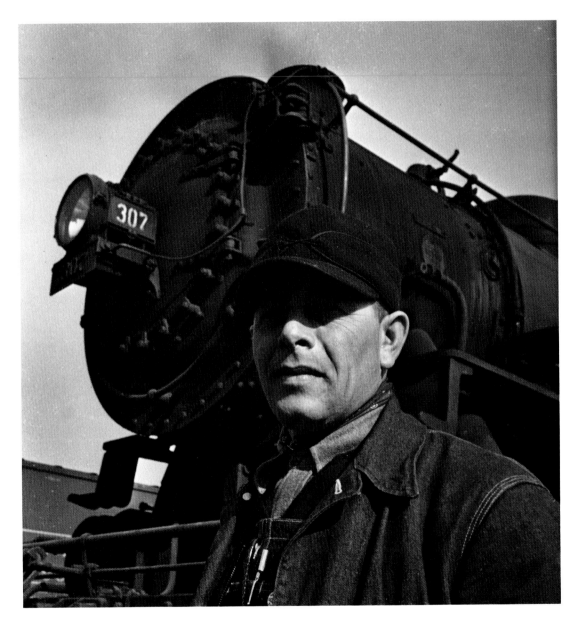

Portrait of Daniel Senise. Blue Island. February 1943. *Jack Delano*

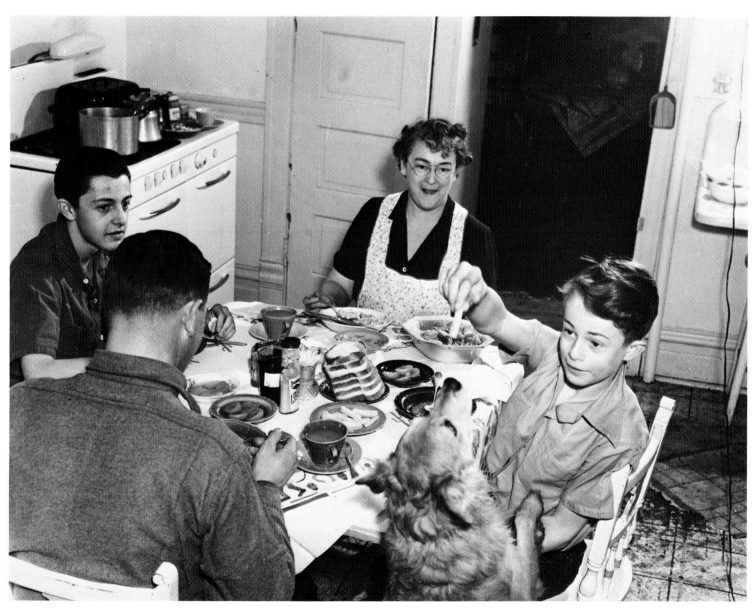

"Pooch" getting his dinner from Bobby Senise. Blue Island. February 1943. *Jack Delano*

170 | Bobby Senise working on his lessons. Blue Island. February 1943. *Jack Delano*

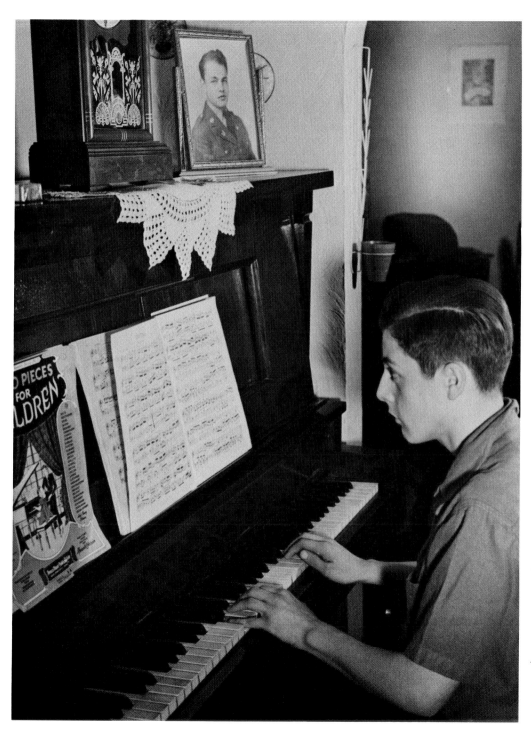

Jerry Senise takes piano lessons and "bangs around" whenever he has time. On the piano is a picture of his brother Jack, who is in the U.S. Army and has just returned from Hawaii. Blue Island. February 1943.
Jack Delano

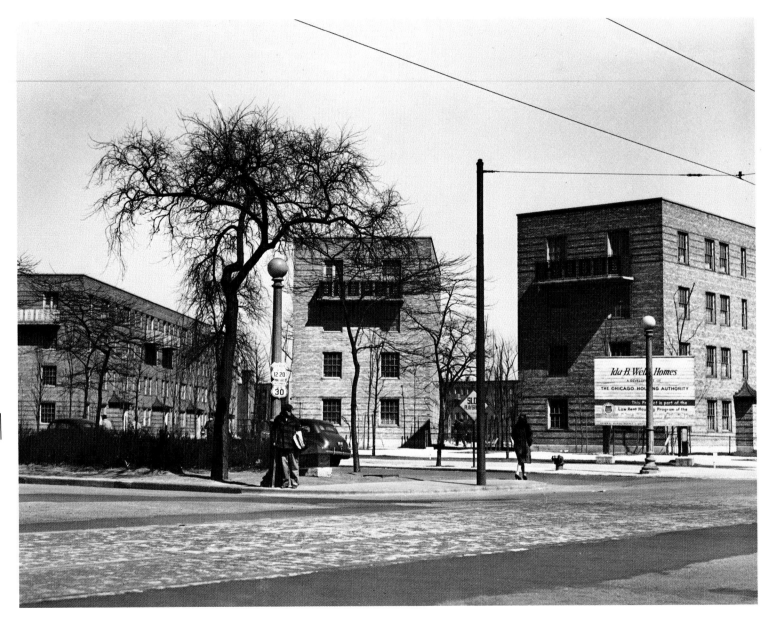

Ida. B. Wells housing project. Houses. Chicago. March 1942. *Jack Delano*

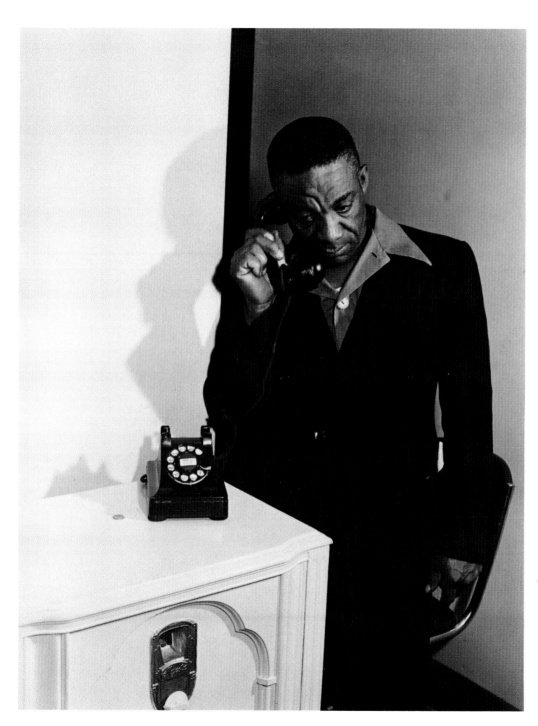

Ida B. Wells housing
project. **Mr. Ray Carr**
making a phone call.
He is in the junk
business and owns his
own truck. Chicago.
March 1942.
Jack Delano

173

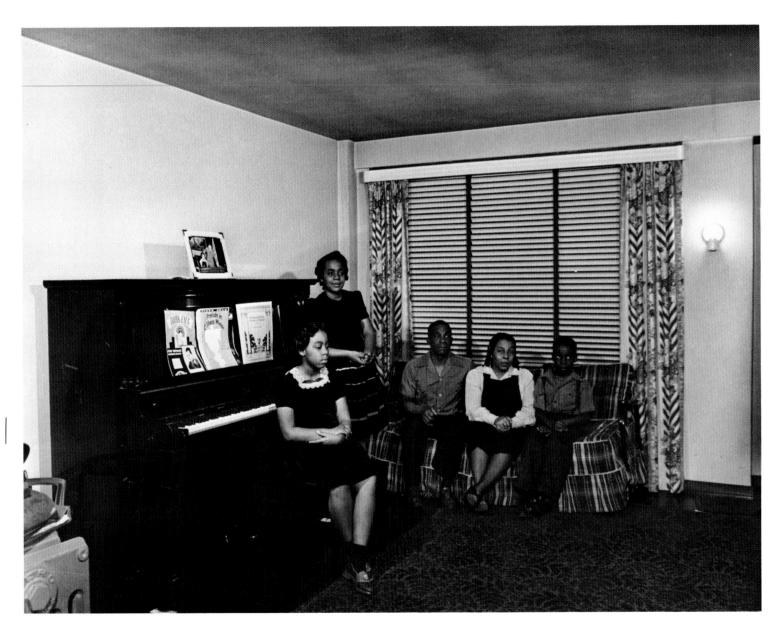

Ida B. Wells housing project. The Carr family in their living room.
Chicago. March 1942. *Jack Delano*

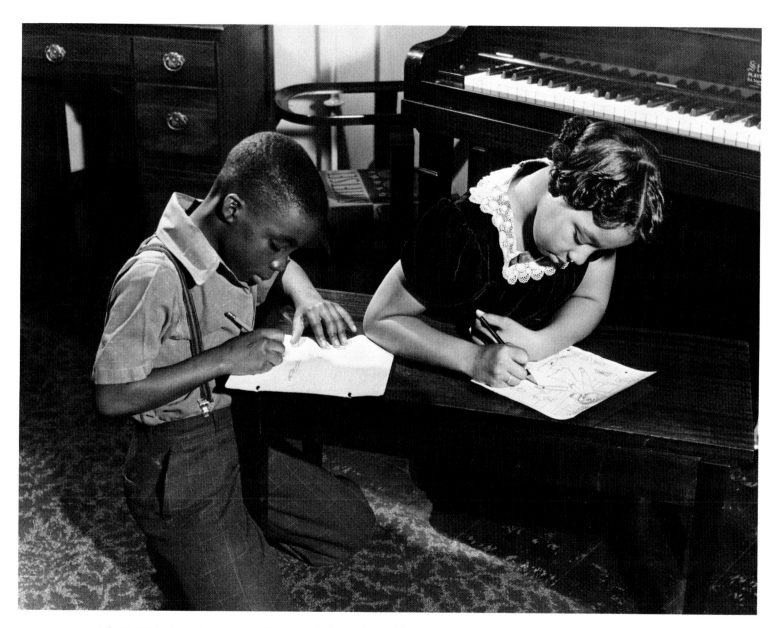

Ida B. Wells housing project. Ralph and Grace Carr, Jelna's brother and sister. Ralph wants to be an aviator, Grace, an artist. Chicago. March 1942. *Jack Delano*

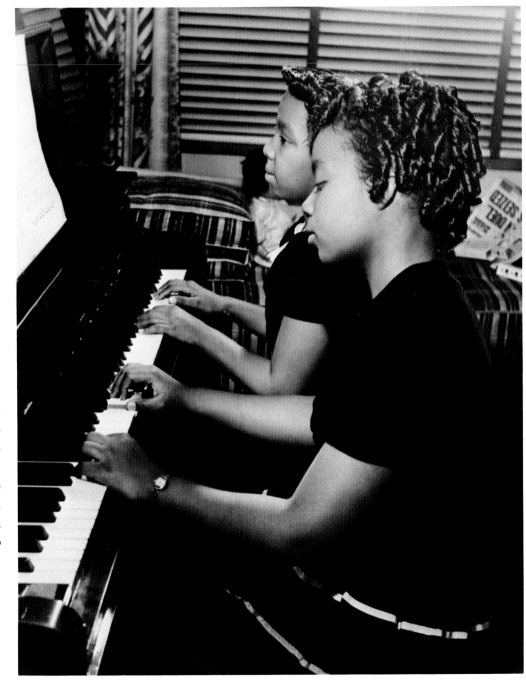

Ida B. Wells housing project. Jelna Carr and her sister Grace both play the piano. Jelna also plays the clarinet in the school band. Chicago. March 1942. *Jack Delano*

WORLD WAR II

■ On 5 October 1937 President Franklin D. Roosevelt came to Chicago to dedicate the Outer Drive Bridge on the city's lakefront. He used this occasion to denounce the "epidemic of world lawlessness" that had followed Japan's attack on China. He called for a "guarantee" against aggressor nations in Europe and Asia who were marching armies of conquest against their neighbors. Despite the threats from overseas, the United States responded as a reluctant belligerent. Selective Service was authorized by Congress in September 1940, following the fall of France to the armies of Nazi Germany. Japan's attack on Pearl Harbor on 7 December 1941 brought America into a two-ocean war. Paradoxically, this was "the good war," an international struggle that seemed to embody the clash of democratic values with systems that were both autocratic and racist.[1]

Illinois played a significant role in the war effort. Approximately one million of the sixteen million Americans who served in the armed forces came from the Prairie State. In addition, the state "held a front line position" on the home front. National defense and war overcame the economic problems of the 1930s. Real per capita income, adjusted for inflation with a 1929 base of 100, declined to 61 in 1933, returned to 100 in 1941, and reached 139 in 1944. In the Chicago area, the total value of industrial production grew from slightly more than $4 billion in 1939 to nearly $12 billion in 1944.[2] By 1945, Illinois led the nation in the production of ammunition and artillery.

Most of the selections in this chapter were taken in Chicago by Jack Delano. John Vachon's photograph of the man picketing Bowman Dairy in the summer of 1941 indicates both the theme of preparedness and the issue of racism. The important role played by blacks during the war years can be seen in the increasing percentage of blacks in the Chicago area work force from 4.9 percent to 11.7 percent over the five-year period.[3] Blacks served with distinction in the military and returned home with renewed dedication to the American ideals of freedom and equality. Although the struggle would continue for many years, World War II marked the beginning of the end for the segregated society of Black Metropolis.

Delano's photographs of Union Station depict a variety of war-related activities. Used by both civilians and military personnel, Union Station served four major railroads. Murals on the walls featured silhouettes representing the major branches of the armed forces, while overhead flew flags of the Allies and a breathtaking display of model airplanes hung from the ceiling. In the center of the terminal was a United Services Organization (USO) information booth. Chicago boasted that

it was America's "number one host to servicemen."[4] These images from this major transportation center convey the bustling activity of the nation at war.

Other examples of the wartime contributions of Chicago are seen in the photographs of Esther Bubley and Ann Rosenor, Office of War Information photographers. Bubley extended the coverage of the nation's transportation systems, including a trip from Cincinnati to Chicago on the Greyhound bus system. The role of women in the wartime labor force was substantial; for example, the number of women employed in manufacturing in Illinois increased 117 percent during the war years. Particularly noteworthy was the Republic Drill and Tool Company, located in Melrose Park. More than eighty percent of its employees were women, and the machinery and procedures of the plant were adjusted for them. For example, free plastic surgery was available for those injured and police escorts were provided to car stops for night-shift employees.[5] The conversion of American industry from domestic to war production is seen in the image of the assembly line at International Harvester. The government provided the funds to construct a large Buick Motors Division plant in Melrose Park, which produced airplane engines for C47s, C54s and Liberators. Two employees are depicted in front of a map of the Chicago area illustrating the commuting range of the work force.

Another notable activity was the well-organized civil defense program of Chicago. More than 900,000 volunteers were mobilized throughout the city. The Delano photographs taken on the north side on Armistice Day, 11 November 1942, show Boy Scouts, organized labor, and others participating in a citywide scrap drive. The U.S. flag and the local honor roll of armed forces personnel were important symbols of neighborhood unity.

Across the state, similar home front activities took place. Agricultural production increased to meet the needs of the wartime economy. Major centers producing ammunition were the Rock Island arsenal and new plants constructed near Joliet and Carbondale. To the north of Chicago, the Great Lakes Navy base provided training for approximately one million men, while other bases in the state trained soldiers and Air Force personnel. More than twenty-two thousand Illini gave their lives for their country in World War II. Those who returned came home to a state with an expanded industrial and agricultural economy that had overcome the travails of the Great Depression.

NOTES

1. Studs Terkel, *"The Good War": An Oral History of World War II* (New York: Pantheon, 1984).
2. Mary Watters, *Illinois in the Second World War*, 2 vols. (Springfield: Illinois State Library, 1952), 2: 1, 134.
3. Robert P. Howard, *Illinois: A History of the Prairie State* (Grand Rapids, MI: Williams B. Eerdmans, 1972), 531.
4. Watters, *Illinois in the Second World War*, 1: 69.
5. Ibid., 2: 252–54.

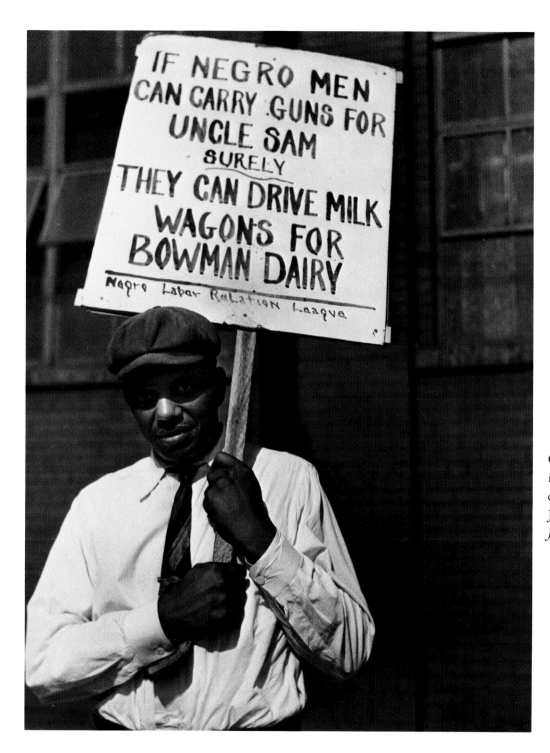

Carrying a sign
in front of a milk
company. Chicago.
July 1941.
John Vachon

180 | Loading airplane
propellers into freight
cars at the U.S. Army
consolidating station.
Chicago. May 1943.
Jack Delano

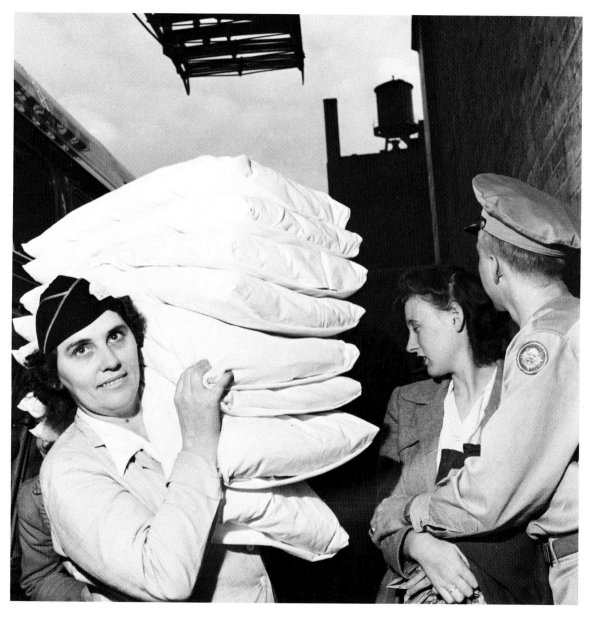

A pillow girl waiting to board a bus at the Greyhound bus terminal.
Chicago. September 1943. *Esther Bubley*

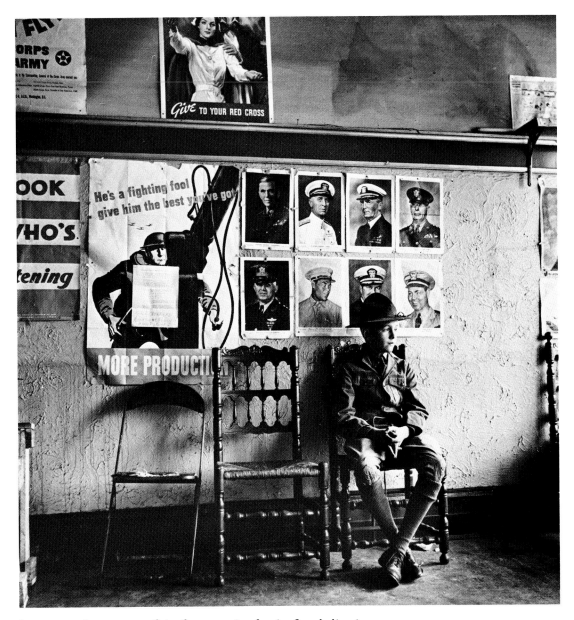

Boy scout who was one of the first to arrive for the flag dedication ceremony.
Chicago (north). November 1942. *Jack Delano*

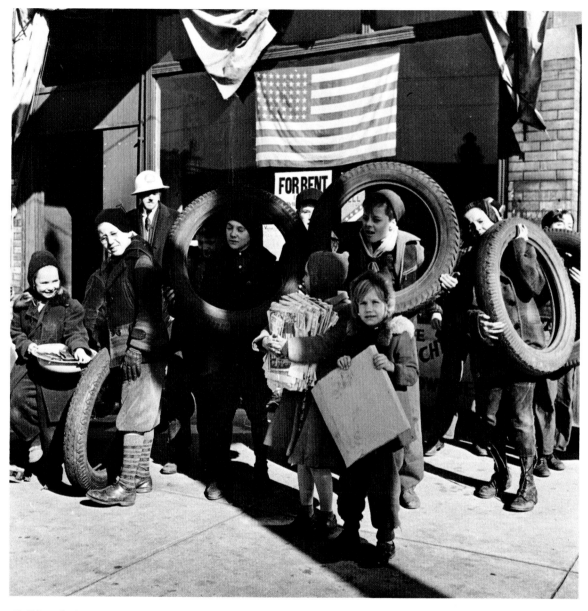

Children bringing scrap into the United States Office of Civilian Defense block headquarters. North Chicago. November 1942. *Jack Delano*

Using multicolored pins to mark residences of its employees, a Midwest aircraft factory
innovates its carpooling system. Like hundreds of other U.S. factories, this plant encourages
workers to utilize all available car space, thereby sparing tires, saving gasoline, and lessening
the load on public transportation vehicles. Melrose Park. July 1942. *Ann Rosener*

Maybe it isn't Shakespeare, but is makes sense to the employees of this drill and tool plant who are manufacturing thousands of drills each day for use in all war production industries. Chicago. August 1942. *Ann Rosener*

Shift from peace-time to war-time economy. Two trains at Chicago's tractor plant of
International Harvester Co., one loaded with farm tractors and diesel-powered units of our new
mechanized army. Both are vital to the health and security of America. Date unknown.
Photographer unknown

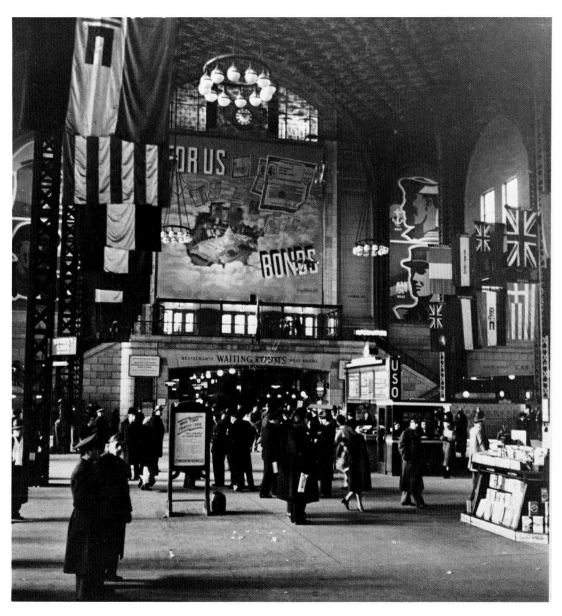

Union Station train concourse. Chicago. January 1943. *Jack Delano*

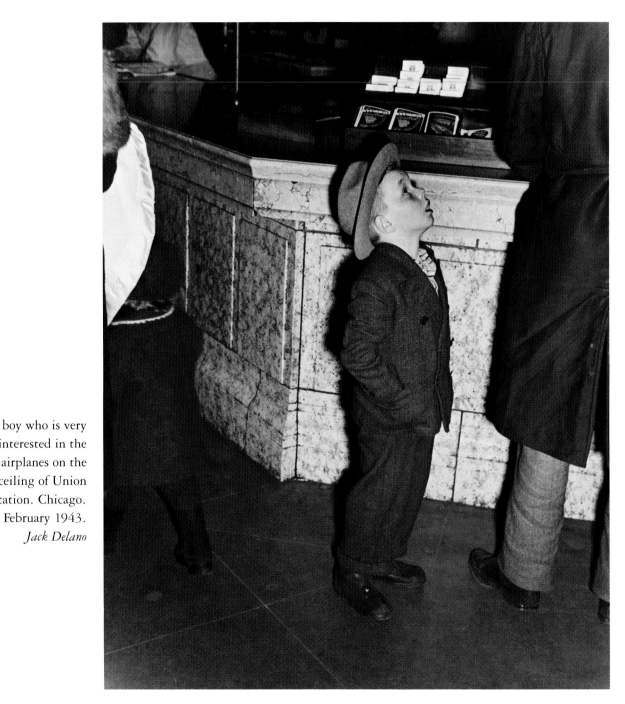

188 | Little boy who is very
interested in the
model airplanes on the
ceiling of Union
Station. Chicago.
February 1943.
Jack Delano

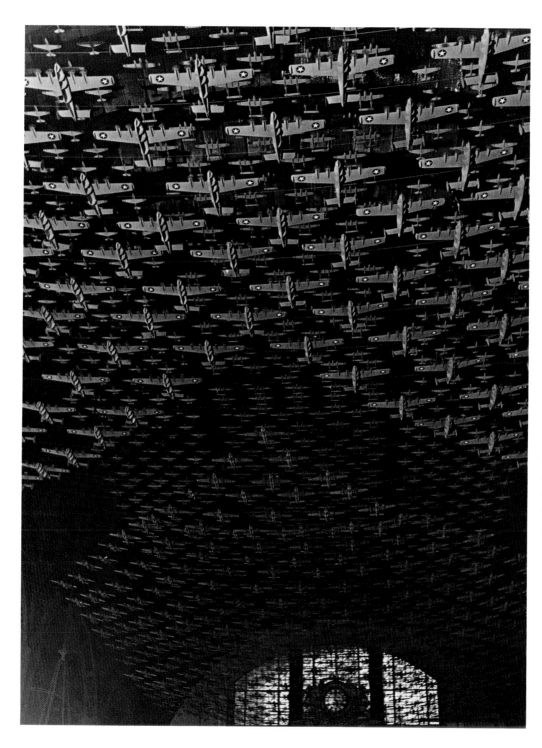

Model airplanes decorate the ceiling of the train concourse at Union Station. Chicago. February 1943. *Jack Delano*

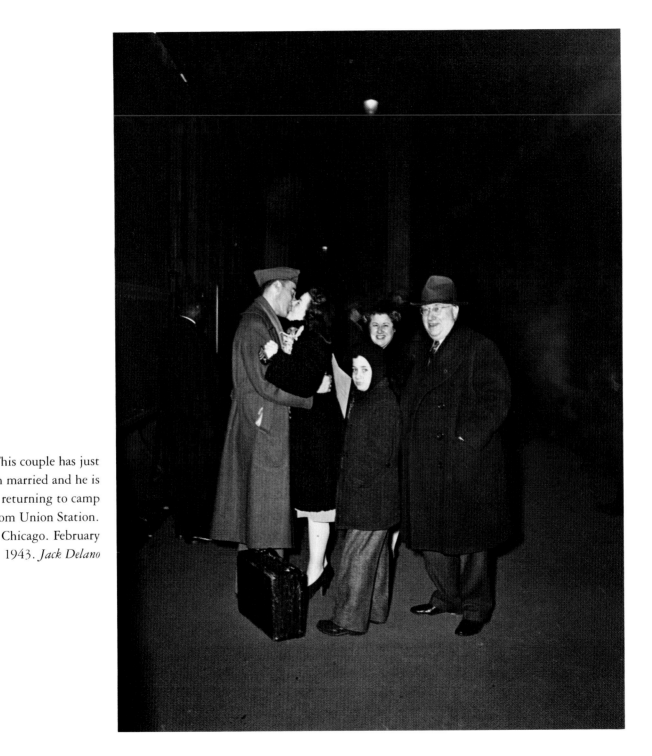

190 | This couple has just been married and he is returning to camp from Union Station. Chicago. February 1943. *Jack Delano*

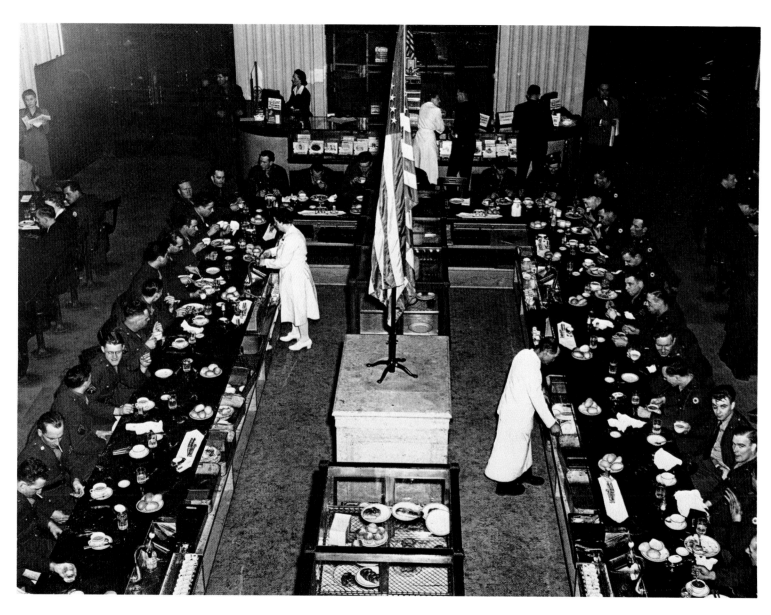

Soldiers being served dinner in the Fred Harvey Restaurant at Union Station.
Chicago. February 1943. *Jack Delano*

192 Frank Williams, working on the car repair tracks at an Illinois Central Railroad yard. Mr. Williams came to Chicago from Pocahontas, Miss. He has eight children, two of whom are in the U.S. Army. Chicago. November 1942. *Jack Delano*

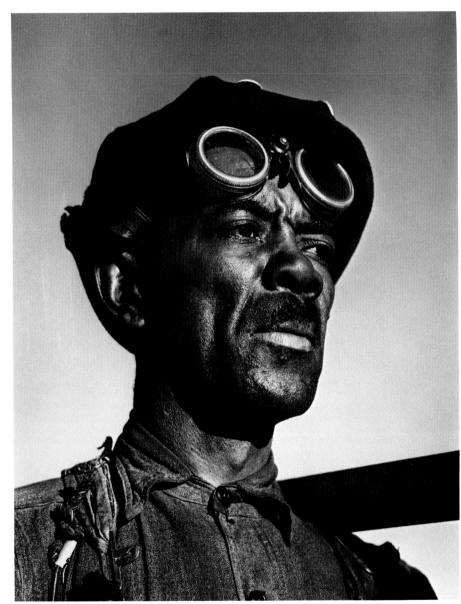

LIBRARY OF CONGRESS
NEGATIVE NUMBERS

iv	/	LC-USW 3-15873-D	44	/	LC-USF 34-10162-D	79	/	LC-USF 34-26962-D
vii	/	LC-USF 33-3528-M1	45	/	LC-USF 34-64324-D	80	/	LC-USF 34-27025-D
13	/	LC-USF 33-16036-M2	46	/	LC-USF 34-26347-D	81	/	LC-USF 34-26744-D
14	/	LC-USF 33-1963-M2	47	/	LC-USF 33-3525-M1	82	/	LC-USF 34-26868-D
15	/	LC-USF 33-16122-M4	48	/	LC-USF 34-10002-D	83	/	LC-USF 34-26808-D
16	/	LC-USW 3-5771-D	49	/	LC-USF 34-30328-D	84	/	LC-USF 34-26996-D
17	/	LC-USF 33-1911-M3	50	/	LC-USF 34-10180-E	85	/	LC-USF 34-26948-D
18	/	LC-USF 33-1907-M1	51	/	LC-USF 34-27061-D	86	/	LC-USF 34-26756-D
19	/	LC-USF 34-19692-E	52	/	LC-USF 33-11512-M3	87	/	LC-USF 34-26823-D
20	/	LC-USF 33-16173-M4	53	/	LC-USW 3-19490-E	88	/	LC-USF 34-26794-D
21	/	LC-USF 33-16119-M4	54	/	LC-USW 3-14097-D	89	/	LC-USF 34-26783-D
22	/	LC-USF 34-63193-D	55	/	LC-USW 3-14096-D	90	/	LC-USF 34-26992-D
23	/	LC-USF 33-16122-M1	56	/	LC-USF 33-1708-M1	91	/	LC-USF 34-26826-D
24	/	LC-USF 33-16085-M3	59	/	LC-USF 341-10210-B	92	/	LC-USF 34-26740-D
25	/	LC-USF 33-16149-M1	60	/	LC-USF 34-10252-E	93	/	LC-USF 34-26782-D
26	/	LC-USF 34-63088-D	61	/	LC-USF 34-10255-E	94	/	LC-USF 34-27053-D
27	/	LC-USF 34-63125-D	62	/	LC-USF 34-10721-E	97	/	LC-USF 33-5167-M5
28	/	LC-USW 3-1525-D	63	/	LC-USF 341-10664-B	98	/	LC-USF 34-38601-D
29	/	LC-USW 3-12723-D	64	/	LC-USF 34-10793-E	99	/	LC-USF 34-38864-D
30	/	LC-USF 33-16147-M3	65	/	LC-USF 34-10659-D	100	/	LC-USF 34-38761-D
33	/	LC-USF 34-3030-C	66	/	LC-USF 34-10653-D	101	/	LC-USF 34-38751-D
34	/	LC-USF 34-6085-D	67	/	LC-USF 34-10648-D	102	/	LC-USF 34-38737-D
35	/	LC-USF 33-1883-M3	68	/	LC-USF 34-10646-D	103	/	LC-USF 33-12993-M4
36	/	LC-USF 34-61020-D	69	/	LC-USF 34-10658-D	104	/	LC-USF 34-38599-D
37	/	LC-USF 34-60998-D	70	/	LC-USF 34-10650	105	/	LC-USF 34-38720-D
38	/	LC-USF 34-30300-D	71	/	LC-USF 34-10652-D	106	/	LC-USF 33-13009-M2
39	/	LC-USZ 62-64492	72	/	LC-USF 34-10408-E	107	/	LC-USF 33-12995-M1
40	/	LC-USF 34-63876-D	75	/	LC-USF 34-27054-D	108	/	LC-USF 33-5183-M3
41	/	LC-USF 34-10718-E	76	/	LC-USF 34-27058-D	109	/	LC-USF 33-13011-M2
42	/	LC-USF 34-63627-D	77	/	LC-USF 34-26981-D	110	/	LC-USF 33-5183-M5
43	/	LC-USF 33-2796-M3	78	/	LC-USF 34-26978-D	113	/	LC-USZ 62-31179

114	/	LC-USF 34-38677-D	141	/	LC-USF 33-13015-M1	168	/	LC-USW 3-17016-E

114 / LC-USF 34-38677-D 141 / LC-USF 33-13015-M1 168 / LC-USW 3-17016-E
115 / LC-USF 34-38618-D 142 / LC-USF 34-38767-D 169 / LC-USW 3-17003-D
116 / LC-USF 34-38791-D 143 / LC-USF 33-5184-M4 170 / LC-USW 3-16989-D
117 / LC-USF 34-38714-D 144 / LC-USF 34-38827-D 171 / LC-USW 3-16987-D
118 / LC-USF 34-38630-D 145 / LC-USF 34-38813-D 172 / LC-USW 3-819-D
119 / LC-USF 33-12984-M4 146 / LC-USW 3-163-D 173 / LC-USW 3-84-D
120 / LC-USF 34-38627-D 147 / LC-USW 3-136-D 174 / LC-USW 3-86-D
121 / LC-USF 33-12985-M2 148 / LC-USF 33-13009-M5 175 / LC-USW 3-68-D
122 / LC-USF 34-38629-D 151 / LC-USF 34-38851-D 176 / LC-USW 3-78-D
125 / LC-USF 34-38808-D 152 / LC-USW 3-1500-D 179 / LC-USF 34-63103-D
126 / LC-USF 34-38814-D 153 / LC-USW 3-1524-D 180 / LC-USW 3-26676-D
127 / LC-USW 3-1469-D 154 / LC-USF 34-38683-D 181 / LC-USW 3-37792-E
128 / LC-USF 34-38559-D 155 / LC-USF 34-38671-D 182 / LC-USW 3-12486-E
129 / LC-USF 34-38582-D 156 / LC-USF 34-63115-D 183 / LC-USW 3-12497-E
130 / LC-USF 34-38593-D 157 / LC-USW 3-1494-D 184 / LC-USW D-5579
131 / LC-USF 34-38585-D 158 / LC-USF 34-38755-D 185 / LC-USW D-5729
132 / LC-USF 34-38583-D 159 / LC-USW 3-296-D 186 / LC-USZ 62-37330
133 / LC-USF 34-38609-D 160 / LC-USW 3-545-D 187 / LC-USW 3-15458-E
134 / LC-USF 34-38587-D 161 / LC-USF 34-38835-D 188 / LC-USW 3-15881-D
135 / LC-USF 34-38543-D 162 / LC-USF 34-38815-D 189 / LC-USW 3-15950-D
136 / LC-USF 34-38878-D 163 / LC-USF 34-38639-D 190 / LC-USW 3-15951-D
139 / LC-USF 34-38825-D 164 / LC-USW 3-105-D 191 / LC-USW 3-15863-D
140 / LC-USF 33-13013-M3 167 / LC-USW 3-17012-E 192 / LC-USW 3-10517-D

A Note on the Captions

The original captions from the Library of Congress have been used in most cases, although corrections have been made to punctuation, capitalization, and spelling. Corrections of fact are enclosed in brackets. The captions were taken from information provided by the photographers, although they may have been edited by Stryker or his staff in Washington, D.C.

The number of each photograph enables one to locate the desired negative at the Library of Congress, Prints and Photographs Division.

Note on the Editors

Robert L. Reid is Professor of History and Vice President for Academic Affairs at the University of Southern Indiana. He holds a B.A. degree from St. Olaf College and the Ph.D. from Northwestern University in Evanston. After teaching for several years at Miami University in Ohio, he returned to Illinois and held an administrative assignment at Sangamon State University in Springfield. His previous publications include *Battleground: The Autobiography of Margaret A. Haley* (University of Illinois Press, 1982) and *Back Home Again: Indiana in the Farm Security Administration Photographs, 1935–1943* (Indiana University Press, 1987).

Larry A. Viskochil is Curator of Prints and Photographs at the Chicago Historical Society. Among his publications is *Chicago at the Turn of the Century in Photographs* (Dover Publications, 1984).